S0-EJI-305

Women I Can't Forget

"These fascinating eye-witness accounts make one see and feel what life is like for women who are locked into an existence of subservience in the male-dominated societies of many developing countries. We can thank this intrepid and sensitive author, who made many dangerous and difficult trips to remote areas of these countries and shares here the engaging stories of what she found."

—Mary Glazener, author, *The Cup of Wrath*

"These profiles of unforgettable women provide a stirring reminder of the power of the human spirit to rise above significant cultural and economic barriers. It is clear that these women, and many other unforgettable women just like them, possess an inner strength that shapes and changes our world. A remarkable look at the truly powerful spirit of these women."

—David J. Spittal, President,
Southern Wesleyan University

"*Women I Can't Forget* is a book I can't forget. The stories and the truth revealed here cannot be forgotten or ignored. Winnie Williams has given us powerful and haunting glimpses into the lives of women in other parts of the world. They are women who have been painfully disenfranchised because of religion, history, tradition, power, and male domination. We need to hear their stories because they, too, are our sisters."

—Raye Nell Dyer, President, Baptist Women in Ministry, Chaplain, Vanderbilt University Medical Center

"*Women I Can't Forget* is a book that will quickly capture your interest. It literally takes you on a journey to other countries, allows you to view different cultural lifestyles and at the same time tells a moving story of the degradation of women and their struggles. This is a must-read book for every woman."

—Jo Ella White, author, *Jim's Court House*

"Winnie Williams ventured where those of us who consider ourselves sensible thought she shouldn't go. . . . This book creates mental images vivid enough to ensure that you, too, can't forget these women."

—Sandra A. Reeves, Ed.D.

To Connie with
Warm Wishes –

Women
I can't Forget

A Global Traveler
Reveals the Struggle and Courage
of Women Without Rights

Winnie Vaughan Williams

WINNIE VAUGHAN WILLIAMS

Blue Dolphin

Copyright © 2001 Winnie Vaughan Williams
All rights reserved.

Published by Blue Dolphin Publishing, Inc.
P.O. Box 8, Nevada City, CA 95959
Orders: 1-800-643-0765
Web: www.bluedolphinpublishing.com

ISBN: 1-57733-081-1 softcover
ISBN: 1-57733-097-8 hardcover

Library of Congress Cataloging-in-Publication Data

Williams, Winnie Vaughan
 Women I can't forget : a global traveler reveals the struggle and
 courage of women without rights / Winnie Vaughan Williams.
 p. cm.
 ISBN 1-57733-081-1
 ISBN 1-57733-097-8
 1. Women—Cross-cultural studies. 2. Women—Social conditions.
 3. Women—Economic conditions. I. Title.

 HQ1206 .W7235 2000
 305.42—dc21

 00-049847

First printing, March, 2001

Photo of author: Woodie P. Williams, III
Cover design: Jeff Case

Printed and Bound in Korea

10 9 8 7 6 5 4 3 2 1

Dedication

To Woodie,
with love,
and
to our children,
Wes, Wyatt, and Wanda

Acknowledgments

THANKS TO DR. SANDRA REEVES who first fanned the embers for me to write of my experiences and who often shored up my doubts as I began the writing process; to Professor Sylvia Titus of Clemson University, who provided me with valuable writing assistance and kindly commentary; to my son, Wyatt Williams, a computer engineer who was always on call to rescue Mom from compute glitches; to my son-in-law, David Vickers, who diligently read the script and gave me precise comments; and to Joella White, a fellow writer, who read and edited my work; and to the gentle loving missionaries who nurtured me in their home and provided me with information regarding the plight of women in specific countries.

Also my warmest thanks go to Woodie, who not only listened as I wrote and read to him but who maintained the home base as my itchy feet lured me to unknown lands. My sincere appreciation also goes to Paul Clemens, publisher of Blue Dolphin Publishing, Inc., and to his staff who have gently guided me through the process of publishing this book.

Table of contents

Foreword

HAVE YOU EVER WANTED TO SEE beyond the narrow confines of your own little world? Have you ever felt so blessed with material and spiritual things that you wanted to share them with someone in need? Winnie Williams had these desires and more and, as a result, traveled far and wide, ministering educationally, spiritually, and emotionally to many different groups of people. She ventured where those of us who consider ourselves sensible thought she shouldn't go, e.g., traveling on a narrow-gauged train full of peasants across China—alone! Most of us would not have the courage to undertake such a trip, when we knew no one nor spoke the language, but Winnie Williams never let hardship and discomfort stand in the way of accomplishing her missions. The conditions of the women she encountered interested her enough for her to write this wonderful book.

For 25+ years of friendship, Winnie and I have worked together as psychologists and educators. She has shared with me the fact that her early training in the ministry was hampered by her being a woman. Having grown up in the deep South during the 1940s, she knew about gender discrimination, but her experience with seminary training greatly increased her awareness of our society's discrimination against women, which was so much greater then than it is today. Her work in education with poverty-stricken families gave her even greater insight into what that

discrimination can mean when gender and socioeconomic status are combined as discriminating forces.

Since retirement from college teaching, Winnie has had opportunities to travel with mission groups. Her missions have been varied. In diverse regions of the globe she has taught a course on mental retardation to teachers at the university level (China), taught in several seminaries and at conferences (South Africa and Haiti), served as speaker in ten cities in India (even participating in the installation of a public toilet!), studied Inca Indians as a Fullbright scholar (Peru), instructed missionaries regarding the homeschooling of their children (Thailand), and consulted with public school teachers in the area of special education (Albania). On her return from each trip, I have been fascinated by her stories and distressed by her resultant depression. She has had the opportunity to see those two factors, gender and socioeconomic status, in combination with extremely diverse cultures—and her heart has been torn by the lives of the women. In *Women I Can't Forget,* she combines descriptions of the beauty of the places she saw and the fascination of the cultures with insight into the forces which shape the lives of people—ecological, economic, and social. She goes further by looking at what hope there is and what progress is being made in the lives of women. She knew that where there was hope, there could be dreams. Where there were dreams fulfilled, there could be change for the better. It was the conditions under which these very special women worked and struggled for a brighter tomorrow that interested Winnie enough to write this book so that she could also share her experiences with other women of the world.

I think you will find that the reading of this book will create for you mental images vivid enough to ensure that you, too, can't forget these women. I further predict that Winnie Williams will become another woman you can't forget.

Sandra A. Reeves, Ed. D.

Introduction

I AM, AND HAVE BEEN FOR MOST OF MY LIFE, intrigued with people who live in countries a world apart from my comfortable life in America. Thus, over the past fourteen years I have roamed the world in search of vastly different places and people, specifically those in developing countries. In traveling to more than thirty countries, often alone, I have spent up to six weeks in some of these countries in exploration of remote villages with primitive settings, observing and talking to people dwelling in slums and villages, and relishing in the splendor of a few wealthy people. I have seen a wide variety of human problems and have viewed a slice of people's lives that is both fascinating and disturbing, especially those facets related to the vulnerability of women.

Through my travels I have explored the enchantment and seductiveness of these countries and have been privy to the views of women whose voices celebrate their joys, especially of mother-hood, and lament their exploitation. I have been touched by the struggles of my sisters in societies that reject women as significant others and cheer with those women who are riding an upward trend in securing professional jobs and joining organizations which seek to empower women.

I mingled with crowds amid the stifling smells of cities and have had women thrust their children with cancerous sores near my face, begging for coins or food. I have spoken with women

who have experienced senseless persecutions and hopelessness in their quest for freedom, women, rich and poor alike, who related their struggles of coping with the fact that an intrinsic part of their culture, their religion, and the ideologies of their countries demand the subjugation of women. I became aware that there is no dignity for many of the world's women, only a life filled with despair and a quest to be loved and accepted.

The woman of China, for example, faces tribulation as she seeks to cope with the limits of one child per family, threats to unwanted female children, and lack of parity in the workplace. The Albanian woman is unable to break out of the trap of domesticity and grueling farm work. Though her mind is athirst for a life that gives her joy and hope, she is hopelessly bound by the longstanding customs of servitude.

The pleas of the Amazon woman are timeless as she ekes out her living along the Amazon River and in the surrounding jungles. Living in a hut built high on stilts, she is surrounded by her half-naked children and condemned to a life of toil.

The South African woman, perhaps the most vulnerable of all, keeps going in spite of adversity as she is beaten by her husband, sometimes raped, and forced to share her husband with other women. She may be left behind when her husband goes to the city to work and adds one or two additional wives to his harem and fails to send money back home to the township to support her, his first wife and his children.

In Thailand, often called the land of the "smiling people," the woman is controlled by the male, and she does not smile as she endures a subservient status and physical abuse. The land of Thailand offers beauty, enchantment, and splendid ocean resorts along with enticements of the prostitute for the visiting male. Thus, many of the women of Thailand are afflicted with AIDS, especially in Bangkok, the prostitution capital of Asia.

As I encountered the women of these countries, I peered not only into their lives and heard their laughter but their hopes as well as their cries and shared in their revelations. I learned of the joys of motherhood and their acts of heroism as well as their menacing bondage. I tried to measure the cost of living for these

women and saw that it is a price that no woman should have to pay. Their pleas are timeless as they reach for hope.

I have tried to arouse the reader's sensitivity to the culturally based roles forced on these women. It is difficult to view their situation without identifying with the intensity of their yearnings and experiencing a strong desire to facilitate change, even though it may be small. My aim in writing *Women I Can't Forget* is to elevate peoples awareness of the status of women in developing countries.

My primary sources of information have been my personal observations, my contacts with people in specific countries, and my conversations with missionaries and other Americans living in the countries. I cannot document all of the information about which I have written, but I believe my sources to be honest and reliable. Some information came from local newspapers and television reports in specific countries. I have relied on *Background Notes*, published by the U.S. Department of Affairs, Office of Public Communication, 1998, for statistical information regarding various countries. The names have been changed to protect individuals.

These experiences of exploration have given me the freedom and delight to wander, to explore new vistas, and to develop an appreciation of other cultures even if at times it meant a cost of sacrificing my comfort and personal freedom. Most of all, however, my pilgrimages have revealed to me the beauty of the universe and its people who are diverse yet empowered with form and order. God's master plan is to embrace all people with love, freedom, and dignity, women included.

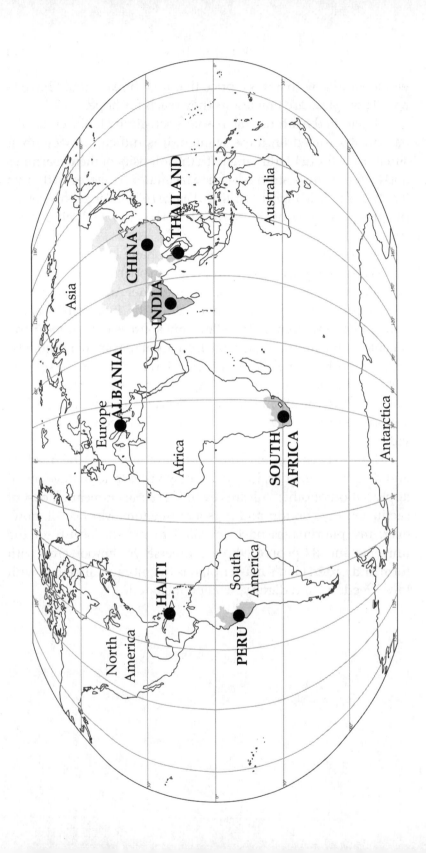

1

South Africa's Women

IT WAS A COLD SUNDAY MORNING and she was cooking porridge in a small black pot over an open fire. The area where she prepared meals for her family was next to her hut and was enclosed by a stick-and-brush fence where her half-naked and filthy children were playing with a shabby, bony dog. When I asked, by pointing at my camera, if I could take a photo of her and her children, she held out her hand for money. I did not have a rand (African money) with me but discovered that I had a few U.S. coins in my pocket, which I gave her. Later, she returned the coins saying it was "no good in my country." After I retrieved my purse from our van I gave her a rand. She did not want to miss the opportunity to secure a few coins for her family.

South Africa, Its Land and Its People

Arriving in South Africa, twelve thousand miles from the United States, was the fulfillment of a dream. I was lured to this exotic country because of its tribes of black people, its wild animals, and its bush country. It is located at the southern tip of the continent of Africa with deserts to the north, giant cliffs and

1

mountains to the south, and the plateau region near the center. It abounds with inviting sandy coastlines of the Pacific and Indian Oceans. South Africa is massive (almost twice the size of Texas), with four main regions: the veld (grassy plains), the Great Escarpment (highlands), the coastal regions, and the desert.

South Africa is a diverse land of rich farmlands, bushveld, scrub and arid deserts, as well as indigenous forest. Most of the interior, however, consists of plains with patches of dense brush and almost no trees. Where rainfall is light, there is only dry brushwood, but in areas where rainfall is heavy, there are tropical palm trees and forests of cedar, yellowwood, and ironwood trees. Where trees do exist, they struggle to survive in untamed grassland, and most of the wild sounds of the jungles are now mute. The trees have been utilized for firewood and the animals have been consumed for food while their hides and tusks have been sold for profits. There is a floral kingdom within the borders of South Africa that boasts many botanical gardens. I relished seeing some of these gardens, which produce an abundance of splendid flowers such as the delicate orchids and scarlet red poinsettias, often fifteen feet tall. Many plants continue to bloom throughout the year, due to the mild winters.

Black Africans were the first people to live in South Africa, followed by the Afrikaners, and then the Europeans. With the influx of white people, race distinction became a highly volatile political issue. Race, especially for the black, is consequential in every facet of life. There are restrictions and limitations, especially if one is a black African woman. There are four black ethnic groups of South Africans which make up 75% of South Africa and the other 25% of the population consists of the whites, mostly Dutch and British descent; the Asians, primarily of East Indian descent; and the Afrikaners or Coloreds, who are a mixture of black, Asian and/or white descents. For this chapter, the term "African women" refers to the black female ethnic group.

South Africa, with its 41 million people, evidences a beautiful landscape, enjoys wealth, and is very productive. However, the struggle that has existed between the whites, who have dominated the country for years, and the blacks, who have demanded a greater share of power, has been a constant conflict. Some

conciliation was noted when President F. W. deKlerk, in 1992, removed the ban on "subversive organizations" and black political parties. This political action was due, in part, to the sanctions placed on South Africa by many other nations. During 1992, a Bill of Rights was passed that gave every South African a right to vote. By 1994, black activist Nelson Mandela, was elected the leader of the African National Congress. Thus began appeasement to strengthen race relations in South Africa. The process is slow.

Africa is a country rich in natural resources, two that have been the most productive for South Africa are the diamond and gold mines. I heard it said that diamonds started the economic change in South Africa, but it was the gold that kept it going. The Dutch came to mine diamonds and gold hidden beneath the mountains but left much of the countryside desolate. In gold mining areas, I observed dozens of gold dumps, piles of residue from which gold had been extracted. Once while we were eating dinner, we heard the huge boom of a dynamite explosion breaking huge rocks loose in the gold mines under the city. While exploring the gold and diamond mines, I was required to wear a hard hat and instructed not to touch any of the mined dirt. I had visualized picking up a few gems from the dirt for souvenirs, but no such reward was allowed.

Surprisingly, the vibrant city of Johannesburg, the largest South African city, resembles an American city with its modern buildings (such as the Carelton Centre which is 50 stories high), exquisite parks and gardens, immense modern department stores, voluminous traffic and adequate infrastructure. The whites were busy with their cricket matches and afternoon teas, while punk rockers, with their bright red hair, meandered down the metropolitan streets, passing women dressed in high fashion. But there was one significant difference from American cities. Without a permit black Africans were not free to enjoy the prize of the city as did the white people and other races. The black people in Soweto, a black township of Johannesburg, could not leave their city after dark. Permits were needed to travel.

One third of South Africa's 41 million people live in the cities with many blacks drifting to the cities due to the prospect of employment. White people live in the center of the city and the

Coloreds and Asians usually live in the suburbs, while the black Africans live in townships or the homelands in the rural areas. In the early morning hours in Johannesburg, I observed large numbers of African women as they walked past the house where I was staying on their way to work. Most worked as servants at white residences, where they were paid meager salaries. As they walked, I observed that some of the women carried large bundles on their heads, even items as large as a table. They were dressed in loose clothing, usually a faded gathered skirt and blouse with a blanket tied around their waist. Their pace was slow for their labor each day was sure to be long and demanding.

Although there are ten different black ethnic groups in South Africa, all are descendants of the Bantu people who came to South Africa centuries ago. Of these the Zulus are the largest of the tribes and perhaps the best known. Each tribe has developed it own language and culture and members retain a fierce loyalty to their tribe. Though there is competition and often violence among the tribes, they have in most cases joined in black solidarity during the apartheid regime. In cities one can observe members of various tribes mingling together, but this is not the case in the rural areas.

Because I was in South Africa during July, their cold season, I experienced their winter and found that little heat was available in homes, public buildings or churches. To keep warm I followed the example of others by wrapping snugly in a quilt. In churches, even with my quilt, I wished for short services. In missionaries' homes where I resided most of the five weeks I was in South Africa, there was sometimes a small asbestos heater in the "leisure" room (the sitting area). This heater consisted of a small board of asbestos that contained a heating element. Often our warmth came from taking a warm bath or sitting in an automobile that had been warmed by solar heat. Black Africans had no heat in their homes but this, of course, was not the case for the white people and some others such as Afrikaners. In a hotel where I stayed for several nights, I paid extra for a blanket but was given a hot water bottle at no charge which kept my feet warm for a while.

Along with two university colleagues, I was in South Africa for a period of five weeks to speak at churches, teach in a seminary,

and lead conferences for the Wesleyan Church. As I lived in homes of missionaries who befriended the African people, I learned much about the plight of African women. I also gained information from visiting the Africans' huts, sharing their meals, and observing their life-styles. Additional information I gleaned about the African woman was the result of communicating with African men, though the men were less candid than the women.

The Effects of Apartheid on Women

Until 1992 the black Africans, representing three-fourths of the population of South Africa, could not vote because laws governing black people were different from those governing white people. These laws, which were legislated by the minority white sector, segregated people according to their race. The white governmental leaders feared that, if the black person were allowed to vote, the rights and the safety of the minority would be endangered. These laws, initiated in 1948 by the Nationalist Party, stated that black people should be segregated and prohibited from participating in governmental affairs and from marrying other races, and legislated that blacks and whites should live in separate communities. The blacks were also prohibited from riding on the same buses, using the same restrooms, or eating in the same restaurants as white people.

Included also in this legislation were laws regarding the statutory position of women related to marriage and divorce, but these laws did not include the black African woman. The laws governing rape and child support for unmarried fathers favored the male. Most black women avoided charging their attacker with rape because of the humiliation and cross-examination they experienced and the insinuations that they were sexually promiscuous. Today, however, there is great concern regarding discrimination against black women, and there appears to be some movement toward needed reforms.

Even though a large majority of the population is black, the government's redistribution plan assigned blacks only 13% of the land on which to live. These areas were called homelands and

many blacks were forced to move to these homelands while other blacks, who resided in cities, were assigned districts in which to live. If a black person worked outside his/her district, it was necessary to have a permit to enter white neighborhoods. The plan was that the blacks would live autonomously in their homeland, but the areas lacked natural resources such as fertile land or mineral deposits. The women fought alongside the men at the African National Congress protesting the unfairness of the government's ruling.

Because of the need for cheap labor, the government of South Africa allowed and even encouraged more than ten million men to work outside of their homeland, provided the men had identification papers to indicate their place of employment. One homeland leader said, "Cheap labor is South Africa's black gold." The government would not allow the black family to come to the cities to live with their husbands and/or fathers but were required to remain in the homeland. Thus, great hardships were placed on the African woman, and she remained in the homeland without income, unless her husband sent money to her. With as much as a year's separation at one time, the African men often had second wives or prostitutes in the city where they were employed and there was no money left to send back to the family in the homeland.

While I was in Johannesburg, I learned of the black township of Soweto, 15 miles from the city and considered the most rebellious of the townships. Its residents were mostly men who had been transplanted from their homelands to work in the gold mines and factories and performed other grueling jobs. I asked to visit this city with its two million black people, to see if the information that I had read and heard about Soweto were true. Each day I read in the local newspaper of 12 to 20 killings the previous night in Soweto, some due to police brutality but more often due to gangs of different tribes fighting and killing each other.

Men being thrust into crowded dormitory-sized rooms with poor sanitary conditions, low salaries, deplorable working conditions, and the frustration of being without their families produced

the volatile situation. When these factors were combined with alcohol, men often became violent. The blacks protested the inequalities through rallies, strikes, and work slowdowns. Thousands have died in the township riots and I was informed that even driving through Soweto was dangerous for white people. I could not get anyone to accompany me, and I did not dare venture into Soweto alone.

Another cause for violence was that black people could not own their own homes in the townships; thus, it was necessary to rent a house, or more likely a room that had to be shared with others. These conditions engendered strong resentment among the blacks toward apartheid and the leaders in the minority white government. For each black man who died in violence, a woman or women and children, were left in peril. With the sudden loss of income, the wife had to assume leadership of the home without preparation for such a role. Women were taught to be submissive, not to be leaders.

Apartheid caused many hardships for black women. Wives whose husbands worked in the city could see their husbands perhaps only once a year. To make the situation worse, women were not recognized to make decisions. Men were needed to get women permits to seek jobs, to qualify for housing, to register children in school and even to open bank accounts. According to Bishop Desmond Tutu, the 1984 recipient of the Nobel Peace Prize and an Anglican Bishop in Johannesburg, apartheid has had a direct effect on women. South Africa is the only country in the world, he says, which makes it a crime for a man to sleep with his wife. If one is a migrant, legally married to his wife, he must for eleven months of the year live in a single-sex hostel. If his wife were to visit him and want to sleep with him, she would be committing a statutory offense. He also told of an incident near Capetown in which the police tore down the plastic shelters of women who had come to visit their husbands, leaving the women sitting on the ground with their babies in the cold winter rain with their household items piled at their feet. "Their crime," he said, "was that these mothers wanted to be with their husbands and the fathers with their children." He maintained that the African fam-

ily structure was being grossly and deliberately undermined by governmental policy.

With equal rights being affirmed in 1994, the black community, which has been exploited for years, now has the freedom to seek more productive lives and rise above the poverty that has controlled them for many years. Understandable, however, the years of exploitation will not be easy to erase, especially for the black women of South Africa, who have not been held in high esteem by the men of Africa, even before apartheid.

The Home Life of African Women

My first close-up view of an African black woman was the morning following my arrival in Johannesburg. She walked past the residence where I was staying, apparently on her way to perform domestic work at a white residence. She walked erectly with a big parcel on her head and a baby wrapped in a small blanket tied to her back. She, like most African women, had full lips and flaring nostrils and wore a baggy dress with a bright plaid cloth wrapped around her hips. She wore sandals, which was unusual in that in the rural areas women were usually barefoot, even in the winter.

Based on what we know of the life of the black women, we can make some assumptions about her. This woman had either walked the distance into Johannesburg or perhaps had ridden a bus into the city to work. She probably lived in a rural area in a house of mud bricks with a grass thatch roof. Her house or hut probably had a chimney in the center of the roof so that on cold nights an open fire on the dirt floor would give warmth to the family. This hut would probably be the home of her extended family, or maybe six or seven individuals. If she lived in a homeland settlement, her husband and the other adult male family members would likely be working and living in Soweto, making her the dominant person in the home. Women and old men run many of the homeland families because more than half of the men who were employed worked in the cities.

For an evening meal she probably served her family cornmeal porridge made from pounded corn, along with curdled milk,

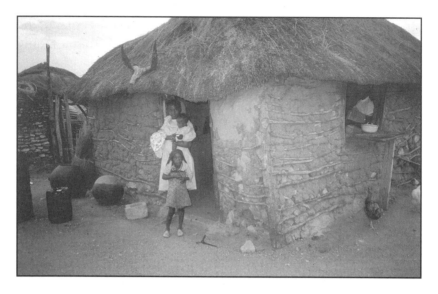

A South African mother and her children.

peanut butter, and maybe grasshoppers. The meal most likely was cooked over an open fire, possibly in a hut built for preparing food. Sometimes there would be beef, sheep, or goat meat to eat or maybe biltong, a dried strip of antelope meat. She may serve *putu*, a thick cereal made from corn which her family will enjoy. When the meal is prepared, the men will probably eat first, at least at a separate time from the women. On the weekend she will brew beer from grain in a large earthenware pot. Though many urbanized blacks have adapted to a Western style of eating and drinking, most of the members of the tribes maintain their traditional way of life.

In the African village, the land belongs to the community and the chief or headman gives a family permission to build a home. This is usually a round hut with clay walls and a pointed roof of thatched straw. However, it may be a shanty made from corrugated iron boxes, giving the appearance of a chickenhouse with a flat roof. Or the family may live in one of the more prosperous areas where her house may be built of concrete blocks with a tin or iron roof. Wherever she lives, there will probably be several chickens, other domestic animals, and maybe a scrawny dog. She will probably keep her animals in an enclosure, loosely built with

stones and limbs, or there may be a *kraal*, a pen in the center of the village to keep the cattle. The number of animals that a family owns usually indicates the wealth of a family.

To secure water for her family, she may walk a long distance and maybe even farther to a river to wash her clothes, which she places on a nearby bush to dry. With the unclean water, her family may become ill and even die. While she is involved with her chores, the children will be playing with the toys they have made, such as a car made from wire or sticks. Her children will play only after their tasks have been completed, the boys herding goats and cows and the girls taking care of the younger children and learning to cook.

Most African women wear dresses or skirts and blouses, which have lost their brightness due to many washings. They also wear traditional clothing of blankets and skins adorned with bright beads and ornaments, though many are adopting the Western style of clothing. I never saw an African woman in slacks, even though it was cold. I was told that only "women of the streets" wear pants. At special events women will wear ceremonial dresses which are colorful and decorative.

I also visited with an Afrikaners or Colored family. The Coloreds are a mixed race of people, primarily descendants of the earlier settlers and the indigenous people, who compose about 9% of the population. Afrikaners often refer to themselves as the white tribe of Africa. In this family the husband was not as dark as most of the black people, while the wife was even lighter than her husband. They lived in a lovely white stucco home, with electricity only recently having been added. The Afrikaners own many of the country's largest farms, vineyards, and sheep ranches. These individuals do not carry the prestige of a white family but are considered to be of a status superior to the black African. Homes of the upper classes are often built of brick or stucco, but never of wood since wood is scarce and expensive.

I also stayed with an African white lady for a week and gained insight into some of the earlier developments in South Africa. Her family had owned 150 acres of land in South Africa during the time when the government began designating homelands for

black people and most of her family's property was designated as homelands for the Zulus. In fact, the family has only five acres of the original land remaining for farming and for a site for their home. The government paid her family about 20% of the value of the land, she said, and gave them only two weeks notice to sell their cattle and move. She later left the family home and now resides in a house that she built for herself. It has no electricity, hot water or amenities, but she lives comfortably in her tiny, three-room house.

The Zulus, the largest of African tribes, are a simple people, who have deep respect for their elders and a patriarchal code with the fathers reigning supreme. The Zulu women lead lives subordinate to their husbands and labor more hours than do their husbands. The Zulu woman may not only work at a public job but must also care for her family needs as well. She lives in a beehive-shaped grass hut and cooks the family's food in a three-legged cast-iron pot. If the woman works away from the home, it is usually the grandparents or older children who take care of the children. Her transportation consists of walking, riding a horse, or in some areas catching a bus to work. The Zulus, as well as other tribes, suffer from much poverty, lack of education, poor nutrition, and a lack of health services. Often present in tribes are corruption and unethical control of community funds and inefficiency in management skills, which has had a detrimental effect on their success.

While visiting in the bush country, we were invited to eat a meal prepared by the ladies of a church. Huts surrounded the small church, so I suspected that the food had been prepared under unsanitary conditions over an open fire. Before the ladies served the meal, they brought a pan of water so that we might wash our hands and moved a hand-made table used during church services to use as our dining table. These ladies, who had prepared the food over an open fire, served us tea (in clear glass cups and saucers), bread, and boiled white sweet potatoes. I was curious about where they had secured clear glass cups and saucers in the bush-country, realizing these women lived in only grass huts. I was hesitant to eat the food but said a little prayer and

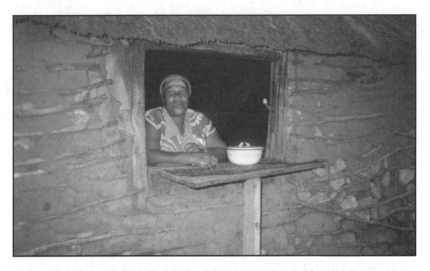

A woman cools her food in the window of her hut.

consumed the bread and potatoes and washed it down with what I hoped was boiled hot tea. These women had given their best hospitality to us three Americans, and through an interpreter we complemented them on the delicious meal.

A common thread which runs through the lives of black African women is that of abusive husbands, too many children, constant work, and nothing to show for it except fatigue, early aging, disease, and scars of physical, emotional, and psychological abuse. There is the dilemma of a husband who has many wives, maybe three, four, or even five and the husband's constant infidelity which causes jealousy, rivalry among wives, monotony, and loneliness. Once a husband pays *lobola* (dowry) for a wife, he adds her to his harem. These women endure misery, drudgery, and often abuse from the husband. Yet in spite of the foreordained misery for a young woman, families continue to groom their daughters for marriage. A young woman must marry well in order for the family to receive a substantial *lobola*, and an unmarried daughter is a disgrace.

With men having many wives, women worry about the AIDS virus. One woman tells of her husband becoming angry with her for suggesting that she might contract AIDS due to his sexual

infidelity. Many first wives are acquainted with their husbands' other wives and mistresses and are knowledgeable of their infidelities as well. It is said that some women have no scruples about stealing another woman's husband since competition for men is fierce. Women are taught that men are superior, the absolute rulers not only of the home but also of every aspect of life. Thus, a woman must accept tradition, regardless of the possibility of AIDS. Custom and tradition lead women to believe that it is normal for men to cheat, lie, abuse and dominate women. Women are taught to remain compliant to husbands in all circumstances. There are few, if any, choices for a woman who does not submit to her husband.

Visiting in the Africans' huts during the day was one thing, but to spend a night in the strange environment of a hut was another matter. When my two colleagues and I visited Kruger National Park, an 8,000-square-mile national reserve for wild animals, I stayed alone in a round hut with thatched sides and a straw roof. Inside, the hut had amenities such as a bathroom and electricity which made it much nicer than the African huts, but I was somewhat anxious nevertheless. There was no lock on the door and only a small fence around the hut to prevent wild animals from intruding. Throughout the night I could hear the sounds of the elephants, lions, and other animals that I had observed during the day. As some of the sounds came closer, and I could not identify the roars of some of the animals, my imagination ran wild. Also, I had heard bizarre stories from the missionaries about their seeing snakes larger than one's arm crawling under their clotheslines. As I looked up into the 6-inch thick thatched roof of my hut, I had visions of the roof nesting long pit vipers and of elephants walking right through the little fence. Earlier in the day I had observed the devastation caused by herds of elephants as they walked through the woods, flattening everything including trees and bushes. It was a restless night for me, and the next morning I greeted the sunrise and my two friends with relief and pleasure.

Prior to the Europeans' arriving in southern Africa, there were vast numbers of wildlife scattered throughout the country: lions,

elephants, rhinoceroses, giraffes, leopards, cheetahs, jackals, hyenas, baboons, monkeys, ostriches, zebras, wart hogs and buffalo, and antelope along with wildebeest, eland, and impala. But today most of these animals live only in the national reserves. It was in Kruger National Park that I was able to see most of these animals in their natural habitat. In addition to the animals that I saw in the national parks, I saw other species in their natural environment including crocodiles along the river, baboons in the mountains, and many small animals such as monkeys on the veldt. Also Africa has about 100 species of snakes and about one quarter of them are poisonous. One snake, the ringhals, is a venomous spitting snake and is found only in South Africa. Since many of the wild animals have been used as a source of food by the African people, visitors are not usually in danger unless they are in a national park where the animals roamed freely. With most of these animals on the loose, my sleepless night in the hut was more justifiable.

An unnerving event occurred late one afternoon when we had a flat tire as we drove our 1980 Chevrolet through Kruger National Park searching for wild animals. Wildlife personnel had cautioned us to remain in the safety of our automobile in the event we had car trouble and help would eventually come. We waited what seemed like hours, but no help came. As night approached, I suggested that Jim, my colleague, change the tire while Ellen, his wife, and I stand at opposite ends of the car to watch in the event that wild animals approached. Earlier we had seen two leopards resting by the roadside. At the first sight of danger we would all dash for the safety of the car. As we proceeded with the plan, Ellen and I continued our light-hearted conversations. Jim felt that we were being irresponsible in watching for wild animals. He, with some agitation, stated that we were all going to be consumed by wild animals because we were not cautiously keeping watch. Eventually, our tire was changed and we continued safely on our journey to another area where the next day we hiked with an experienced guide through a jungle area to find six or eight hippos resting in a lake with their head protruding slightly out of the water.

Before we left the reserve, baboons attacked our car as we waited for a school of more than 100 monkeys to cross the road in front of us. The baboons climbed up the sides of the car, on top of the hood, and even sat on top of our car squealing. We were not in danger as our windows were closed but the squealing was disconcerting and we dared not drive over any of the animals. Ellen became rather alarmed and suggested that we drive on, which we were able to do after a while. It was a photo moment, but then we were inside the car.

Health Care and Education in Africa

South Africa's white people enjoy modern medical facilities such as the medical hospital at Capetown. This research center at Capetown is located in a city where primarily white people live, as is true of most of South Africa's hospitals. Hospital facilities have been separate for black and white until recent years and the government would not provide funds for hospitals that treated both black and white people in the same medical facility. Since hospitals have not been located near the homelands where the majority of black people reside, sufficient health care has not been available for most black Africans, especially for women and children. The infant mortality rate per 1000 babies is 94 for black babies, as compared to 25.3 for Asian babies, and 14.0 for white babies. Blacks suffer due to poverty, overcrowded living conditions with unsanitary facilities, poor diets, impure water and illnesses such as pneumonia, intestinal disorders, heart disease, and cancer. As many as 50% of all deaths among black South Africans results from life-styles of excessive smoking, unbalanced diets, alcohol abuse, and increased urbanization and tension. Since 1994, there has been more emphasis on preventive, curative, and rehabilitation services for all races, but even now it may be necessary for the black person to share a bed or sleep on the floor in a hospital. It was estimated that in 1982 there was one doctor for every 330 white Africans while there was only one doctor for every 12,000 black Africans. Presently only 5 percent of doctors

practice in rural areas where disease is estimated to be 10 times higher than in the urban areas. Conditions have improved since the lifting of apartheid, but health services still remain inadequate.

Just as health care is inadequate for the black Africans, education has been, and still is for many blacks, in a deplorable condition. I visited several schools for black children and observed overcrowded rooms, inadequately trained teachers, limited materials and buildings in pathetic conditions. The children sat on benches with no backs and did not even have meager supplies like chalkboards or books. For years, education of the black was not a priority of the government. In fact, I was told that the government chose not to educate the black, because if they were illiterate, the blacks could more easily be kept subservient. Although the laws that relegated the blacks to illiteracy have been abolished, the arduous process of restructuring the country's educational system to a single nondiscriminatory system has just begun. It will be a long journey.

In contrast, education for the white child has not been neglected. The white children attend schools that are adequately

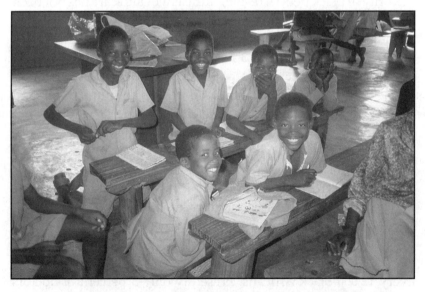

Smiles of students abound in spite of poor school conditions.

funded with excellent teachers and fine facilities. Many of the white children attend private schools, while some are sent abroad for their education.

Pretoria University, located high above the city of Pretoria, is an exemplary university. This campus enjoys one of the loveliest settings in the country and is recognized for its excellent program of studies. Even without resident facilities, the university has an enrollment of 72,000 students. However, many of the courses are extension courses, as were those that my missionary friends were taking at the time of our visit to Pretoria University. They were enrolled in anthropology courses and were intrigued with their course of study. Perhaps the black Africans will now have exposure to such excellent universities as Pretoria.

Black Women and Their Men

One of the greatest tragedies of family life in South Africa is the abuse of women. With black men being poorly paid and living in roles of subservience to the white man, much of their discontent and frustration is transferred to the black woman. Abuses of women also come as a result of tradition, alcoholism, infidelity, and insufficient resources to provide for the welfare of the family. If the husband is away working, then the abuse is that the woman is left without resources to provide the essentials for herself and her children. Often the women, as well as the men, resort to alcohol to forget the pain, and because women have the expertise to make their own alcohol, it becomes easily accessible.

One area of violence against black women is sexual crimes, especially rape. Being poor and uneducated, women become vulnerable to the black man. When a crime is committed, the woman is usually expected to provide proof of the crime. The law tends to protect the male and women are cross-examined to determine if rape really occurred. I learned that it is rare to find a black female teenager who has not had a child, and it is just as common to find that the male involved does not support the child of a teenage girl. Thus, the teenage girl leaves school, if she is in school, to raise the baby or has to work to support the child. She

may eventually marry or go through more relationships and have more children. Unmarried motherhood has a debilitating effect on the young woman, especially when the state can rarely find the father to support his child.

Another struggle for the black African woman is that of polygamy, a tradition in black African society. The law recognizes only one legal marriage, so the second or third wife and their children have no legal rights under the law. If a husband abandons them, there is no legal recourse. Thus, women are overwhelmed with trying to raise numerous children under the hardships and pressures that tradition and apartheid imposed upon them. In addition to polygamy, women struggle with securing employment and of finding caregivers for their children, if they work. They also struggle to secure funds to send their children to school and worry about the future of their children.

Men control the woman in almost every aspect of a black woman's life. The repressive life-style of the black woman is vastly different from that of the white African woman. Due to economics and higher standards of education, white women are able to live an easier and more relaxed life-style. The white woman has greater security, usually does not work, and even though the husband is the patriarch of the home, he is usually not as harsh with his wife as is the black man with his wife. Surprisingly, though, I had numerous white women tell me that they support governmental laws subjugating black people. Their basis for this position was that the black people were incapable of leadership in South Africa.

Even when a black woman makes equal financial contributions to the household, she is still ignored when major decisions are made concerning the home and family. Because black women could not own property under apartheid, this law made them subservient to men. To gain equal status with their male counterparts, black women not only have to change laws of the land but also have to combat years of tradition of male domination. Unfortunately, though, many black women have such an ingrained tradition in their concept of life that they do not seek or desire a change in the status quo.

An African woman who befriends many missionaries.

Many men, especially the under-educated man, oppose birth control. Some see it as a plot by the government to keep the black population in tow, while others see having lots of children, particularly girls, as a means of receiving *lobola* when the daughters marry. A male baby, however, is preferred as a first child since the male can perpetuate the family name. Many men desire to keep their wives pregnant because they feel that pregnant women are more manageable. The man thinks if he can produce many children by many different women, it will be evidence of his virility. If a man desires a baby and the wife refuses, it could be the end of a relationship or marriage, or if a wife is discovered using birth control, she could be abandoned by her husband. A married woman not producing a child is considered grounds for divorce and the woman can be returned to the woman's family in disgrace and shame. If a woman is sterile, her family, to appease the husband, will purchase him another wife or offer a younger daughter or niece as a second wife.

For abused women there is almost no recourse. Most have nowhere to go as most of their families struggle just to keep alive without another person to support. Divorce is expensive and there is also a stigma associated with the woman who seeks a divorce. As a result, many women turn to drinking and abusing their children, then losing their jobs, and the cycle is repeated.

The Ritual School and Lobola

Black women are taught early how to please men and prepare for marriage, thus the young black girls participate in a ritual school called "tikhomba." This four- or five-week school is considered necessary for girls to make the transition from puberty into sexually active womanhood. It is a time when young women are provided information about sexual matters and taught their role as future wives, whether or not they desire the information. Young girls, knowing that the school is presented to them near the time of a girl's first menstrual period, face "tikhomba" with dread due to the horror stories told by girls who have been forced to attend. Since it is taboo for mothers to discuss menstruation and sex with their daughters, this school is considered necessary in preparation for their daughters' marriage.

Lolota, an African woman, who was tricked by her family into going to the school, describes her experience. She was told that she was going somewhere else but was led to a house for her training. She realized, upon arrival at the school, that she would not see her family again until the training was completed. Her teacher, or "mothers" as they were called, was to teach her how to be obedient, subservient, compliant, and how to be a man-pleasing woman.

Though the rooms where the six or eight girls lived were cold and bare, their clothing consisted of only a burlap thong, wrapped around the pelvis like a diaper, a short skirt, made of cowhide and a thick rope low on their hips. There was no clothing for the upper part of their bodies. Though this was a school for virgins, the exposed sagging breasts of some of the girls indicated that several of the girls had already had babies. Lolota said she and the other

girls sat in a huddled position in a corner of a room with their legs crossed all day singing repetitious chants and stomping in time to their singing. She said they were taught tribal songs with dirty lyrics, did exercises to limber their bodies for lovemaking, pregnancy, and childbirth.

According to Lolota, the girls were tortured if they failed to follow instructions or recite what they were taught. In addition to scolding or thrashing a girl, "the mothers" would place the offending girl's head in a vice and squeeze her head until she howled with pain. The girls were whipped if they refused to eat their food, which usually consisted of porridge with chicken feet or intestines to be eaten with their fingers. A requirement was to eat everything they were served so they could be fattened up and promoted as plump and attractive women to prospective husbands.

Upon completion of the school the girls would discard their leather skirts and belts, and would smear white clay over their bodies, which they would then wash off. When these two rituals were complete, the girls were initiated into new roles wearing a tiny apron called a motolo and beads to indicate their readiness for marriage. Parents submitted their daughters to this ritual school for training because they knew men desired meek and obedient wives. After ritual school, parents assumed their daughter had acquired these desired qualities and presented them for marriage.

Another custom of black Africa is for a man to pay *lobola*, a specified amount of money or property, to a family for their daughter. It is then that the woman becomes the property of the husband. However, once a couple is married before a magistrate during a civil ceremony and the woman has a license and a ring, she then would have rights under civil law that women were denied under traditional law. Under civil law the wife can divorce a husband and sue for custody of the children and even request alimony. However, under *lobola*, the woman has no such rights. The husband may keep the house, children, savings, and is under no obligation to give the wife anything. Even the husband's parents and relatives have a right to claim all of his property, including his wife. It is understandable to see why black men have preferred the tradition of *lobola* to a civil ceremony.

Ancestor Worship and Christianity

Most tribes adhere to the age-old tribal religious traditions of ancestor worship, following the spirits of their forefathers. Believing in the supernatural, many black Africans consult a *ngnaga*, who is the person that predicts the future and gives spiritual direction. It is thought that without this protection, evil could befall a family. Thus a *ngnaga* is called to cure illness, to appease the ancestors or even to protect one's house. Believing in the supernatural, including witchcraft, is reality to the black African. There are those who practice animistic faith in which they believe that good and evil inhabit the world and that a tribal priest can communicate with these beings through various forms of magic. Though many Africans have accepted Christianity, many continue to participate in the animistic belief and witchcraft.

Eighty-five percent of South Africans are Christian; therefore, it was no surprise to find that the Bible is taught regularly in schools. More than half of the white population belong to the Dutch Reform. The next largest denomination is the Anglican Church with 16% of the population. There are also Methodists, Wesleyans, Roman Catholics and Presbyterians. Most of my contacts were with the Wesleyan Churches, where I led conferences

A rural South African church.

for pastors, spoke in churches, and led seminars on church-related topics. The membership of the churches where I spoke was primarily white Africans.

With many of the churches understanding the plight of African women, some were actively involved in African women's organizations such as the Manyano. This organization operates in the urban areas, primarily helping women of various tribes in developing self-confidence and security and giving assistance to those in need of welfare. It was this organization that developed money-saving clubs called "Assist" to give financial assistance with educational fees and to advise women in dealing with their creditors. The Manyano organization protested apartheid: however, I learned from listening to white people that this organization's philosophy was not always congruent with all white churches.

Missionaries have been instrumental in making improvements in South Africa, not only in establishing churches but also in developing schools, hospitals, and clinics for the black Africans. Most missionaries have seen the travesty of apartheid and philosophically oppose the dilemma placed on black women and men.

A visit to a tribal church revealed the efforts of missionaries. Early one Sunday morning, two missionaries, my colleagues, and I boarded a van to travel to the bush country for a church service. On previous journeys to this church the missionaries had hiked, so we were pleased to be riding; even though it was a rough ride, it certainly beat walking. Our journey took us over recently-constructed roads of rocks and dirt. The corduroy-like roads were unlike any I had previously ridden on. The "developers" had forgotten to remove the large rocks which we bounced around or over. There were no bridges so we just drove through creeks and up steep banks on our adventurous journey. Even though the roads were new, erosion ditches made it difficult to travel. Due to the excessive bumping from the jagged road, the back doors of the van continually flew open, which required us to stop often to close them.

During the more than two hours of traveling over the road, I absorbed the beauty of Mother Earth. While traveling from val-

leys to mountainous plateaus, I viewed the rosy-orange sun as it peeked from behind the hills. Along the road was an occasional tribal person who gazed intently at us strangers. We saw hundreds of cone-shaped huts, some with people sauntering around a fire preparing their morning meal. Finally, we arrived at our destination, a small block church sitting at the highest peak of a mountain. The little church, about 20 feet wide and 30 feet long had been built from concrete blocks, which the people had lugged up the mountain on top of their heads. This church was evidence of their community spirit, driven by determination and sprinkled with love.

Inside the sparsely-furnished church were benches without backs, and at the front was a small, handmade wooden table and chair. The people came from miles around the church for the church service, many from the small huts that we had seen along the road. The missionaries interpreted the two-hour Zulu service to us. The service began with only three women present but others kept coming in until there were about twenty women, twenty-five children, and one old man present the first hour. Because most men were attending a meeting called by the tribal chief; they were late in arriving. When the men arrived, they sat

Gathering of people after church service.

on the right side of the church, and the women and children sat on the left. Singing was spontaneous. Whoever wanted to sing a particular song, sang out and others joined in. There were several sermons and many testimonies from the people. At the end of the service, most of those present went to the altar and with folded hands knelt to pray. Though all the children and more than half of the women were barefoot and lacked warm clothing, they knelt to give thanks for God's provisions. Having eaten a full breakfast and dressed in warm clothing, I felt unworthy to even pray with them.

Though most Africans are Christians, they have not forsaken their old beliefs in witchcraft and the casting of spells. I encountered a situation where the family felt that witchcraft had caused a child to be severely handicapped. This family consisted of the husband, wife, and seven children. They lived in a small, improvised blockhouse, which reeked with a pungent odor. The father was employed at a telephone company and the mother taught religion at a high school. Though educated above the norm of

A family who believes voodoo spirits caused their daughter (held by author) to be handicapped.

most blacks in Africa, this family still believed in witchcraft. The wife, at about forty years of age, had given birth to a handicapped child, and the mother assumed that the retardation of her little girl, Sula, was due to her husband's mistress casting a spell over the mother.

While we were served tea and biscuits, I tried to explain, through an interpreter, the many causes of mental retardation. Though Sula was about eight years of age, she had been examined only once in her life by a doctor who told the family there was nothing that could be done to help her. Sula will probably remain a severely handicapped person due to superstitions and lack of medical services even though I informed the parents that she could be trained in many areas of her life with proper training. After returning home I mailed information to the family regarding how they might assist her in the developing of self-help skills.

Witchcraft and superstitions continue to influence many areas of the black Africans' life. Another example of witchcraft that I learned about was that of ritual killings, even though there are laws that prohibit such acts. An incident was related to me that had happened about ten years ago when a councilman became involved in killing other men in order to receive magic medicine. It was said that a passerby observed three African men holding down a younger man amputating the younger man's arms. During the process, the younger man begged to be killed. Later, when the men involved in the amputation were caught, they implicated the councilman who had hired them and said that the councilman's refrigerator contained body parts. In their search, the police discovered that the allegations were true. The councilman was taken to trial but was eventually released, even though he was found guilty. He was released to prove his innocence. He then enlisted the services of a witch doctor who said that if he desired to have magic medicine he would have to eat the brains of a confused person. They found an old woman, killed her, and the councilman cracked her head, cooked her brains and ate them. Afterwards, at his trial by a higher court, the jurors were confused and let him go free. As he left the court, he was arrested for the second murder and is now in prison.

Another incident that I learned about was that of a witch doctor who informed a father that the father could locate his two missing children if he would first eat a fetus. The father located a pregnant woman, had two men restrain the woman, and removed her baby by cutting open her stomach. Next, the father cooked the fetus and ate it. It was told that he then doused the dead woman's house with oil before setting fire to it, and her charred body showed that her stomach had been cut open. At first those who discovered her body thought that she had just gotten hot and exploded. These stories are typical of ritual killings, horrible as they are; fortunately they occur with less frequency than in previous periods of the tribal history.

Employment of Black Women

According to the Institute of Black Research in 1983, seventy-four percent of women between 21 and 44 years of age in South Africa work. More than half of these women, who have less than an eighth-grade education, spend eight to ten hours daily in a factory, agriculture, or domestic work. Because their work is usually located a long distance from their homes, they travel, on the average, five hours a day to get to and from their employment. Women complain of work overload but do not visualize a change in their situation. Because half of all adults are unemployed, these women feel fortunate to have a job of any description.

One of the disturbing factors in the study was that black women accepted their traditionally-taught inferior status to men. Even when women performed the same type of work as men, one third of the women interviewed were satisfied with receiving less in wages than men, and sixty-nine percent of the women stated that men needed jobs more than women did. Because women often feel guilty for being absent from the home, they willingly give their wages to their husbands, as if atoning for their working.

In an effort to cope with unemployment during the period of apartheid, the government restricted the movement of workers, particularly women. The government made stringent efforts to block urbanization, which limited the employment of black

women. At one period (1981-1982) the Pass Laws (prohibiting free movement of blacks) violations increased by 28% and fines paid by black Africans arrested for being in restricted areas without passes increased by 45%. Most of the fines and imprisonment were mainly African women who had sought to live and work with their spouses in urban areas. The state even made raids and arrested those who lived in shack settlements outside of the homeland.

Black women work primarily as agricultural workers on white farms or as domestics in white homes. With the lifting of apartheid, women still have been unsuccessful in rising above menial and poorly paid jobs to which they have been restricted for years. They work only when someone else is not available for a job. Thus, one does not see a woman working in a position if a man is available to perform the work. I observed this practice on numerous occasions, for example, at the Culling Diamond Mine, near Pretoria.

Upon entering the Cullinan Diamond Mine, I observed that only men were employed. It is here that the Cullinan diamond, the world's largest diamond at 3,106 metric carats, was found in 1902. This diamond, about the size of one's fist, is in the crown jewels of the Queen of England. I observed how black men excavated the dirt from the mine, crushed it slightly, to extract 8,000 metric carats a day. Only men work the mine, which is a huge hole deep enough for a mountain. There were many tasks at the mine that women were capable of performing, but they were not considered for employment.

Most white homes have black servants. With the white people paying meager wages for their domestic help, they can afford to have yard laborers in addition to household maids. One of the justifications I heard for paying low salaries to black people is that additional workers could then be hired and thus more black families would have food to eat. This is the same rationalization that I heard in India and other developing countries.

In that most black women receive limited education, the black schools are taught largely by colored teachers (mixed black and white descendants), who have received more education than the

black teachers. With insufficient education, black women tend to accept whatever jobs are available at whatever salary is offered. With additional educational opportunities, though, there is anticipation that black women will prepare themselves for professional positions that command better salaries and thus allow them to enjoy a quality of life that heretofore has been unknown by the black African woman.

Hope Aflame for the African Woman

Though South Africa is a beautiful country with rich natural resources and the most industrialized country on the African continent, black people continue to suffer from the harshness of years of apartheid. The discontentment of the black people has led to revolts, whites have retreated, and changes in attitude and laws are slowly replacing the subservient role of the black person. Blacks have transformed the white republic and now luxuriate in control of the South African government. Individuals like Bishop Desmond Tutu have worked endlessly to prevent bloodshed through promoting parity for all races with an even distribution of political power.

With the shifting of governmental leadership, there appears to be less exploitation of black women, and women are now able to organize in a search for a better way of life. It had been the case that African women were restrained from seeking supportive services from organizations without approval of their husband. Now, there are unions and action groups, and women are joining community and women's organizations. There appears to be an awakening among many African women encouraging them to move past traditional roles of servanthood. Many women are developing an awareness of freedom and are seeking to rise above their plight.

Among the women who have assumed a leadership role in South Africa is Dr. Nkosazana Zuma, the Minister of Health. She has been referred to as the "nanny of the nation" by her critics but has provided leadership in health care that has previously been unknown in South Africa. She made primary health care free for

pregnant women and children under six and in 1996 she made
health care free for all South Africans, and she has been instru-
mental in the construction of hospitals. By the end of 1997 she had
directed the construction of 350 hospitals compared to 17 hospi-
tals that were constructed during the last year of apartheid. She
has been successful in leading the Parliament to pass one of the
toughest anti-smoking laws in the world. If President Mandella
signs the law, it will ban smoking in public places and ban all
tobacco advertising. Though not without her critics, she continues
digging her people out of the abyss. She is not only a role model
for black women but also a strong advocate for improved health
conditions in South Africa.

The Black Sash (Women's Defense of the Constitution
League) is an organization, in existence since the 1950s, which was
designed to protest the lack of human rights. Women chose to
wear black sashes as a silent demonstration. The government,
sensing this league as a rebellious female organization, demol-
ished the league and restricted women from assembling, even
silently. Today this group, with its new-found freedom, renders
valuable advice to black women.

Another organization that has contributed significantly to
black women is the Federation of South African Women, which
since 1954 has worked to improve housing, passes, and education
for black women. In more recent years other organizations that
contribute to the freedom of women are the United Woman's
Organization in the Western Cape and the Natal Organization of
Women. They seek to gain full democratic goals for women,
including the elimination of race and sex discrimination. The new
South African constitution grants more than 25 inalienable and
fundamental rights to all South Africans, including universal
suffrage, equal protection under the law, freedom of assembly,
movement, and religion. These rights are guaranteed to all
people, regardless of race, sex or color. It will, however, be
through networking that women can wage campaigns to see the
implementation of the new laws. There will also be a need for
women to bond in their efforts to see additional laws passed that
will further secure their freedom

Another optimistic aspect for the African woman is that the state is aiding in public welfare services. There is networking in community services and voluntary organizations that aid the black African woman. It is a beginning, but has the potential of enabling the African woman to be the beneficiary of social and health services. Living in a country which is the most industrialized country on the African continent, it is evident that resources are available for the black African, who composes 2/3 of the South African population. Previously the resources of the country have not been distributed equally to black Africans, especially to the women and children. The blacks have been "Africa's black gold," but now, hopefully, their labor and efforts will be rewarded through services and opportunities to become a meaningful part of South Africa.

Swaziland, a South African Neighbor, and Its Women

While in South Africa I traveled to Swaziland, a small country nestled between South Africa and Mozambique. This fascinating little country has a half million people (99% are black) who live principally in mud huts with roofs of straw and floors of either dirt or cow dung. They live very much like the tribes people of South Africa and their food consists principally of bread and porridge, which is prepared outside their hut over an open fire.

While in Swaziland we were to spend a week teaching at JOY, a Wesleyan Bible Seminary, which enrolls about 20 students a semester from South Africa, Swaziland and Mozambique. I was inspired to learn that women were in classes at the seminary. Some of the women sat in class and nursed their babies while others supervised small children playing on the floor of the classroom. Needless to say, classes were conducted in a relaxed atmosphere.

Before I arrived in Swaziland, I had prepared lectures for the seminary students consistent with the level of seminary classes in the United States. However, after my first lecture, I became aware that these students were more comparable to junior high level

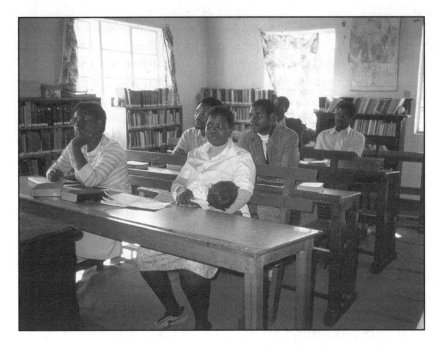

Students at Joy Seminary, Swaziland.

than graduate level. In spite of their lack of formal education, though, these dedicated people were committed to learning more about theology. Their zeal to become more effective in their ministry was evident.

During my stay in Swaziland, I lived with Lolita, a missionary to the Swaziland people who also was my interpreter with the Zulus. Lolita, about 35, was compassionate, gifted in using her hands, and committed to service. She had constructed the very small house, perhaps 400 square feet, where she lived. It was made of blocks and a tin roof, and contained a sitting room, a bath, a bedroom and a tiny kitchen where she cooked on a gas stove. Since there was no electricity and her lamp did not have a wick, I used candlelight at night to read and write letters. Most times, however, we went to bed about dark and got up at sunrise. The small bedroom was just large enough for Lolita's bed and a cot for me. In that it was winter and there was no heat, the nights were very cold. I had only one quilt, as Lolita had given her extra bed

covers to a family who was passing through from Mozambique. As the wind blew through the windows, the curtains fluttered and I shivered. Finally, I put on my robe and threw my coat and sweater over the bed for cover. It was a long cold night.

Taking a bath in this unique little house located on the seminary campus was a chilly experience. I heated water on the stove and then poured the water into a bathtub for my bath. I also used the bathtub to wash my clothes and then hung them on a clothesline behind the house to dry. In spite of the smallness and lack of amenities to this house, there was a maid, who came in daily to clean. She bent to her knees to brush the rug and the floor. I wanted to ask why she didn't have brooms or brushes with handles but since I could not speak Zulu, it was difficult to communicate with her

At daybreak Lolita and I helped prepare breakfast for the seminary students. We walked a few yards to a poorly-equipped kitchen to begin the breakfast that was usually mush (maize and brown sugar cooked together), jelly sandwiches, and fruit; and we drank *milo*, a milk-like substance. It was served in the dining room on handmade wooden tables covered with a checkered oilcloth. The first morning, on an empty stomach, I ate some of the maize

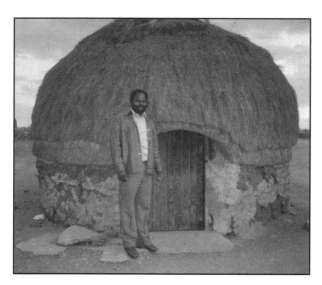

My Zulu interpreter in front of an African hut.

and felt sick. I learned quickly to avoid maize and eat the bread and jam, and bananas. A typical lunch would consist of hard porridge (mush), cabbage, ground beets, and chicken curry over rice with tea being served after the meal.

Even before we arrived at the seminary, we discovered that the living condition for Swaziland people are similar to those of the poor blacks in South African. This concept was confirmed as the missionaries took us to visit Zulu huts. The round huts, with cone- shaped roofs of straw and sides made of concrete and rock, had dirt floors. Inside, the huts were dark, but enough light penetrated through the door to see junk and trash all over the floor. The custom is that the man of the family sleeps on a cot to the right of the door and the woman sleeps on a straw mat to the left of the door.

Usually a family of six or seven lived in a hut. Sometimes large families had a hut for the children, one for the husband and wife, and one to cook in. The ones that we visited had a hut for cooking with a very small hole cut in the wall for a window (windows had to be small in order to keep the spirits out). At the bottom of the window was a board used for cooling food. One of the ladies who had a small naked child gave us bread to bake. I was overwhelmed with this act of kindness from a lady who had meager amounts of food for her family yet was willing to share with strangers from another land.

Swaziland, with its attractive terrain, does not have the re-sources or wealth that South Africa does, thus many Swaziland people travel to South Africa seeking work as do people from nearby Mozambique. As they travel through Swaziland, some have learned that the seminary is a refuge where they stop for food, housing, and a kind word before continuing their journey to South Africa.

Like in South Africa, Swaziland has its wild animals—zebras, monkeys, buffalo, wart hogs, kudu (deer-like animals) impala, wildebeest, nyala (tiny deer), hippopotamus, blue cranes, and guinea fowl. One time in order to see hippos coming to a watering hole, I climbed up a ten-foot lookout stand. Because of my fascina-tion with the hippos and lack of attention to my belongings, I lost

two precious rolls of film as a crane dipped down and consumed them. Next I encountered a wart hog head on, tusks and all, as he became annoyed with my close-up camera shots of him, and he made an attacking approach on me. Trembling with fear, I quickly took my distance from him.

While in Swaziland I participated late one afternoon in a funeral service for a black woman. It was a passionate and moving experience, even though I did not know the woman. Singing was a large portion of the service. When Swaziland people sing, there is a melodious harmony that seems natural and warm. Usually, someone begins singing and others join in with harmony. As they sang, each person took a turn of tossing a shovelful of dirt on the coffin until all the dirt dug from the grave was piled on top of the coffin. They sang as they shoveled, and the sun settled beneath the trees.

2

Peruvian Women
Overcoming Poverty
& Tradition

HE WAS A GRAVE ROBBER destroying Inca history. This small man, with his sooty black, rumpled hair falling randomly over his deep-set eyes, his shabby, dingy clothes, and reeking his musty odor, approached several of us at a hotel in Paracas. From a plastic bag that he carried over his shoulder, he produced several mummy skull caps that, according to tradition, were placed on women's heads at burial. He also showed vases, coca bags, and other artifacts that he had looted from Inca graves. His merchandise, verified by an archaeologist in our group, dated between 200 BC and 1500 AD, and he was selling the items for $5 to $10 each. Several of our group could not resist the opportunity to buy a piece of Inca history, even though we were all aware that it is illegal for artifacts to be taken out of Peru. This destitute man depended on grave robbery for his family's survival and in the process was destroying Inca history.

Since there is no recorded history of the Incas prior to colonization, the archaeological excavations of graves provide significant information regarding the lives of the Inca people. Among

the artifacts legally removed from Inca graves that we observed were five mummies from the 15th–16th centuries. Their bones were covered with their skin, their teeth intact, and their faces surrounded with black coarse hair, matted to their heads. This was Inca history, preserved and honored.

Peruvian People and Their Heritage

My purpose in Peru was to develop an appreciation of Peruvian society and culture through first-hand experiences. Along with eleven other university professors from the South, I had received a Fulbright Scholarship to visit Peru for six weeks. This study provided me with the opportunity to observe the culture of Peruvian women, as well as to explore the contemporary socio-economic changes occurring in Peru. In my six weeks in Peru I spent two weeks studying at a Catholic university, mostly receiving an orientation to the history of the country and the Inca Indians before we began our journey over Peru. While there I observed many female students at the University. I learned that there were 34 universities in Peru with enrollment of 250,000 students, and about half of the students were female.

Traveling on the western side of South America, one observes the fascinating and beautiful country of Peru, which stretches 1,400 miles along the Pacific Coast. As the third largest country in South America, Peru is earthquake prone, and half of its 23 million people live in the coastal areas. Lima, the capital of Peru, is a cosmopolitan city of skyscrapers, modern facilities, and unique culture. It is a diverse country, not only in its people, but also in its topography, with hot and dry deserts along the coastline and mountains extending down through the middle of the country. On the eastern side of Peru are hot and humid tropical forests fed by the mammoth Amazon River. Traveling 300 miles from the sandy and rocky West Coast eastward across the snow-capped mountains to the Amazon jungle, one travels across Peru at its narrowest point.

Traveling in the Andes, which is the highest range of mountains in the world except for the Himalayas, reveals a continuous

range of snow-capped glaciers surrounded by miles of lakes and lagoons and succulent green pastures. Along the winding roads are orange groves and fields of various grains that appear to be hanging from mountainsides. There are marshy basins filled with waving grains of rice, sugar cane fields as dense as jungles, and women herding goats, llama, or sheep on the mountainside, while men plow with oxen in the fields. Often the narrow bridges, consisting only of planks stretching across rivers, were a challenge to cross in the rather dilapidated bus that transported us most places. As we passed the adobe huts, some without roofs, we observed the impoverished people with children begging, some with outstretched hands. And then there were the poor donkeys that served as transportation for as many as four children at one time. These people struggle daily, yet the greatest discomfort I was experiencing was a temporary shortness of breath due to the high altitude.

The long history of Peru and the saga of the Inca Indians are tragic as well as intriguing. Prior to 1430 the Incas, numbering about six million people, ruled the valley of Cuzco, believing their

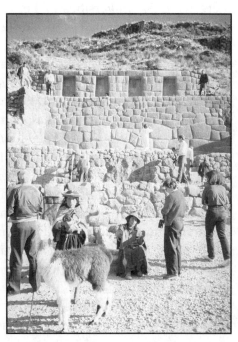

The architectural engineering feats of the Inca are phenomenal, such as this stone wall.

emperor was a descendant from the sun. When Pizarro, the Spanish conqueror, arrived to discover the richness of the Inca Empire, he returned to Spain, secured finances, and recruited men for the conquest of Peru in 1528. He captured the land, its people, and its treasures, which are reported to have been as much as twenty tons of silver and gold. By 1532, Pizarro had founded the first Spanish town, San Miguel, and had captured the Inca Emperor, Atahualpa. For the next three decades, conflict and fighting continued with the Spanish imposing their culture, religion, and traditions upon the Incas. With the conquest of the Inca Empire and the cruel oppression by the Spanish, the Inca people's culture was forever altered.

Because of the Spanish influences, many of the names of cities and other locations in Peru are Spanish. For example, the Andes, or the highlands, are referred to as La Sierra, while the coastlands are called La Costa and the woodlands, La Selva. Another significant influence of Spanish rule is the design of towns, which are built around town squares as they are in Spain. The Spanish also introduced Catholicism and located Catholic churches on the town squares.

Though the Spanish made a significant impact on Peru, less than half of the people today have Spanish blood. Indians compose 54% of the ethnic population with mestizos (mixed European and Indian heritage) composing 32% of the population. There are also Caucasians, Japanese and Chinese. Other descendants of the South American Indians are the Quechua and Aymara. Even though Spanish is spoken by the government, the media, and in schools, those living in the Andean highlands speak Quechua and Aymara. Other tribes living in the jungle and on the eastern side of the Andes speak a variety of languages.

An outstanding feature of Peru is the tumultuous waves on the Pacific Coast which are considered to be some of the best waves in the world for surfing. The waves are said to reach a height of ninety feet and thus are a surfer's paradise. I did not see waves that high, but I experienced waves higher than I wanted to see. I rode in a small boat to Ballesta, a desolate island of rocks, fifteen miles out in the Pacific Ocean, to view thousands of birds,

sea lions, and pelicans. The wind was fierce, and our small boat rocked and bounced in the water as we tried to capture the beauty of these creatures with our cameras. The pelicans were taking it easy on the rocky shores as the waves splashed near them, and the hundreds of slick black sea lions frolicked in the water near us, often emitting thunderous roars. On the return trip to shore, we viewed the elegant pink flamingos with their graceful long necks and pink feathers glistening in the morning sunlight as they fed in the marshy land, often standing on one foot.

Contributing to the culture of Peru are their expressive designs in ceramic and clay pottery, textile designs, and other artifacts of Inca and Spanish culture. These artifacts are not only in museums but are popular items in tourist shops. Much of their pottery displays an erotic theme; in fact, designs of sexual anatomy were intricately carved in pottery, and human figures positioned in sexual acts were also attached to the pottery. Most of the pottery in shops are replicas of relics excavated from Inca graves depicting early periods of the Inca's life.

The Role of Women in Peru

According to the dictates of Peruvian culture, the primary role of a woman in Peru is that of motherhood. Even though a woman is honored in her role as a homemaker, when she moves into the workplace, or seeks parity in other areas of her life, this hard and fast rule creates hardships for women. Though a few women are skeptical about pursuing human rights as job parity and find it is easier to succumb to the traditional system rather than jeopardize their livelihood, others are adamant about seeking a change to receive equality in their human rights. For those women who have been indoctrinated regarding their unworthiness and appear content with the status quo, an intensive educational program will be necessary to alleviate their misconceptions. Most women, however, desire that the Peruvian laws treat men and women equally.

While attending a lecture at a Peruvian university, questions arose regarding the status of women in Peru. The male professor

responded, "The situation is difficult, but we hope it won't last forever; if it does, who cares?" It seems, according to this professor, that the general philosophy of Peru is that men feel equality is "somebody else's problem, not mine." Though women become emotionally exhausted as men show apathy regarding the status of women, women must persevere in seeking justice. They need hope, support, and options in order to view life beyond their "duty" as submissive wives and mothers.

Though a small percentage of elite Peruvian women live in the urban areas and enjoy a rather lavish lifestyle, they too are plagued with the submissive roles assigned to women. They live in homes constructed of stucco or masonry with red, tiled roofs, surrounded by manicured yards. Their lives are filled with a number of amenities such as servants, beautiful homes, and quality food. A few women who live in haciendas in the rural areas also enjoy this lavish lifestyle. I recall having dinner at an enchanting hacienda surrounded by ornamental trees, blossoming flowers with soft fragrances, and special South American music provided by a band of four young men. But this is not the typical

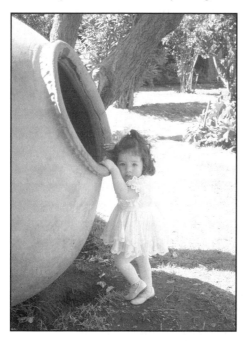

The children of the elite are easily recognizable.

lifestyle for most Peruvians. There is a small middle class that enjoys a less lavish style of life, but there are masses of indigent people who lack basic essentials for an adequate life.

Throughout Peru one encounters the poor. They live in block-houses, shacks, lean-tos or sometimes houses without roofs. In the Amazon, houses are often built of bamboo poles tied together with thatched roofs made of leaves and grass. The river houses are often built high on stilts to prevent the annual floodwaters from invading their premises. The slums of Lima, known as the barriadas, are living quarters for masses of people who left their rural home for employment in the city and a better way of life. The barriadas covers miles of shacks of destitute people who are living in deplorable, unsanitary conditions. Many, or perhaps most, of these people were in better living conditions in their mud huts in the Highlands and Amazon areas than in the congested, polluted, environment of the barriadas.

In whatever type of house a woman lives, she is responsible for preparing food for her family. The type of food she prepares depends largely on what is available in her area and her resources for securing it. In an urban home I ate a dinner which consisted of wheat soup, spaghetti, green salad, bananas with sugar and

The poor struggle, as this little girl's surroundings indicate.

canned milk, and a dessert made from potatoes. For a beverage I was served homemade apple juice. Papaya juice, or tea matide coca, a beverage made from the coca leaf, are also popular drinks. The diet of a very poor Indian family would probably consist of soup made from fish skins, fishmeal and rice. It was not surprising to see children begging for food when the diet of those in the highland is considered to be 40% below minimum level for good health.

Though there is a shortage of food for many, there seems to be an abundance of alcoholic drinks. Chicha, one of their popular alcoholic drinks, is made by a person chewing corn and spitting the juice into a container. The juice is then allowed to ferment before consumption. Some houses near Cuzco had long sticks protruding from the front door, which indicates that chicha can be purchased at the house. Another popular beverage, often referred to as the national drink, is Pisco, a brandy that is also used worldwide to make drinks called Pisco Sour.

One means of survival for the Indian woman is to sell her produce at the Sunday open market, a primary means of securing income for her family. The open market is not only a place for vendors, but it is also a social gathering where women fellowship and enjoy food with their friends. Wrapped in shawls, sometimes with babies strapped to their backs, the women display their merchandise on the tables or more often on the ground, while hundreds of people mill around the market, selling and buying. The specialty items that the women sell consist of foods, blankets, scarves, ponchos, *trilbies* (hats), *maté* (painted gourds), and stone carvings. The women's popular felt and straw *trilbies* resemble men's hats, and women say they prefer this style of hat because it protects their heads from the cold and windy climate. They also think the hats look attractive on them, which they do.

Though a few Peruvian women live in moderate comfort, there are many tribal Indian women in Peru who are living as their ancestors did centuries ago. They make their pottery, grow their food, hunt and fish, weave their cloth, and live in primitive huts. I became aware of this primitive lifestyle as we took a three-and-a-half hour ride in a small boat across Lake Titicaca, the

highest lake in the world with an altitude of 12,506 feet. Our guide
informed us of the folklore regarding the lake, indicating that the
very first Inca rose from this lake. We were in a small boat with two
Indian guides who wore their coca bags around their necks and
chewed their coca leaves as they guided our boat. It was just past
dawn, and I shivered uncontrollably as the early morning wind
penetrated the blanket that I used to keep warm.

After we made it through the rough waters that morning, we
arrived at Taquile Island where the Aymara Indians reside. In-
stead of the flat island that I anticipated, we docked at the base of
a mountain that was jutting right out of the lake, reaching a height
of 13,500 feet. Our guide, with an oxygen tank strapped to his
back, led us up the mountain to the village. I stayed pretty close to
the guide because I didn't want to be too far from the oxygen in
case I had a need for it.

Prior to beginning our hike up the mountain, we ate our bag
lunches, knowing this was all the food that would be available to
us until our return trip later that day to Puno. There was a bar of
candy in my lunch that I stuck in my pocket to save for that spurt
of energy I thought I might need before the day was over. As we
climbed the rocky path up the mountain, a small Indian boy
darted from the bushes in front of me. He placed his open hands
together, lifted them up to me, indicating that he was hungry. I
thought, "I cannot give him my candy bar. It is my only source of
food for the rest of the day," but I did. Without a word or even a
smile, he took the candy bar and darted quickly into the bushes.

Discovering the village of Aymora Indians justified our
breathless climb up the mountain. We marveled at women in their
trilbies and their colorful ankle-length dresses as they walked
barefoot on the cold ground. Their dark brown faces radiated a
curious smile as they rather skeptically observed us. They were
clearly as curious about us as we were about them. We were
fascinated with the primitive yet intricate weaving of cloth made
from llama and sheep's wool. Their textile designs were impres-
sive and skillfully woven into blankets, coca bags, and clothes.

As we visited their huts, we observed their outdoor cooking
areas where they cooked potatoes and grains, which they raise on

their farms. In some of the highland areas the temperature averages about forty degrees, so it is difficult to cultivate crops, but here, because the lake is very deep, the waters are warmer, thus warming the land near the lake. Farmers are thus able to grow pasture grasses for their sheep, llamas and alpacas (a type of llama with long, matted hair). These animals produce not only wool for the women to sew but food as well. Though we could only communicate with these women through our interpreter, after a time, they became more talkative and more cordial. These Indian women, living and working at this high elevation, appeared healthy, but poverty was evident at every turn.

In addition to poverty, many women are confronted with emotional and physical abuse from the significant males in their lives. The *machista* attitude of males toward women in Latin American countries was inherited from the Spanish conquistadors who took Indian women as sex objects. The culture allows men to express their macho, double standard of sex life, without consideration for the human rights of females. Male vanity is staid in his virility and his ability to procreate, often without assuming the responsibilities of fatherhood. As a result of this *machista* attitude, as well as women being abandoned by husbands, more women are thrust into the role of becoming the head of households, and, therefore, women are becoming less dependent on the male for income and survival.

To give an indication of the deferential role of women in elite circles of Peru, I share my visit to a Rotary Club in Lima. It was at this meeting that I learned of the macho role of men as they designated the tedious work of their Rotary Club to women. I arrived at an old but splendid hotel that was embellished with lavish designs and elaborate furnishings to attend a Rotary Club meeting. Immediately upon entering and identifying myself, I was introduced to the Rotary Club president, who to my surprise introduced me as the first woman Rotarian to visit a Rotary Club in Peru. The evening had been designated as ladies' night (women were not members but guests), and the Rotarians' wives were adorned with knee-length fur coats, elegant dresses, and jewels. My simple white blouse and black skirt with no jewelry

seemed inappropriate. However, even though I did not look the part of an "elegant lady," I was graciously accepted during the cocktail hour, dinner, and speeches that lasted three and one-half hours. Their hospitality was gracious, but then I was not asking to join their club, only to visit. Representatives from other Lima Rotary Clubs were present and invited me to attend their club meetings later in the week, which I did.

Without conversations with some of the Rotarians' wives, I would have been unaware that women were responsible for doing the charitable work of the Club for their husbands. The wives said they were designated to raise funds for service projects and then to see that the service projects were completed. Men spent their time socializing, determining the nature of service projects, and determining how the money the wives raised would be utilized. Men received the recognition for the service projects that were performed by the women. I asked a woman attorney, who was a Rotarian's wife, about her reaction to being the actual worker for her husband in his Rotary Club. Her response was, "It is understood that when a man becomes a member of a Rotary Club in Peru, his wife has a commitment to be his helper. That is just the way things are here."

Women are concerned with the lack of protection under Peruvian law. For example, a rape law was passed in 1924 by the Peruvian Congress that exempted a rapist from prosecution if he subsequently married his victim with her consent. In 1991, the law was extended to protect other men who may have been involved in the rape provided any one of the rapists consented to marry the rape victim. Many of these women were pressured into marrying their attacker because women's families felt shame and feared their daughter might be rejected as a wife as a result of her having been raped.

The *New York Times* (3-16-97) reported the following incident: "In Lima, a 17-year-old girl on her way home from work was raped by a group of drunken men. Her family tracked them down, vowing vengeance, and she was set to press charges. Then one of the men proposed and two others vowed to slash her face if she refused. Her relatives, with the family honor at stake,

pressured her to accept. She did. Her husband abandoned her a few months later."

Because of the unfairness of the rape law, the Peruvian Congress voted 86 to 1 for its repeal in 1997. Though the government no longer endorses women marrying her rapist, the rapist and/or her family often encourages the victim to refrain from pressing charges. A change of attitude plus enforcement of the new law will be necessary to alleviate the previous unfair rape custom.

Though women have been relegated to the traditional roles of childbearing and infant care, this has not protected women from spousal abuse. It has been estimated that 80% of the crimes reported yearly to police are those related to spousal abuse. Though spousal abuse is a violation of human rights, it is a culturally accepted practice that is controlled by the macho man. As a result of abuses, neglect, and inappropriate treatment, more women are now seeking divorce and separation to escape the constant abuse.

However, as women enter the workplace, their problems continue as they encounter discrimination, low wages, and little opportunity for advancement. Though some women have acquired broader responsibilities and power, there continues to be the cultural hostility toward them as men continue to dominate in the business and political arenas.

Women, as well as men, also face daily crimes in the streets. Upon our arrival in Peru we visited the American Embassy for an orientation regarding our safety in Peru. We were informed that on the average eight people were killed daily and often as many as twenty were killed at one time by the Sendero Luminoso terrorists. We were informed that the terrorists were dangerous and that we must move with caution as we toured the country. This political party, also known as the Shining Path, had penetrated about a third of Peru and would often kill without provocation if one trespassed into their territory. This group is reported to have captured, raped, tortured, and killed many women who have been outspoken leaders for the rights of women in Peru.

One such woman was Maria Moyana, who was a leader in the woman's movement, campaigning not only for women's rights

but also for the rights of poor people. She pleaded for the government to protect human rights and thus became a target of the Sendero Luminoso. She was killed and died in front of her two sons. Other women who have fought for human rights have also perished at the hands of the terrorists.

If a person refused to join the terrorist activities, they were often given a mock trial in their own village and shot immediately. Not only were many killed, but also scores of people were tortured and their businesses, homes, and villages destroyed. To further terrorize the people, the Sendero Luminoso would announce when they would be arriving at a village. As I visited with Baptist missionaries, I learned of pastors who refused to join the political terrorists and thus not only had to leave their churches but leave the areas as well.

There were two experiences that related to the terrorists that caused us anxiety. One was in the city of Puno. Since there were no telephones in our hotel, two of the men from our group walked several blocks to an exchange telephone station to call home. As they returned to the hotel, they were arrested by the city police who assumed they were associated with the Sendero Luminoso terrorists. They were escorted to police headquarters with thirteen policemen holding guns on the two men. After hours of trying to persuade the police of their role in Puno, the police came to the hotel where we were staying and searched all of our rooms. After finding nothing in our rooms to tie us to terrorists, the police released our colleagues. However, the police informed us that we were not welcome in their city and to get out of town. They said it was dangerous for us to be in Puno because the Sendero Luminoso was trying to move in and they, the police, had thought we were part of that group. This event occurred late one evening and by five o'clock the next morning we were on a train with our belongings heading for Cuzco. This experience gave most of us a headache, but we didn't know what a really bad headache was until we reached an altitude of 14,000 feet while traveling on the train in the Highlands (at 15,000 feet one needs oxygen to survive).

The second experience of near contact with the Sendero Luminoso was during our visit to Cajamarka. After a delightful two-day visit to the city, we were told that the terrorists were to strike Cajamarka the next day and that all roads out of the city would be manned by terrorists. Our guide told us to prepare to leave town as we were in danger. After eating a quick meal, we boarded our bus and headed out of the city. I wanted to be able to see any action that might occur in case we were hijacked, so I asked to sit "shotgun." The front seat also gave me a fantastic view of the mountainous scenery. As we put distance between the terrorists and us, I decided that we were in greater danger of dropping off the narrow roads into the deep ravine than we were of being hijacked by the terrorists. This is the type of climate that Peruvian women face daily.

Even being on the streets in Peru was often dangerous for women. The beach, which was only three blocks from our hotel in Lima, was the perfect place to jog, so we thought. My roommate, who ran faster than I, often ran far ahead of me as we jogged. As she was running one morning, a man approached her, pulled a broken piece of glass from a book, thrust the broken glass between her legs and began molesting her. She screamed for help and the man ran. Though she was unharmed, we realized that danger was constantly lurking and that we should run in pairs thereafter.

Another example of violence was that of stealing which we were cautioned about by the American Embassy. Because so many Peruvians are hungry and unemployed, stealing becomes a way of life. Travelers are placed in separate train coaches from Peruvians to curb stealing. However, while we were at a train stop at a village, one in our group stepped off the train for a stretch and his wallet was stolen out of his pocket. Even while one is walking on the streets, his or her pockets can be picked in a rather skillful manner. On one occasion a colleague of mine and I were returning to the hotel after having eaten mango ice cream at a little shop. Very quickly and professionally a man slipped his hand into my friend's pocket, took his money and darted into a crowd. I learned to clutch my purse in front of me as I walked; I was not as

concerned about my money as I was about my passport and
return plane ticket. These were two items that I would have
almost given my life to keep.

In my contact with Baptist missionaries, I learned of the
kidnapping of two women missionaries just prior to my visit.
They told how robbers entered the women's home, took many of
their possessions, and then took the female missionary and her
teenage daughter as hostages in the family automobile. The mis-
sionary described the ordeal, telling how certain they were that
they would be killed. Fortunately, though, the robbers drove then
into the hill country and released them. The local police said they
did not understand why the robbers had not killed the women, as
they would be able to identify the robbers. The missionaries felt,
however, that they had not finished God's work and so He
allowed them to live. Another missionary related his experience
with violence in Peru as he stopped his car in a street to allow a
crowd of people to pass in front of his car. While he was stopped,
four robbers came out to his car, jacked it up, and removed all four
of his car tires—all within just seconds. He said he was not even
aware that the tires were being removed until he tried to drive
away.

I became a friend with a Peruvian teacher who spoke English
fluently. She was a single mother and expressed fear for the safety
of her children and herself because of the political climate in Peru.
She feared that she and her children would be killed or injured
during the constant terrorist attacks and requested that we help
her immigrate to the United States. I understood her predicament
and that of thousands of others like her. Though I made an effort
to find her employment in the United States after I returned
home, I discovered it is a complicated process to bring a person
from a country like Peru to the United States. I regretted that I
could not help her or others who would like to find a new way of
life in another country.

Women Along the Amazon

Perhaps there is no woman in the world whose life can
compare with the life of the Amazon woman; she is a woman of

strength whose life evolves around the Amazon River. Her food is caught in or near the river; her water source and her transportation is provided by the Amazon River; and it is here that she washes her body, her clothes, her pots, and watches as her children play. She cuts weeds from the river for food and uses the river for disposing of her refuse. It is the Amazon, its tributaries, and the surrounding land that provides livelihood for her family. Hers is a rugged, hard life, with no frills, but there are smiling faces on many of the half million people who thrive on the mystique of the Amazon.

The Amazon River, the mightiest and widest of all rivers, flows more than 2,300 miles from the city of Iquitoes south to the Atlantic. The flow of water is so great that the river often rises 30 to 60 feet during flood times. As a result of floods, roads are useless, so it becomes necessary to travel by air or boat. After flying into the city of Iquitoes, we began our journey down the Amazon to visit some of the primitive tribes who live on or near this mighty river.

To visit with Amazon women, we boarded a thatched-roof small boat, powered by an outboard motor, and our Indian guide maneuvered us through the swift waters of the Amazon. We traveled about 25 miles down the river to the Explorama Inn, a camp in the jungle. As we arrived, we were almost overcome with swarms of mosquitoes that resemble a small black cloud. I soon discovered that I would be living in a quaint little hut with a homemade bed and a cotton mattress; it would be lacking hot water, but we would enjoy the invigorating cold water that flowed directly from the Amazon. My excitement was enhanced as I chased an alligator from the doorsteps and was told to scan under the bed, prior to retiring, for poisonous frogs. When I observed a snake dangling over the table in the dining area, I knew we were going to have an exhilarating few days on the Amazon River.

Even though I felt danger lurking constantly, I appreciated the splendor of nature, the lush flora of the jungle where man's hands had not marred God's beautiful creation. The jungle was a naturalist's paradise. There were orchids and masses of wild flowers amidst vegetation that provided habitats for the greatest variety of birds in the world. There were rare species of birds,

including brilliant colored parrots perched in rubber trees and giant hummingbirds that are found only in the headwaters of the Amazon. It is in this jungle that butterfly enthusiasts travel from all over the world to view the elegant iridescent butterflies, some with wing spans of eight inches. Small insects nibbled at the mammoth ferns with fronds taller than six feet. The ferns, along with other plants flourish in the high humidity. We hiked on a path into the jungle, crossing streams on logs, scanning the path for unique plants as well as for snakes, and with an eye-ever-open for jaguars.

In order to see some of the tribe's people we took a small hand-made boat and headed up the swift Amazon, dodging floating logs, grasses, and plants along its edges. After about an hour's ride we ventured off the main river to tributaries where we saw houses that were constructed of bamboo and elevated six or eight feet high on poles to avoid the floodwaters. When we stopped near one of the houses, several raggedly-dressed children ran out to observe us and eventually led us up a path to their house. The children climbed a ladder that was leaning against the porch to enter the house and let their mother know strangers were here. I will never forget the expression of the mother's face as she came out of her house to see these uninvited white guests. She stood on the porch of their thatched-roofed, one-room house, quite startled. A small child hung to her skirt while other small children

A husband displays the catfish he caught in the Amazon River.

leaned over the stick railing around the porch that provided them some protection from falling. Through our interpreter we asked about her family and also about their pet, a three-toed sloth that one of the children held. The father appeared from out of the woods with a three-foot-long catfish that he had just caught in the river. The woman was pleased with the catch for now there would be food for the family. It would be a good day.

On another day we ventured further down the river into the jungle to visit another Amazon tribe who wore almost no clothes. Some of the women wore pieces of cloth tied around their waists like a skirt, while others had grass skirts. Their brown, exposed breasts sagged from many years of nursing children. One woman had curly hair, but most of the other women had straight black, stringy hair hanging to their shoulders. Around their necks were beads made from wild berries and vines and even necklaces that held the skulls of small alligators. We were greeted by the tribal medicine man who had a painted face and wore a grass skirt, as well as beads and other decorations. We were fascinated with the

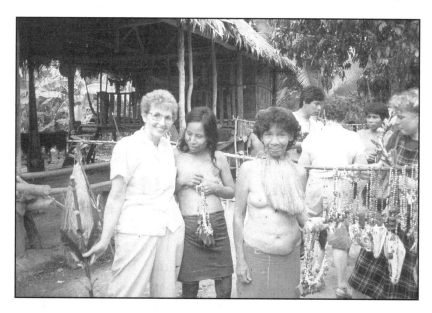

A Peruvian tribal woman sells the author a blowgun and necklace made from the head of a baby alligator and wild berries.

tribe's necklaces, snake skins, and poison blow guns whose arrows tips were piranha teeth that were used to pierce their prey. The arrow tips were dipped in a mixture of snake, frog, and leaf poison and were then blown through a reed cane to strike wildlife and fish.

We left these tribal people loaded with items that we had purchased to validate our experience. Many questions remained unanswered regarding their primitive lifestyles, but one concept was clear to me. These women were so involved in the struggles to survive that I doubt they gave much credence to abuse, discrimination, or a value system. It is difficult for me, even yet, to perceive that women today exist under the primitive conditions that I observed regarding some of the Amazon women.

Leaving this family, we rode further up the river to find other families, to fish and swim in a river filled with piranhas. Using a seine the guide pulled in as many as a dozen piranha at one time for us to see. He said we could swim in the water with the piranha unless we had fresh blood on our body. However, if we did, the piranhas would attack us, eating flesh from our bodies. I felt sure that I had a prick on my body somewhere, so I chose to remain in the boat and watch the more adventurous ones swim in the tributaries with the piranhas. As we left, a 6-inch piranha flipped into the boat at my feet. With teeth as sharp as needles and its silver body floundering, I placed my foot on its head, restraining the piranha, and then picked it up, grasping it behind its head. It was another photo moment.

On the return trip to camp, we were caught in a rainstorm on the river. With the Amazon being nearly a mile wide in places, the waves became high like waves on an ocean. As the wind and waves rocked our boat, we tightened the belts of our life jackets and pulled off our shoes, in case we had to swim. This little boat did not have a thatched-roof so we experienced the downpour of the rain and became drenched in minutes. The sky was dusty-dark, the wind slapped us in the face, and we shivered not only of the cold but also out of fear. Though we were not in great danger, we were mostly just inconvenienced, as we returned safely to our camp.

The Impact of Family Planning on Peruvian Women

Over population and family planning have been major concerns for the Peruvian Government who initiated a sterilization program for the Peruvian women. At issue was the fact that many women did not wish to participate in the sterilization effort. Prior to 1995, sterilization was illegal, but that year the Ministry of Health decided to make sterilization a major approach to family planning. The Peruvian government, under the leadership of President Alberto Fujimori, initiated a mass sterilization program called Reproduction and Family Planning. This program gave the appearance of assisting poor Peruvian women, but its primary thrust was for controlling population growth. Those targeted for sterilization appeared to be mostly poor women in the rural areas who were of Indian or mixed descent. Each month health workers were given a quota for voluntary surgical sterilization and were rewarded according to the number of sterilizations they performed.

A Peruvian family who survives because of the Amazon River.

It was reported that women were not only bribed to have sterilizations, but also threats were used. For example, women in need of food were promised supplementary food, while those already participating in food programs were threatened with the removal from these programs if they did not "voluntarily" submit to sterilization. Some women said they were told that legal action would be taken if they refused sterilization, while others told of being sterilized during caesarean childbirth without giving permission to the medical personnel to do so. Others said they were forcibly restrained in order to be sterilized. Women felt the sterilization process was intrusive and that it should be a matter of choice since it eliminates a woman's rights to future childbirth.

It was Peru's Comprehensive Women's Movement that called for a cessation of the quota system in the Reproductive and Family Planning Program. Two of the major concerns for women were that the government failed to inform clients of health risks related to sterilization and the failure of health workers to suggest alternative means of birth control. Also, the conditions under which the sterilization process was performed were inadequate, including poor sanitary conditions. Reports indicate that at least 15 women died from complications as a consequence of the sterilization procedure. People were startled at the brutality of the program.

When the Peruvian television networks and newspapers revealed the forced sterilization program, the government abandoned the sterilization practice and required a 72-hour waiting period before sterilization. It is reported that more than 100,000 Peruvian women have been sterilized since 1995, many under duress. In 1998, in the wake of scandal, the government ended their quota system and now involves women in sterilization only at a woman's request.

Controlling unwanted pregnancies is still a major concern for Peruvians. Though abortion is illegal, it is used as a method of birth control with estimates of 270,000 unsafe abortions each year. Abortions are the second leading cause of female deaths in Peru. Sterilization has dropped nearly 70 percent since 1998, and the request for information about birth control methods has dropped 30 percent, which is of concern to women's groups as well as the

government. Along with the high rate of birth-related deaths for women is the high infant morality rate, 265 deaths per 100, 000—one of the highest rates in the Andean region.

Women in the Workplace

The Peruvian's work ethic is somewhat relaxed. The work day is shorter, about 5 hours a day, and they enjoy a long lunch break, from one until four o'clock. Then there is the philosophy of "mañana"—do it tomorrow. It is difficult to accomplish an abundance of work with this schedule and relaxed attitude, but Peruvians do appear to lead a less stressful lifestyle than workers in the United States. There is, however, immeasurable hardship for many working people in Peru, especially women. I saw women working laboriously on the streets, digging the hard soil for the placement of a monument, selling their wares, farming, and doing whatever was necessary to provide for their families.

Women are plagued with discrimination in the types of jobs available to them as well as in the wages they are paid. Women occupy positions with low pay, receive minimum recognition for their performances, and seldom rise to positions of authority. In addition, unem-

A woman sells her handmade sweaters, scarves, and other items made from alpaca wool.

ployment is much higher for women than for men. It is said that it is the women of Peru who keep the economy afloat with their low incomes and long working hours.

A major area of employment, especially for poor women, is the selling of crafts to tourists. During pre-Colombian times, Peru was a center of artistic expression and today Peruvians continue to produce high-quality pottery, textile, artwork, sculpture, and other crafts. In this way employment is generated, not only in the production but also in the selling of crafts. Selling is very competitive among the vendors on the streets, in shops, in open-air markets, at train stops and especially in the vicinity of hotels. When we traveled by train, we stopped at most crossroads where Indian women always were present to sell their wares. They would beat on the sides of the train with their hands, requesting passengers to open the train windows to see their items, such as food, alpaca sweaters, and rugs. Once when we had stopped, a woman begged desperately for me to buy something from her. I cannot forget her pleading for me to purchase an alpaca rug, which I did. As she passed the round six-foot wide rug to me through the already-moving train window, her face filled with delight as I threw her a $20 bill.

Women are usually discouraged from entering political and highly technological professions. They are encouraged to maintain their private roles as mother and family person and leave the professional jobs to men. An area, however, where women have received success is in the field of education, even though salaries and benefits are low. Also, women are employed in occupations pertaining to social services and health careers where remuneration and benefits are also limited. Though women are accepted at universities in areas of science and technology, upon graduation they enter these professions at a low level, if they are able to secure employment at all.

Thirty-five percent of all employment in Peru is in the agriculture industry, thus making it a major area of employment for women. One of the major crops is the growing of the coca plant, which have been consumed by the Peruvian people for many years. The growing of this plant is a major source of income for many farm families, since this is the only plant that seems to thrive

in certain areas of the jungle. The coca leaf is used in making coca tea, which is a common drink served in most restaurants. It is also used as a medicine for minimizing hunger pains, for treatment of altitude sickness, and is chewed as one would chew tobacco for recreational use. I observed many Indian men who kept their coca leaves in small cloth bags hung around their necks.

However, the greatest profit derived from the coca leaf is its use in making cocaine. Once the coca leaf is harvested, most of it is sold to people in Colombia, South America, who process it into cocaine. Two-thirds of the world's cocaine supply originates in Peru, and the same percentage eventually ends up in the United States via Colombia. As many as 100,000 farmers and their families in Peru are involved in the production of the coca plant. Efforts have been made to eliminate the process of using chemicals to transform the coca leaf into cocaine through destroying the coca labs and punishing drug traffickers. However, these actions have not eliminated the growing of the coca plant. It is difficult to imagine how the many women involved in the growing of the coca plant could be oblivious to the destruction caused by cocaine, but to most of them it is simply another crop that provides income for their families.

Redefining the Attitude Toward Women in Education

Though there does not appear to be opposition to females attending public schools as provided by the Constitution of Peru, several factors affect the quality of education girls receive. Most of the families in the upper classes and the small middle class send their children to some private schools, but poor children attend crowded and poorly equipped public schools. There is no consistent support for public schools in Peru.

Many women are functionally illiterate, due to the poor quality of teaching. This is compounded by the effect of gender, ethnic minority, and social class discrimination, which causes some women of Peru to have the highest illiteracy rate of any group in the country. Though there appears to be a slightly greater enroll-

ment of girls in high school than boys, it has been suggested that girls need a high school education more than boys do—because for a woman to be a serious contender for a job she needs more training, at least four more years of school than does the male.

Though females attend some levels of school more than boys, the education for females differs from the male in some critical ways. Gender difference is noted in the curriculum. In textbooks, for example, women are presented as mothers caring for their families, not as professional women. Women are depicted as subordinate, caring, and limited in their creative ability and initiatives. References to women decrease in textbooks as the students move to higher levels in school. When girls are taught that they are subordinate to men and that they should be passive in their roles, they come to believe that this is the proper role for women. Boys are accepted as being aggressive, but if a girl is aggressive, she is considered to have unacceptable behavior.

Illiteracy for women in the urban areas is 27%, while in the isolated areas it is above 70%. It does appear that the literacy rate is improving with as many as 84% of all children in Peru now attending school, with the number rising each year. However, as we traveled down the Amazon, I discovered that many of the women and children we encountered had never been to school. If the children went to school, they traveled by boatbus to schools built out of bamboo, high on stilts. The limitation of adequately trained teachers, lack of sufficient materials, and the lack of opportunity to attend school, results in high female illiteracy in rural areas.

A school principal of a private urban school.

In the urban areas, however, I visited six public and private schools and was impressed with much of what I observed. Many schools are so overcrowded that most operate in half-day shifts. I met one teacher who teaches in a public school half the day and in a private school the other half. With salaries in public school about $100/month and in private $150/month, one can readily see the competition for jobs in private schools.

One of the positive aspects of their educational system is that the female teachers are perceived as mothers first and teachers second. With 60% of teachers being female, teaching is a strongly female orientated occupation. With this philosophy teachers are granted generous maternity leaves with pay up to thirteen weeks. Women teachers are making a tremendous impact on the children.

Inca Religion and Catholicism and Their Impact on Women

When the Spanish conquistadors arrived in Peru, they were accompanied by Catholic priests whose task was to convert the pagan Indians to Christianity. They were successful, with 90% of the people today claiming allegiance to the Catholic Church. I was told, however, that only 10% of the people are actively involved in the Catholic Church. Through my visits to Catholic churches, I observed that most of these participants are women, and most of these are old women. Because the Catholic Church allowed the Indians to incorporate many of their pagan customs and stories into Christianity, it is not unusual to see processions where a statue of a Christian saint is accompanied by Indian dancing with loud drums and instruments. Also, one can observe the statues of saints in the church with painted Indian faces and Indian clothes, or a statue of baby Jesus wearing a woolen cap similar to those worn by the highlanders.

The role of women in religious history of Peru reveals a unique place in the Catholic Church for some women. For example, the Twin Towers Church called Santo Domingo, in Lima, is often visited by pilgrims who go there to honor the burial place of

Christian religion's first American patron saint, Saint Rose of Lima, a Spanish woman born in Peru.

Even the mystery of Machu Picchu, considered the most spectacular archeological site and greatest tourist attraction in South America, may have actually been a site for sacrificial offerings of women. This Inca city of prehistoric relics, built circa the 12th or 13th century, was discovered in 1911 and sits high in the almost-impenetrable mountains near Cuszo. Though little is known about the city, it is believed that the Inca Virgins of the Sun occupied the city eighty or more years before the Spanish and that they, the Spanish, never discovered the city. In the city was a torture chamber where hundreds of female skeletons have been found, but only a few male skeletons. People can only speculate what happened there and why there is such an imbalance about this city, and its occupants. As the people of Machu Picchu died, the city was lost to the world, covered with vines and other vegetation.

To arrive at Machu Picchu we rode a train from the valley of Oyantautambo, following closely the Urubamba River, which flows between steep cliffs as it drops more than 8,000 feet over rocks, foaming and bubbling. We passed through thick vegetation and continuous milky fog and climbed steep mountains to arrive at the ruins of the Inca Indians' city, Machu Picchu. Since there are no roads, it is necessary to ride the train or follow a walking path, which is called the "Inca Path." This path, which follows the top of a mountain range, is certainly for the strong and hardy.

Upon arriving at this Inca city of approximately three square miles, we discovered that it is divided into three areas: the Royal Group where the Incas lived in the 216 rooms, probably with thatched roofs and white granite walls built out of millions of stones carefully cut and notched. There were even aqueducts to provide water for at least sixteen rooms. The second area of the city was the religious area, which was the highest point of the mountain, and where the Incas came to worship the sun. The third area was the industrial area, which had designated rooms for weaving and making pottery and dyes.

(Before I could visit the entire city, I experienced a terrific headache from the altitude and found it necessary to return to my

room at a small hotel located at the edge of the city. A nurse diagnosed my problem as altitude sickness. She prescribed coca tea, which helped, and within several hours I rather sluggishly returned to our tour.)

Typical of the ornate Catholic churches attended by many poor people.

In almost every city we entered, we were shown a cathedral or areas of religious significance. For instance, we were taken to see the neoclassic Catholic Church in Cajamaraca, built in 1700 of volcanic stone, and to the Portrait of the Sexual Woman built atop the city of Cuzco, and to Tambro Machay, where a spring flows from the side of a mountain providing a site for the Inca to come for spiritual baths. Here we drank the cool pure water, which we had not been able to do prior to this time. Since Tambro Machay is a tourist attraction, a Peruvian mother had positioned her 2-year-old daughter, dressed in colorful native attire, nearby to entice us to take the child's photo. After taking her picture, she extended her hand for money.

Efforts to Move Forward on Women's Issues

Women are mobilizing in Peru to help alleviate the plight of Peruvian women as they unite to secure better salaries and working conditions, become more involved in the labor force, and seek legislative safeguards against job discrimination. They are also mobilizing to erase the double standard that exists in many facets

of Peruvian life, to improve women's reproductive and health rights, and to eliminate abuse and violence.

Though most women recognize the significant roles of motherhood, many desire to redefine their role and encompass careers along with nurturing a family. With many women being forced into the role of single parenthood, they need education, training and jobs in order to provide sufficiently for their children.

More teachers will need to become cognizant of their social and gender identities to make changes in the field of education. Since teaching is the primary occupation for most women in the cities, an increase in salaries and benefits would significantly enhance the standard of living for women. Because of the significant difference in public and private schools, women need to address the quality of education in the public schools. Also, the gender discrimination in textbooks and unequal disciplinary measures toward male and female students needs addressing. A significant improvement has been made, and now there are gender studies at universities in Peru, which are engaged in research, presenting conference seminars, and offering degrees in gender studies.

The Peruvian legislature has taken some initiative in addressing women's issues. In 1982 they ratified the Convention on the Elimination of All Forms of Discrimination against Women and in 1993 the President introduced legislation to help eliminate domestic violence. This legislation resulted in the opening of police stations staffed by women and setting up of women's refuge stations for victims. In 1996, the legislature ratified the Inter-American Convention to Prevent, Punish and Eradicate Violence against Women. Amnesty International has been an advocate for human rights in Peru and in the process has revealed many of the injustices against women, particularly the abuse of women in prisons.

A note of encouragement was offered to Peruvian women in 1996 when President Alberto Fujimori announced to the nation that "we have not forgotten that Peruvian women must be in control of their own destiny. For this reason we will stand firm in our support for rural and urban community women's organiza-

tions." Also in recent years the Ministry for the Promotion of Women and Human Development has been created. These efforts are worthy attempts on the national front, but the significant changes must be made at the grassroots level.

Amnesty International has urged the Peruvian government to end human rights violations against women and to guarantee human rights, both for women and the female child. Without help from the outside world, it will be a long and tedious struggle for women to rise above the imposed culture. Women in Peru have the right to expect the same freedom that the country affords its male citizens.

3

India's Women:
An Endangered Species

SHE KISSED MY FEET. I was dumbfounded and would never have permitted this act to happen if I had anticipated it. I was departing from a home where I had been a guest for a week in Allahabad, India, when a gaunt, shabbily dressed, servant woman, laid her straw broom aside and with deliberation bowed to her knees and kissed my shoes. Though this is an Indian custom to demonstrate humility and honor, I was overwhelmed by such action. I perceived it degrading for the servant woman. I was so astounded that I responded with a fake smile and slight nod to the woman.

This experience happened as a result of my being in India as a good will ambassador for Rotary and being a guest in the home of a wealthy Indian family in Allahabad. I was experiencing a cultural awareness of Indian protocol.

A Land of contrasts

India, with one billion people and the poorest country in the world, is a land of vast contrasts—the peasants vs. the elite; the mud house vs. the mansion; the large family of the poor vs. the smaller families of the wealthy; the squalor of the deprived vs. the manicured gardens of the affluent; the car vs. the rickshaw; the

scantily clad, malnourished child vs. the robust child; the lush colorful sari vs. the cheap, faded sari of the poor woman; the beggar and snake charmer vs. the Western suit and briefcase of the businessman; and one of the most visible of all contrasts is the superior status of the Indian man vs. the demeaning, low status of the Indian woman. These contrasts were observed over a five-week period of living in ten cities in India.

An obvious contrast was that of transportation, ranging from modern vehicles to rickshaws pulled by men. Vehicles customarily drove on the left side of over-crowded streets. However, many people drove their cars swiftly down the middle of the street, dodging other vehicles including rickshaws, bicycles, scooters, cows, goats and people. As approaching cars met, usually in the center of the street, it appeared that each car waited until the last moment to determine who would relinquish the center of the road first. This was an inescapable battle on every road. It was usually the driver of the smaller vehicle who relinquished the center of the road first.

Another evident contrast is the clean countryside air vs. the pollution of the cities. More than four million people of India have pollution-related diseases. Fumes bellow from the exhausts of cars, inciting spasms of coughing. It is not unusual to observe people wearing a covering for their mouths and noses to stifle the strong exhaust fumes and dust.

In addition to exhaust fumes is the pollution of garbage, smoke, defecation, and noise. Loudspeakers, mounted on cars and trucks, emit music, political speeches, and loud advertisement. One could always hear the cows bellowing, the clanging of bells, children squealing at play, venders hawking their wares, and people with dirty hands

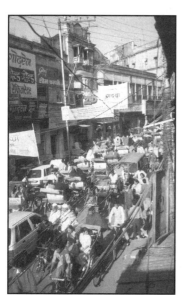

A street in Varanasi, India.

begging. The endless noises of rickshaws, cycles, and other vehicles blowing their horns were continuous. The piercing noises were amplified because of the masses of people and the abundance of vehicles. The noises made one long for the solitude of the countryside.

The roads varied from some good functional roads to those that were narrow, winding, and abounding with potholes and uneven pavement. The sight of the poor who crowded many roads, the mud shacks with straw roofs, and the abundance of poverty was always present. The rice fields along the rural roads provided the main substance of livelihood for many of the poor.

As one traveled, scrawny camels laden with heavy loads of straw were observed, as well as elephants who provided transportation for several people at one time. It was often necessary to stop for cows, wild-looking pigs, and other animals as they crossed the road, as well as for some animals that were just resting in the road. The slothful, sacred cows and bulls are kings of the highways in the country as well as in the city. It was said that the bull was the animal chosen to carry the sacred Hindu God, Shiva, to earth. To hit a cow or bull while driving would place one in jeopardy.

Indian Women, Their Home Life and Hospitality

Being a guest for a week in the home of a wealthy family in Allahabad revealed the lifestyle of just a small percentage of the Indian people, for most are very poor. The residence contained 25,000 square feet and housed an extended family of twenty-five members. The father, his parents, as well as all of his sons and their families were housed under one roof. Each segment of the family occupied its own apartment, but the families socialized and lived as a unit. This arrangement appeared to be the norm for middle- and upper-class families in India. The father of this family owned a newspaper as well as a flour mill, which employed two hundred people.

The morning after I arrived, the father of the house and I were served breakfast at an ornate, mahogany table that could seat at least eighteen people. The wife or other females in the family were not allowed to sit with the two of us but stood near the table to meet our every need and assure that the food was warm. Each morning we were served several courses of highly spiced vegetables and usually a flat piece of bread called a *chapati.* While the father ate breakfast, his servants carefully removed his slippers and replaced them with spit-polished shoes.

I ate sumptuously in this large house which exhibited two courtyards, marble floors, and brass stair-railings. Throughout my stay, however, the house was musty, damp, and cold. Hot water was unavailable in the bath except when provided via a bucket by one of the nine servants. The electricity was nonfunctional for hours almost every day, and the phone service was less than adequate. The masonry walls were cracked and evidenced greenish mold, due to the extensive moisture during monsoon season. One morning I discovered a cow grazing in the yard and was told that due to the lack of pasteurization most wealthy families kept a cow or two in their yard to provide fresh milk, butter, and the makings for yogurt.

Another upper-class home in which I visited was in Varanasi where I again observed the role of women. I entered the home through a small courtyard, which was enclosed by an iron fence and a gate that was always locked except during entry. There I found a modest downtown residence with old but clean furniture, lace curtains, and faded, handmade slipcovers on the chairs. Little dainty crocheted scarves covered the tables. It was reminiscent of America fifty years ago.

I, along with two American female traveling companions, were greeted by the two daughters-in-laws of the home who were to be our hostesses for a week. The father and mother of the home were away on a business trip, so their daughters-in-law were hosting we visitors. Lola, the youngest, spoke fluent English and was highly verbal, while the other woman, Enea, appeared shy and spoke broken English.

Visiting in this home was another opportunity of communicating with young Indian women and becoming more familiar

with their lifestyles, culture, and attitudes regarding the women of India. Issues discussed related to clothing for the family, religion, cooking, and the education of their sons. Later, as we became more familiar with the women, we discussed their hardships and the plight of Indian women.

At mealtime the two women refused to sit at the table with us three women guests but stood nearby to chat with us as we ate. Indian women do not sit at the table if men are present or if there are guests. Even on a picnic with another group of men and women, the men and guests ate first and the women and children ate leftover food. Because we were American females, we were invited to join the gentlemen as they ate.

The first night at the home I observed a servant boy about twelve years of age as he rolled himself in a blanket and slept on the dining room floor. He had been taken from a rural village at a very early age to work for this family. He had no idea how old he was. Here, at this home, he was treated kindly, had a roof over his head and sufficient food, which he probably would not have had if he had remained in the village. However, separation from his family, whom he never visits, must be painful. Though the women and servants in this home showered us with traditional Indian hospitality and offered to launder my clothes, I preferred to do my own. After washing my clothes by hand I hung them on a line stretched across the flat roof of the house. It was necessary to throw rocks at monkeys who tried to pull the buttons from my clothes. Life in the home for even affluent Indian women is not easy.

In addition to these wealthy homes where only two percent of the Indian people live, there are millions of people who live in villages with only some semblance of a house. Most village people live in mud huts with straw roofs and dirt floors. Inside a one-room hut a fire is built in the center of the dirt floor for both cooking and warmth. On a very cold morning I saw a small baby wearing only a shirt, lying on a straw mattress, which had been placed on the floor, while his parents cooked a meal on an open fire in the hut.

Women in one village distinguished themselves from other peasant women by wearing large silver bands on their legs. On

the rainy, cold day we visited, these women were somber, which was quite a contrast from other village women we had visited. Most Indian women are pleasant and endure their toil and hardships admirably. With a lack of toilets, inadequate cooking facilities, lack of food, disease, impure water, little if any health care, and lack of education, it is a marvel that these women survive. Many do not.

In addition to the people living in shacks there were thousands of people rolled up in blankets using the sidewalk and floor of train stations or other public buildings as their hotel. People often lay in huddled clumps with their heads covered by a blanket to shut out the cold. For many a woman the street was her bedroom, toilet, and kitchen. The sky was her canopy as the cold air hovered over her like an umbrella. Often a mother could be seen lying on the street, wrapped in a blanket cuddling her child in her arms.

Though women fulfill the role relegated to them by centuries of Indian culture and endure deprivation beyond description, most of those I met were warm, friendly, and offered gracious hospitality. They, along with their servants, will prepare an elaborate meal for guests and serve it with perfection. In spite of their

An Indian woman loves and protects her most precious belonging, her baby.

low status they appear to maintain dignity and graciousness as they abide by the roles relegated to them by tradition and society.

Though women are not permitted to sit with men at a meal, they are allowed to eat at the same time with men at a stand-up meal. Following a stand-up meal everyone places his empty plate under the table. A typical meal would be a cup of hot tomato soup followed by a curd with sauce, hot and spicy potatoes, spicy cauliflower, tiny dry noodles, dried lentils, and for dessert a candied watermelon rind or a sweet carrot dish. Neither meat nor eggs were served due to religious restrictions. There is little distinction between foods served at breakfast or dinner. For example, cauliflower and carrots are often eaten for breakfast. Instead of forks or other eating utensils Indians use a *chapati* to scoop up their food. The *chapati* is a flat bread-like piece of fried food resembling a tortilla. It was torn into small pieces and used to pick up food.

Though eating is usually a pleasant experience, it can be a dreaded experience if the food is extraordinarily hot with spices, which was usually the case. Beverages, which are not served with food, would enable those unaccustomed to hot seasoning to endure eating more pleasurably and gracefully. If one comments about "the delicious food," you could expect to be offered several more servings of the dish. It became necessary to limit one's compliments of the food due to the risk of offending the hostess by refusing more food.

Only in one home did I have the opportunity of sharing a sit-down meal with an Indian woman. In this home the son, who had studied in America, had observed the American custom of families eating together. Upon the son's return to India, he convinced his parents that his mother should sit at the table with the family to enjoy meals. The husband encouraged his wife to eat dinner with us, but she was most uncomfortable in doing so and kept jumping up from the table, saying that she must serve us and keep the food warm.

Perhaps the greatest show of hospitality was in another affluent home in Allahabad where Rotarians gave us a reception. The men were dressed in dim Western business suits with black,

greased-down hair overshadowing their dark olive skin. The ladies, who stood in the background, wore exquisite colorful silk saris that rustled as they walked, each finger embellished with numerous rings and their wrists covered with small rhinestone bracelets that jangled with each movement.

Upon arrival, leis, made of marigolds, were placed around our necks as we made polite conversation. Incense and sweet-smelling perfumes, plus the aroma of the marigold leis, replaced the stench of the street as we were directed to the dining room where a table was adorned with exquisite flowers and dainty finger food. It was the beginning of a lovely evening.

Our journey took us to Satna where we resided in a lovely, new, white stucco home with a well-manicured yard. Our hostess was gracious and charming. As was expected, we removed our shoes as we entered the home. Being exhausted from an extended train ride, we were shown to our bedroom where we slept on a one-inch pad and an inflated pillow. I requested a bucket of hot water for a bath since it had been seven days since I had taken a hot shower. Our host said we would get water in the morning. It is customary to take a bath before prayers in the morning which is a ritual of the Hindu religion.

One of the marks of the Indian woman's hospitality is the presentation of flowers to her guest either as a lei to be hung around the neck or as a spray of flowers. The day following our arrival in Satna we were presented with a spray of roses and marigolds. The flat arrangements of flowers were about twenty inches long and eight inches wide with gold thread woven throughout the petals. This gesture, and the warmth of the Satna women, aided us somewhat in forgetting our uncomfortable accommodations.

Another pleasant show of hospitality by Indian women was the showering of gifts on guests. I was the recipient of gifts at every home I visited, which included clothes, replicas of their various gods, brass plates, vases, and craft items. After five weeks in India I had accumulated about forty gifts from individuals which created a problem getting them back home. Their hospitality was overwhelming.

Most of India suffers from inadequate housing.

Lack of clean water creates serious health problems for Indian people.

Not only was the hospitality of the upper-class admirable, but the hospitality of the poorest village women was touching. We drove to a remote village on dirt roads to view a village that was the poorest of poor. The people, many of whom had not seen white people before, lived on dirt floors in huts with the poorest of sanitary conditions. During our visit the ladies of the village prepared tea and cookies for us in their mud/straw huts. Though I hesitated momentarily to accept the graciousness of refreshments from these ladies due to the lack of sanitary cooking conditions, impure water, and an open fire on the floor on which to cook, I knew I must. Dirty hands had given of their best, so I could not refuse their hospitality. In the open yard we sat and drank their tea and ate the cookies. Interacting with this village was an intensive encounter that drained my emotional energies to their lowest ebb.

The majority of Indian women are poor and scramble daily for food just to survive. Their social graces are limited, but they too are kind, warm, and offer whatever they can to show their hospitality.

Customs and Social Concerns of Women

A custom that is adhered to in India is the parents' selecting a mate of like status for their son or daughter. The bride's parent pays a dowry, which may consist of the bulk of her parents' savings, and in addition the family may incur large debts to enhance the dowry. An unmarried daughter is a disgrace to a family and becomes an outcast. As a result of the enormous expense incurred in getting a daughter married, the parents prefer a male child. The female is considered a liability.

Due to parents' desire for a male child there is an alarming rate of aborted female fetuses. With the introduction of amniocentesis in India the sex of a fetus can be determined. The test is relatively inexpensive, thus allowing the procedure to become commonplace. A fetus is often aborted when the sex is determined to be female.

Tradition dictates that a bride move into the home of the groom's family and become a part of their "extended family." As

many as four generations may live in one house. This tends to intimidate a bride who attempts to make major adjustments in her life. Some of the difficulties encountered are a lack of privacy, being submissive not only to the husband but to the mother-in-law and other members of the family, and lack of worthwhile activities to consume their time. Being a part of a household that had as many as ten servants, women do not perceive the need to develop skills in cooking, sewing, or housekeeping. Even servants are available for childcare. Few women are employed outside of the home, so these brides are faced with extreme boredom.

One of the positive aspects, however, of the extended family is the security and support system a young couple acquires as they move into a "ready-made" family. There is also an assurance that as one arrives at the "golden age of life," the extended family will provide more than just the necessities of life.

A Delhi airport restroom attendant.

There was no incident in India that troubled me more than reading in an Indian newspaper of "kitchen fires." These are subtle murders of women who have married. The woman's family may have failed to provide adequate dowry as promised for their daughters to the in-laws or to the husband, or it may be that the young wife has failed to meet the expectations of the family into which she has married. These women are "locked in the kitchen," doused with gasoline, and set afire. Seldom did authorities ever examine a "kitchen fire." The value of a woman's life appears to be inconsequential. Upon the death of the wife, the husband would then seek another bride to gain another dowry. This atrocity appears to result from the desire of males for fiscal greed, which is somewhat foreign to traditional Hindu custom.

It was at Renekoot that I encountered my first rejection by an Indian man. I was on a tour of a power plant when I was introduced to the manager of the plant who was an orthodox Hindu. I stuck out my hand to shake his, but he refused. He commented that he did not shake hands with any woman or touch any woman out of reverence to his wife and mother. Several Indian men observed the manager's behavior and were later apologetic for his actions.

A custom I observed numerous times was that of peasant women who were following behind meandering cows seeking droppings. Rubbing dirt on their hands, as we would flour, they picked up the warm fresh cow dung and patted it flat like a pancake. The dung was then stuck on a wall to dry and sold for fuel. Often we observed walls covered with hundreds of these round dung pancakes basking in the sun.

Observing how a developing country was seeking to assist handicapped individuals was encouraging. Upon visiting such a resident/home operated by five sister nuns under the order of Mother Teresa, I had an inspiring encounter. The sisters were ministering to the sick, handicapped and elderly in a building that was clean but sparsely furnished. It was by far the most suitable building that I had encountered in India that was ministering to the needy. These nuns were caring not only for the physical needs of these individuals but sharing love and warmth with the clients.

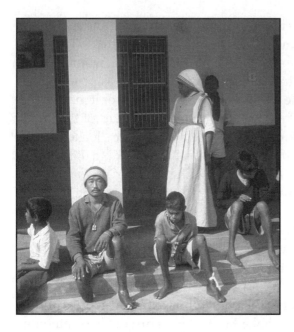

*A home for handi-
capped individuals
operated by Mother
Teresa.*

This type of home was the exception rather than the norm, meeting the need of the handicapped or ill individual.

Later the same day we distributed fruit to the "Woman's Protection Home" which was housed in a small, dark and dingy building. There were approximately twenty women residents who had been rescued from severe spousal abuse or abandonment. These women, in their loose-fitting, drab clothes with faces that revealed anguish and despair, formed a line to greet us as they received the fruit. They acknowledged our gifts with the Indian's courteous bow and gracious appreciation. (Indians customarily clasp their hands under their chin and bow their head in greetings and salutations.) These women, some just teenagers, were already experiencing life beyond their years. Spousal abuse is common and is part of what a wife is to expect. This home, a rarity, is a new approach in dealing with abused and abandoned Indian women.

The future is gloomy for these abandoned women, who have been abused or forsaken, not only by their husbands but their families as well. An abandoned woman is considered a disgrace to society, isolated, and stigmatized with almost no possibility for

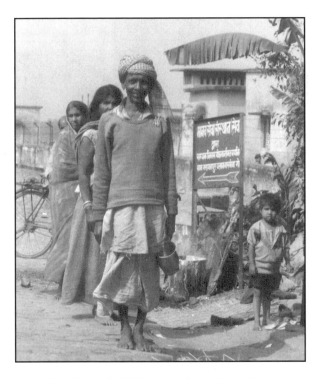

Typical scene, women behind a man.

vocational work. This was the only refuge center providing shelter for outcast women that I encountered.

Neglect of children did not appear to be common in India, but while waiting in a train station, we encountered a three- or four-year-old little girl who roamed the train station. She thrust her hands up, begging endlessly. The station porters kept trying to shoo her away. Finally she meandered away and sat on the concrete floor to tear scrap paper into bits, begging as passengers passed her way. The porter said her mother left her at the station daily to beg from the train passengers. It was a wrenching experience to watch this child with her pleading, begging hands. I kept turning my head to look away, even closed my eyes hoping she would go away. She did not, and I still have visions of this forsaken child.

One significant disparity between men and women was evident at social events. It was not customary for women to socialize with men, but as American women we mingled with gentlemen who spoke English. Most Indian women were not fluent in En-

Spouses of Rotarians gathered for a meeting.

glish due to their limited educational background and thus were relegated to other areas or would oversee the serving of food.

Indian men consume alcohol effortlessly and frequently, but consumption of alcohol is not acceptable for Indian women. We were offered "spirits" with the gentlemen but used the greatest of tact in refusing their generosity. There were days, however, when a strong drink might have alleviated my stress.

The topic of conversation with men ran the gamut from politics, religion, economics, to the endless inquiry, "What do you think of India?" The typical conversation with women revolved around food, clothes, flowers, and children. It was evident that the average elite woman was deprived of information beyond the area of the home.

The custom of cremating the dead on pyres is a Hindu custom strongly adhered to by Indian people. The dead are placed near pyres, wrapped in green and red blankets, waiting their turn to be cremated. Sandalwood is the choice for burning at the pyres, but it is so costly that bodies of the poor as well as many small children are often dumped in the Ganges. Not only do the bodies pollute the Ganges, but the river is also the receptor of raw sewage and industrial waste.

Religious Views Impact on Women

Hinduism, the oldest active religion in the world, is adhered to by 80% of the Indian people. Hinduism consists of a variety of beliefs and practices with minimum organizational structure and no significant hierarchy. There is no congregational form of worship. Individuals visit shrines, present flowers and money to the gods, and participate in worship activities in the homes. A Hindu may worship several gods, and often it is a family god that is placed in a shrine in the home. Because everything is considered worthy of devotion, almost anything can be worshipped.

As I inquired about tenets of Hinduism, a religion professor, in addition to other Indian people, told me that Hinduism was perplexing with too many facets to comprehend in a short period of time. Their religion appears to emphasize a way of life which regulates every action of the individual and provides a strong sense of identity which is called "dharma." The gods addressed most frequently in our presence were the gods Brahma, Vishnu, and Shiva.

The lowly status of females in India may be the result of the persistence of traditional religious cultural and family traditions. The caste system of India, even though outlawed by the Indian government, is inordinately tied to Hinduism, which shapes the Indian woman's life. For example, there has traditionally been a deep mistrust of the female sexuality by Brahman (the priestly caste).

Varanasi, located on the Ganges, is the center of Hinduism. It is one of the seven ancient Sacred Cities and is considered to be one of the oldest living cities in the world. The city is filled with fascination and beauty, yet it is a swarming city of mass confusion. There are temples, shrines, bazaars, mosques, vendors, palaces, and the notably holy river, the Ganges. The Ganges, with miles of ghats, which are steps that lead down to the water, is a point of interest for the Hindu as well as tourist. Pilgrims come, at least once in a lifetime, to visit Varanasi and dip in the Ganges to receive purification. It is the place where the old come to die. They believe that to die here will ensure rebirth to a better way of life.

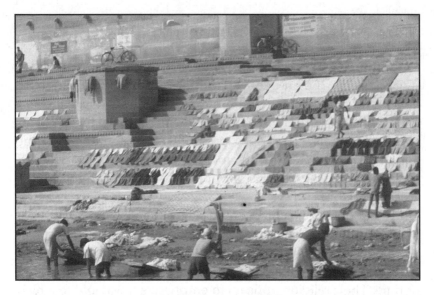

After washing sarongs in the Ganges, they are dried on the ghats.

While at the Ganges we observed business people, twisted figures of beggars whose skin sagged over their bones, small children pleading endlessly with us to purchase their flowers, picture postcards or trinkets, and sweaty, smelly Indians who sought rest for their bodies on the ghats. Priests, sadhus (holy men), and men with cobras in baskets were frequently visitors at the Ganges' ghats. It was an endless smorgasbord of Indian people.

We visited a home in the business section of Varanasi, near the Ganges. We entered this residence by passing through narrow walkways where vendors were hawking their wares, money-changers were demanding, and beggars accosted us at every turn. The residence was fascinating, even though the stone walls were covered with dirt and soot. Our host's grandfather, who had come to live near the Ganges during the last days of his and his wife's life, had built the house.

Inside the small, residential compound was a temple and shrine which had also been built by the grandfather. The private temple, small but elaborate, was an open structure where monkeys jumped from one altar to the other. Beside the temple were

servants sorting vegetables. Their clothes were colorless, due to having been washed too many times in the Ganges. The dining room of the house, only ten feet or so from the family shrine, was on a verandah, an open type of unscreened porch, wrapped with the biting odors of the streets. There was no yard at this house since land is very valuable near the Ganges. A shrine in homes of the upper caste is common.

In every home I visited, I observed that the family gathered after a morning bath at their special shrine room to recite sacred words and offer food and flowers to their gods. In the evening, families would sometimes put sweaters on the miniature god figures before putting the gods to rest for the night. At one residence where I was a guest, I wanted to show my colleagues the family shrines that I had previously observed. When I requested the father of the home to unlock the door of the shrine that we may view their elaborate shrine, he responded rather emphatically that he had put the gods to bed for the night and they could not be awakened until morning.

Wealthy homes have a center for worship where family members
meditate at the beginning of each day.

On a visit to Gorakhnath Temple at Gorakhpur, we discussed religion with a Hindu high priest. When asked of his opinion of Jesus, his reply was that we all worship the same God, just in different ways. He said that we worship God through Jesus and they worship God in other ways, through other means. It was an amicable conversation but one that left us with many unanswered questions about Hinduism.

The Indian people relished showing us their shrines and temples, which were usually the first sights to be observed in a city. As we observed the unique Guptu Godawari Temple Cave near Chitakoot, we removed our shoes and climbed up steep, stone steps to the entrance, which was a cave. The dimly lit cave contained approximately two feet of cold water through which we had to walk to arrive at the temple shrine. As I stepped cautiously into the still water, I lifted my skirt above my knees and cringed as my bare feet touched the rocky bottom. I sloshed through the water, often reaching out to a companion for balance. The frigid water chilled my body as we wound through the cave and tunnels for about twenty minutes. We finally arrived at a shrine, which was somewhat like a hole carved in the side of the cave wall with statues and religious symbols adorning the area. A priest, on an elevated type of island, was administering sacred

Indian woman meditating.

rituals and accepting money and flowers from the worshippers. Our host paid a tribute of money and we began wading out of the cave.

The most elaborate of all temples were the ancient temples at Khajhrako. One was built in 960 and took forty men fifty years to build. Some of the temples featured elaborate stone carving on both the exterior and the interior walls. One temple featured nude statues of women in sexual acts with the king. Our guide informed us the king had no other recreation than sex; thus when the temple was built, he placed these small statues on the outside of the temple. Because the king did not want these exact scenes duplicated, I was told that he cut off the hands of the sculptors and cut out their tongues so they could not reveal the designs.

Women's Medical Concerns

Medical services for the majority of poor Indian women are almost non-existent. The elite is privileged to medical service, however I was told that in most cases medical care is deficient. The rural village people have limited access to medical services, poor nutrition, polluted water, lack of health education, and rampant diseases. These factors contribute significantly to the medical conditions of the people. Health services for most women, rich and poor, are inadequate.

Our journey took us to a hospital that specialized in eye surgery. There were approximately 3,500 beds at this hospital for those who received eye surgery without charge. Some of the patients were in large buildings and others were in beds placed in tents. Families prepared food for patients and met their other personal needs. One of the eye surgeons indicated the high incidence of eye problems in India was due to the extreme brightness of the sun, improper eye care, and nutritional deficiencies.

Another medical moment for me was when I was requested to make a speech and present prostheses to handicapped people in a hospital. Medical doctors, hospital attendants, and family members of the handicapped were present for the occasion. I presented hearing aids, crutches, walking canes and other devices to

handicapped individuals, mostly children. The prostheses had been purchased by a Rotary Club for these needy people. The local newspaper was there to cover the event. I was astounded the next day when an Indian read to me the headline of the article, "American Promises Aid to Indian Handicapped." That concept had not been mentioned in my speech. I wondered just how much other information had been incorrectly translated through the interpreter.

I was taken to a village to observe the preparations for a volunteer eye surgical team who would arrive the following day to operate on hundreds of people with eye disorders. We went upstairs to a room about half the size of a gymnasium and there, on the floor, were straw beds which had been placed about a foot apart for the patients to lie on while recuperating. This makeshift room would be the recovery room for at least the next seven days for most of the surgical patients. Without the services of nurses, the patients' needs would have to be met by others, primarily by the females in the patient's families. Under the most incredible conditions, people were going to be prevented from blindness, or in many cases sight would be restored—what a phenomenal humanitarian service provided for these village people.

Because of the masses of people, lack of medication, inadequate hospitals, poor health education, insufficient medical personnel, and dearth of medical resources, India, the most deprived country in the world, will probably languish in medical care as a result of being the poorest country in the world.

Illiteracy Among Indian Women

Many of the ills of women in India are significantly impacted by the lack of education. Traditional education for women has not been a priority. About one half as many women can read as men. This was so evident in conversations with women who primarily centered their lives on the home with little understanding of the outside world. Unlike their husbands, most Indian women did not speak English. I was told that this was due to the fact that the women did not have the same opportunities as the men to study English in school.

Many of the women of India, especially of the elite class, have potential but because of societal customs, their lives lack color, challenges and stimulation. Television is available in most of the homes of the middle and elite classes, which creates unrest as the Indian women view American programming. They observe the freedoms and activities of American women that had previously been unknown to them. Those who can read spend time reading American books, which heightens their desire for change.

A trip to a farm village was another bumpy ride where we encountered about 500 divest peasants drowning in deprivation. We were the first white people the village people had encountered, so they were as fascinated with us as we were with them. The shriveled, malnourished peasants hovered together while the little peasant children came forward to view the paleness of our white skin. The village was remote, unencumbered by the masses one encounters in the cities. However, the smell of sweaty, unwashed bodies was evident.

A Village Director who accompanied us to this remote village stated that only 2,000 of the 3,000 villages that he supervised had schools. The female children spend 27% of their time collecting limbs for fuel and 20% of their time fetching water. There is little time left for education for the female even when schools are available. These children, with scrawny faces and blank, expressionless eyes, cautiously touched us as though we would crumble. However, before departing we were lovingly holding the little ones in our arms.

Upon returning to Varanasi I was taken to a girl's school to dedicate a toilet. Nothing surprised me any more so I readily agreed to the request. Knowing that most rural schools did not have toilets and that a Rotary Club had gone to great expense and admirable effort to build a toilet for these young teenage girls, I thought this would be an interesting experience.

After traveling perhaps fifteen miles over ragged roads we arrived at the village schools. Several school buildings were scattered over the area, but we headed for the girl's school. As we walked down a path, we encountered an honor guard of young boys dressed in school uniforms of khaki short pants and short-sleeved shirts. One young boy indicated that he was our escort to

lead us through an honor guard to the girls' school. These boys, perhaps thirty or forty of them, stood on each side of the path in an erect position with imitation guns hoisted upon their shoulders.

As we turned a woodsy corner, we viewed the girls' school; sitting precariously in the center of the play yard was a brand new toilet. The principal of the school presented us with leis and graciously sat us at a table. There was a spicy rice dish, another Indian dish, and a sweet cane drink. Parents and friends, perhaps a hundred or so, had gathered to observe the ceremony. The girls, perhaps sixty or more of junior high age, were all dressed in their blue uniforms with their black hair arranged immaculately. A program of music and dance was presented while we ate.

Then came the moment of dedication of the toilet. I was to walk over to the toilet and pull back a little yellow curtain, which I assumed covered a small window. To my amazement the yellow curtain did not cover a window but was a hand carved, white marble plaque that read:

Model Toilet for Ladies
Village of Chanditara
opened by
Mrs. Winnie Williams

The crowd was so very proud of this first toilet for the school. The group applauded wildly because their girls now had a toilet, about 4 by 6 feet in size, adjacent to their school. Following the "dedication" a leader said, "Now that Ms. Williams has dedicated the toilet, she will now initiate the toilet." My heart began beating rapidly, for I was not sure what I must do to initiate the toilet. As we walked to the toilet door I prayed, "Dear God, please help me here. I can't do what I think they want me to do."

What a relief it was when the Indian man handed me a pair of scissors to cut the red ribbon which had been draped across the toilet door. After cutting the ribbon, two men and I walked inside the toilet as the audience applauded. A hole in the floor was provided, and it was private.

This was a commendable effort to help provide social graces for young women in India. How proud I was to have a small part in the dedication (after it was over). The young schoolboys had

previously been provided a toilet, but the toilet for the young women was late in coming, as are most events for women in India.

Winnie uncovers a plaque at the dedication of the toilet for women.

Usha, Lady of Charm

It was in Gorkahpur that I encountered the most beautiful, educated, and charming woman on my visit to India. Though she had been married seventeen years, she had no children. Her husband, who had a Ph.D. in chemistry, came from a family of wealth and distinction. Usha was a leader in charitable services for her community, well educated, knowledgeable in areas outside her community, and spoke English elegantly. She with her enviable charm was our host for several days.

Usha resided with her husband's family, in an elegant home surrounded by immaculate gardens, which was cultivated by four of their servants. We turned from a dirty, repulsive street of smelly debris and hopeless humanity into this garden of roses, dahlias, marigolds, and dozens of potted flowers dotting the massive green lawn. The huge three-story white house, surrounded by the usual high walls, stood majestically in the heart of the city. The garden was the site of a tea given in honor of us Americans.

Thirty-five couples had been invited to enjoy this elegant garden tea. Folding chairs had been placed on opposite sides of the garden where the gentlemen sat on one side to converse while women gathered on the opposite side. I just floated from one side to the other, not really knowing where I belonged. Among the many toasts given to the Americans was one by an Indian gentleman, having been liquided quite well, spoke rather abruptly. "Americans drink English tea, ride in German cars, use Japanese computers, eat Italian food, and wear Indian-made clothes but still complain about import tax."

Usha was a gracious hostess and a river of information concerning women of India. She was like a laser ray, cutting though tradition. She was a visionary in a place where vision is bound. With an army of Usha among the one billion Indians, women could rise above the subservient role of their present status.

Ramon, the Siek's Wife

A trip to the National Reserve at Pail Kalan led me to another wonderful encounter with an Indian woman. Our host and driver was two hours late picking us up for the trip, which was not a good beginning for the day (time seems to be of little essence in India). After an eight-hour ride, with little food, we arrived at the residence of a wealthy Siek and his wife where we were to spend the night. The sprawling white house was like a scene from *Out of Africa.* This Siek farmer, who owned a village where 2,000 people resided, lived in a long white house with twenty or thirty columns adorning the porch. The Himalayan mountains rose majestically in the distance. The palace-like house was surrounded by more than a hundred acres. We learned that four crops a year were grown on this farm through the process of crop rotation.

The Siek, who is from Pakistan, was a former follower of the Hindu faith but now follows a different path. Sieks are easily recognizable because of the turbans that adorn their heads. There is immense strife between most Hindus and Sieks.

The Siek's wife, Ramon, was young, charming, and a wonderful hostess. She and the servants rendered hospitality that was

typical of Indian women. She appeared far more liberated than most Indian women, making decisions and assuming a role to which most Indian women were unaccustomed. Ramon's home was another example of an elegant home that lacked adequate plumbing or hot water.

After dinner the servants built a bonfire in the front yard. We sipped tomato soup from a cup as we sat around the fire and told of our homeland. It was an exhilarating experience. We sucked in the crisp clean air that enveloped us as we slapped at the mosquitoes and bugs that were drawn toward the fire.

Women such as the Siek's wife and Usha are rare exceptions in India. It is because of women like these that hope exists for a better way of life for Indian women.

Indian Women Endangered

As I left the most devastating, poverty-laden country in the world, I tried to remember the beautiful temples, the lovely leis of flowers, the rustling of the silk sari, the dahlia as large as a plate, the warmth of the Indian people, especially the women, and the honor and gifts given to me. Yet mingled in these exquisite memories, I vividly saw the millions of starving people rolled up in blankets at night in the streets, women in demeaning roles, the crippled boy pulling himself in front of me, refusing to let me pass unless I gave him a coin, women abused and abandoned, the snake handlers, the mother thrusting the cancerous child in my face begging as she stopped our car, women and children starving, the masses defecating in the streets, the children working, the women digging with a pick to build streets, the mud huts, and the naked children shivering in the cold. This was India, maddening and yet wonderful at the same time, even worse than I had dreamed. This journey has become a part of me. I cannot, nor do I want to forget, the experiences of India.

4

Women of China

I ACCOMPANIED SEVERAL CHINESE FEMALE STUDENTS as they took their two bowls and chopsticks to a university dining room for lunch. One bowl was for rice, and the other was for either egg or tomato soup or a dish consisting of noodles and tofu or vegetables. When the girls finished their meal, some eating inside the dining room and others eating as they stood outside, they rinsed their bowls at an outside faucet and then returned their bowls to their rooms to be used at the next meal. The food was usually cold, and I had difficulty eating it, especially with chopsticks.

As I walked with the students to their dormitory, I observed that as many as eight female students were living in one small room. There were triple-stacked bunks and a washstand that held a pan of water for sponge bathing and washing clothes. After washing their clothes, the students would hang them out the window on poles to dry. Trash, such as orange peelings, leftover food and paper, were simply thrown in the hallways. Walking down a dorm hallway and stepping over debris without falling was a challenge. This was typical of dorm life in China.

Discovering China and Its Women

Although the country of China is picturesque, fascinating, and alluring, it is at the same time oppressive, dehumanizing and

threatening. Though it has a legacy of 5,000 years of civilization, it is presently a dreary-looking country with much of its beauty having been destroyed during the Cultural Revolution from 1966 to 1976. Nevertheless the people are friendly and, for the most part, warm and caring.

These were my impressions as I lived in NanChang for a month and traveled in Shanghai and Beijing. I had come to China through an invitation of an Exchange Program with the People's Republic of China to teach a class at Jiangxi University at Nan-Chang. I was able to speak, mostly through an interpreter, with faculty and students at several universities in China, families, and some English speaking individuals regarding their country and the status of women in China.

China is the world's third largest country and is a little larger than the United States. It has a population of 1.2 billion people, more than any other country in the world. In fact, China has one fifth of the world's population.

It is a clandestine country, shrouded with controls, and it is only half-open to the world. A communistic controlled government dominates China with an iron hand. Understanding the Chinese Communist Party's authoritarian structure and ideology is necessary to understand the role it serves in the liberation of women from their demeaning role in Chinese society. The nucleus and basic principle of China's state system is that all power belongs to the people. The party works to see that policies are followed and that non-party members do not create an organization that might challenge the party's regulations. Improving the role of women must in no way create entities that could threaten party rule.

Being a communist brings an individual power, prestige and social status, plus an improved standard of living. I was told, though, that less than ten percent of the people of China are communist and that the ordinary people who are not communist live in fear of governmental retaliation if they oppose governmental policies or regulations. The major policies of the country seem to be made by the elderly people while the middle-aged people implement them and a youthful army and police force stand ready to enforce them.

Although tradition weighs heavily on China, many of the youth cry for freedom and individualism. The Tienamon Square incident in 1989, in which 100,000 youth rebelled against their imposed lifestyles, indicates the young people's strong impatience and dissatisfaction with life as it is in China today. Many of the students who rebelled against the communist government were dealt with severely, some executed and some placed in prisons. In addition, it has been reported that the government harassed some of the families of the youth as well. As a result of the Tienamon Square rebellion, before they enter college, students are now required to participate in one year of study developing loyalty to their country.

Shopping is a challenge in cities that are congested with people and the heavy traffic of buses, trucks, taxies, and more bicycles than perhaps anywhere in the world. Fumes from the vehicles and other irritants are stifling. Policemen and soldiers swarm the streets and sidewalks as shoppers visit the mostly small, privately-owned shops and governmental stores. The privately-owned shops are small, with no more than 10 to 20 feet of store frontage, and are quite limited in their inventories with items like clothes and household furnishings. However, the government-owned stores are larger, with extensive inventories and greater variety. With the large population in China, shopping in cities there is similar to shopping the day before Christmas in the United States.

The variation of food in China is endless. There is a saying that if it flies, crawls or swims, the Chinese eat it. While in Shanghai, I was introduced to my first authentic Chinese food at Mamas Restaurant where I had a Mongolian hot pot. This was a pot of water placed on top of hot coals in the center of the table. When the water began to boil, I used chopsticks to dip small pieces of mutton, tofu noodles, and a green vegetable in the water to cook. Not being proficient with chopsticks, I often lost my food in the hot water but when I was successful with the cooking, I found the food tasty. In another restaurant called a "fast food" restaurant, near the Great Wall of China, I found the food hard to eat. Rice was served in a bowl covered with vegetables and sweet potato

noodles. First the bowl was filled with hot water that was used to rinse it out, and then the hot water was thrown in the floor (a custom used to settle the dust). When the bowls were filled with food, I tried to assume the Chinese position with the bowl just under my mouth. I found that the Chinese raked food into their mouths, filling their cheeks with food to the extent that it reminded me of a chipmunk's fat cheeks. This was a custom I only tried once. Slurping of soup and rapid eating is a common practice.

Traveling by train through the country where 75 percent of China's people live gives one a different perspective of China than being in the city. In rural areas, even though some land is barren because of its mountainous or desert-like qualities, every cultivable piece of land is utilized. Peasants labor to etch out a living on the small plots of land designated for their specific families for growing their crops. I saw people irrigating their crops from buckets of water, which they had brought to the field, two buckets of water balanced on poles situated across each person's shoulders as he or she walked to the fields. Every inch of land appeared to be planted in crops, even the land on every side of apartments. I did not see a green lawn or even a large yard.

As the train passed over rivers and lakes, I observed fishermen in their wooden-hulled boats, people working near their shabby houseboats, and farmers maintaining irrigation ditches. Often the raggedly dressed peasants tending their rice or wheat crops and the farmers herding their ducks would then wave to the people in the passing train. Always in view from the train in the rural area was an apartment compound. With such dense population (322 persons per square mile), apartment houses are built everywhere, even in the middle of fields.

Traveling on the train presented a few problems. Because I was unable to secure a sleeping berth, I was assigned a hard seat in the last car of the train which accommodated about 200 peasant men, and several women. I had been unaware that in a car for peasants, no services in the dining car would be available, so during the long trip of 18 hours I essentially had no food or water. Locating a toilet was difficult due to my lack of speaking Chinese

but when I did, I found that it consisted of a hole in the floor through which one could see the railroad tracks as we rode over them. Perhaps the most difficult part of the ride though was the Chinese peasant men who stared at me. Some men even stood in the aisle so that they could see me better. I became rather paranoid because there was never a moment when I was not being observed. Later, I learned that women seldom travel alone for long distances, especially in a car with peasant men, and I was told that most of these people on the train had not seen an American woman before. Thus, they were very curious.

During the night a mother and a small child boarded the train. When the lights illuminated my white face, the child became frightened, screamed and hid her face in her mother's lap. In addition, a fight broke out during the night between two teen-aged boys in the seat facing me and I was alarmed at the commotion only two or three feet from me. I couldn't understand what the fight was about and I wondered what I would do if they became so violent that I might get hurt, especially since I could not speak Chinese. Finally, one of the boys walked away and things became calm and I said a long prayer of thanksgiving.

Near daybreak on the train I saw dozens of hand towels hanging to dry in the oddest places, like over the windows and on the back of the seats. I soon learned that the Chinese wash their face early and late in the day and then hang their towels out to dry. Not having but one bath in five days, I really envied those Chinese people of their wet towels. I was dirty, hungry, thirsty, frightened, and had a terrific headache.

How did I get myself into such a predicament, I wondered.

Chinese Women and Their Education

Although China has made significant progress in the education of women since 1949, when the People's Republic of China was founded, illiteracy among women is still predominant. Some 90 percent of the women were illiterate in 1949, today only 30 percent are. Since 1990, there has been an increase in the number of girls attending elementary schools and education is now com-

pulsory for the first nine years of school, so there will probably continue to be an increase in the percentages of literacy among females. The government states that the ratio of girls between the ages of seven and eleven attending school has grown from 80 percent in 1990 to 97 percent in 1994. However, the percentage of girls attending high school has risen only about two percent and that for women attending Universities has risen only one percent. In 1997 the government reported that there are more than 13 million women in universities and colleges. About one third of all students attending college are female.

Several factors apparently contribute to the lag in the education of females. One is the traditionally subservient role of females in Chinese society; and other factors include early marriages and pregnancies, gender-biased teaching, inappropriate educational materials, and the lack of adequate educational facilities. Classrooms have as many as 50 to 60 children in a room and the atmosphere is often bland and lacking in creativity. Also, many young girls are required to undertake heavy domestic work at a very early age and are expected to manage those responsibilities along with schooling. This often results in poor academic performance and the girls dropping out of education training. In many of the remote areas of China, such as Tibet, education for women has lagged due to the nomadic nature of tribes, however, efforts have been initiated to improve the education and lessen the dropout rate for many of these girls.

While observing women students at several universities, I learned that only about 3% of China's high-school graduates attend college. Students must

Domestic workers in dorm where I lived.

pass difficult entrance exams, so only the women who excel are accepted at universities or technical colleges. While over two million students take the strenuous national examination, only 500,000 slots are available at China's universities, although three of the universities are for women only. If women do not go to college, there are other programs where they can develop their skills through adult education programs and vocational training. There are more than 1600 of these secondary vocational schools for women. Though statistics published by the government can be misleading, it does appear that the education of females is on the rise.

The phenomenal discouragement of the value of higher education during the decade of the Cultural Revolution (1966-76) plunged education into such disarray that major changes were necessary to bring about recovery. During that period, many colleges and universities were simply closed. A college professor reported being moved to the country and placed in the fields to work 12 to 14 hours a day, seven days a week during the Cultural Revolution. Professors, artists, musicians and other professionals were removed from their positions and forced to perform hard labor in the countryside. They were located in farm areas with no choice but to perform manual labor. Not only did the Cultural Revolution cause deterioration in the educational system, but also every aspect of culture in China was seriously impaired.

I found the campus at Jiangxi University a rather large, dusty campus surrounded by a high wall with guards at the entrance. At one time the campus might have been very attractive, for there were several pagodas and a small lake with surrounding gardens, but now due to a lack of maintenance, weeds and debris leave it cluttered and unattractive. In the places that I visited in China, aesthetics and beauty did not appear to have high priorities.

On the first night of my arrival at Jiangxi University, the president of the university gave a "banquet" (we would call it a dinner) in honor of my coming to teach. He had invited several male dignitaries from the university, interpreters, and a visiting American professor and his wife. The president did not speak English but the interpreters were there to assist in communication. He made a number of "toasts" and I was told that I should

Peru, a land of beauty.

Urban garden in South Africa.

*A mother walks a long distance to work
in a white neighborhood in South Africa.*

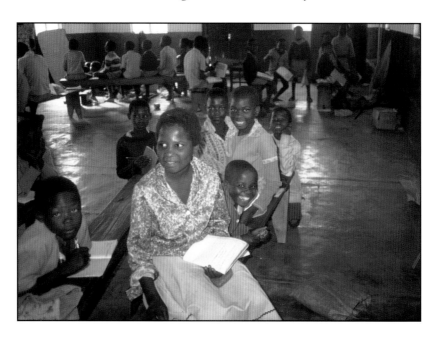

Few books or materials are available to South African students.

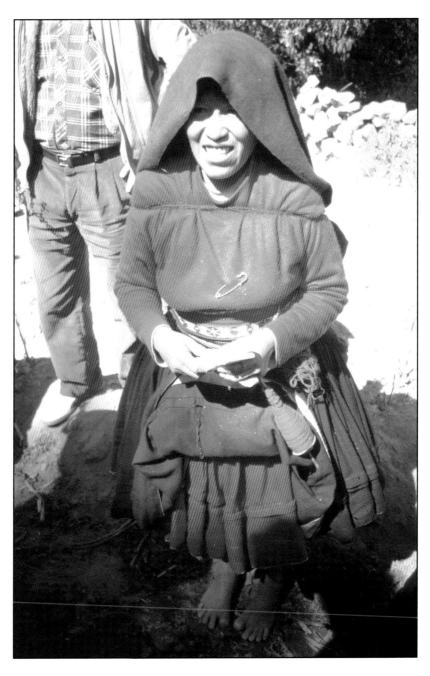

*I climbed a 10,000-foot mountain
to visit this Peruvian Aymore Indian woman and her village.*

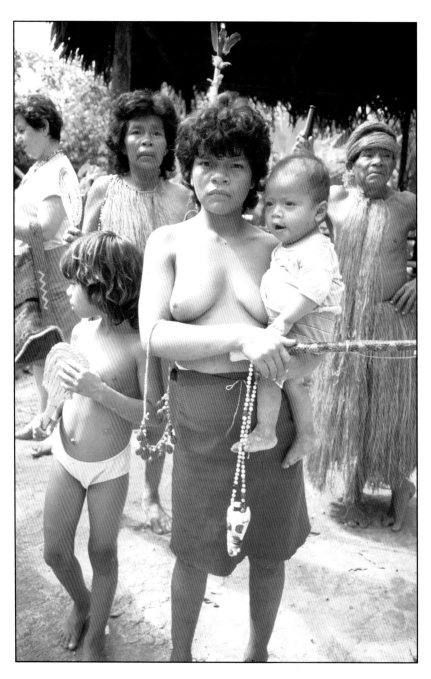

A tribal Indian woman and her children show anxiety regarding the Americans approaching her Amazon village in Peru.

Peruvian mountain children.

*A woman
seeks medical
assistance for
her child in an
Indian hospital.*

Winnie visits with a woman of the upper caste system in India.

An Indian village, which Americans had not visited before.
The ladies served us tea.

An Indian woman poses in her garden.

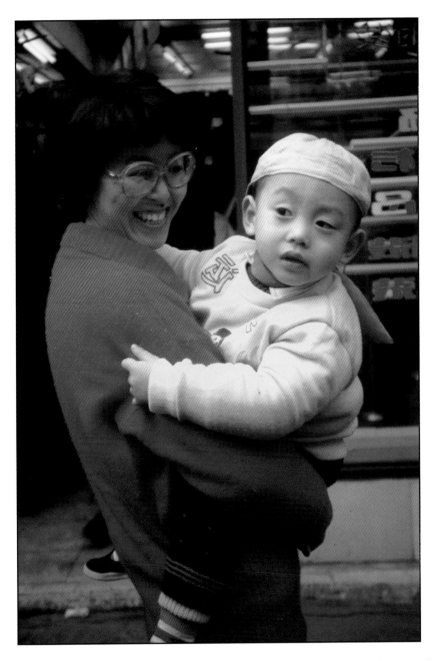

An unknown woman poses with her child at Tianamon Square, Beijing, China.

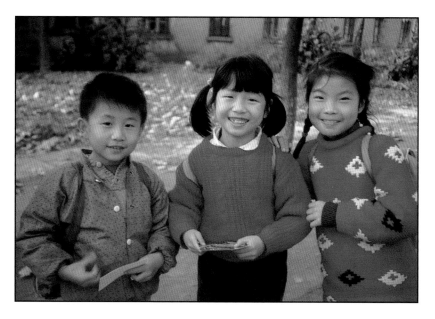

Children who live on the campus of Jiangxi University,
NanChang, China, enjoy trying their English on a stranger.

A Chinese family, who lives in one room of a dormitory,
shows off their new baby.

A Haitian farmer.

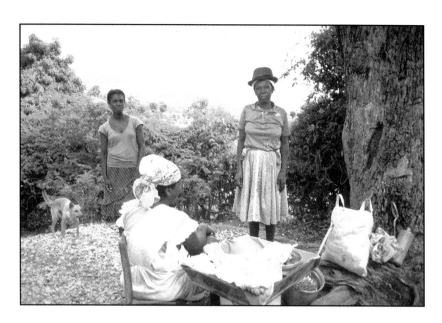

Lunchroom ladies prepare food for a remote Haitian mountain school.

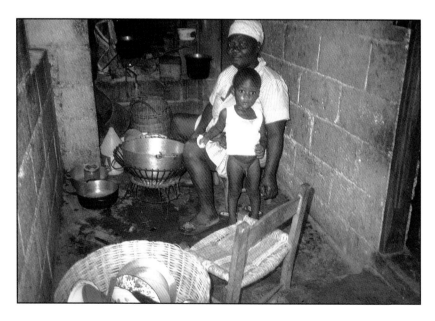

*A Haitian woman prepares food at a clinic
for a member of her family who is ill.*

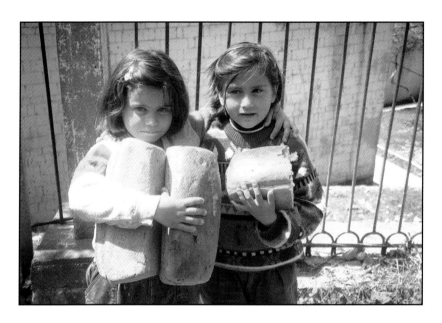

Albanian children returning from purchasing bread at a local bakery.

Winnie visits with a grandmother and grandchild in an Albanian home where she is served Turkish coffee, grounds and all.

An Albanian gypsy woman holding her grandchild tells of many handicapped children in her village.

Winnie with children in Albania.

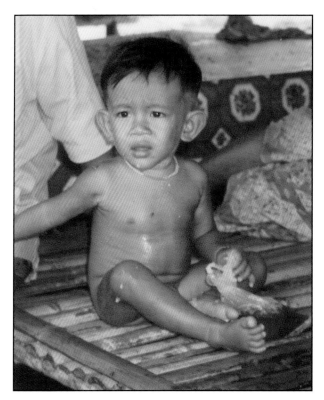

The extreme heat of Thailand is evident as this baby is placed under a tree to catch a breeze from the nearby lake.

A Thai Muslim woman seeks assistance at a medical clinic.

Hindu Temples at the Grand Palace, Bangkok, Thailand.

A Thai business woman sells her merchandise at an open market.

Taj Mahal, India.

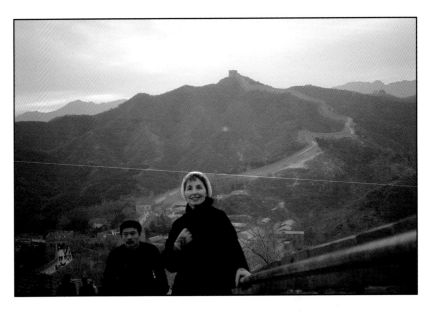

Winnie walks the Great Wall of China.

stand each time he made a toast; so I was continually jumping up and smiling during the meal, not knowing what he said until after I sat down. The dinner consisted of fourteen dishes on a center turntable with such dishes as duck, chicken pieces (including the head), lamb, fish, pork, vegetables, a sweet soup with mushrooms, and bland, white cake with delicious bananas and a caramel sauce. Since there were no plates, we ate from the main dishes using our chopsticks. After we ate, the men, but not the women, smoked and when they finished a cigarette, they threw it on the floor and put it out with their feet.

Teaching at the university was a challenging experience. In my class on mental retardation most of the 22 students were women who taught mildly mentally handicapped students in the public schools. Students ranged in age from about 20 to 35 years of age and were excellent students. They listened intently, performed well on tests, and completed their assignments diligently in spite of having to listen through interpreters. The interpreters often asked that I talk more slowly, as they could not interpret as quickly as I presented information in the three-hour lectures. Since the content of the material was unfamiliar to the interpreters, I found it beneficial to give them an overview of the lecture before class.

The classroom in which I taught was relatively small with rough concrete floors, no heat, and cardboard replacing broken windowpanes. Since there was no heat and the temperature was usually around 50 degrees, I wore several layers of clothes, gloves and cap, and the warmest socks and shoes I had, but I was still cold. The students poured me warm "white tea" (hot water) in a cup not only for drinking but also for warming my hands. Having hot tea in a cup was the way the students kept their fingers nimble in order to write. As the morning progressed, the sun warmed the building and the classroom temperature became more comfortable. Because of the cold and dust, students had many respiratory problems and often spat on the floor, a common practice which challenged my adaptation skills.

While teaching at Jiangxi University, the students were very attentive to my needs and welfare. Each day a student came to my apartment to walk me to class and carry my books and supplies for

the four or five block distance to the classroom. At the 15-minute break between lectures, they saw that I was supplied with "white tea" and looked after me in splendid style. Even without an invitation, they would come to my apartment to chat with me about school or their families or other concerns. Of course, there often had to be an interpreter for us to communicate. Occasionally as I walked on campus, I was followed by a group of 12 to 15 children of the faculty. I was a novelty to them. They had learned to say "hello" in English and practiced it with me regularly. I, in turn, had learned to say "nehi," which is their Chinese greeting, so I practiced my few words of Chinese with them. The Chinese greeting is interpreted to say, "Have you eaten today?"

One day following my conversations with the children, I was taken for a visit to their school. It was an ordinary-looking school building with classrooms large enough to accommodate 75 or more students in each class. One teacher told me in a private conversation that she felt more like a policewoman than a teacher; however, I observed the children to be respectful and obedient with much rigidity in their behavior. They always stood as a teacher or visitor entered their room. Most of the Chinese children are enrolled in first grade as they become eligible, but many do not complete primary school. The dropout rate is high in the rural areas where the family needs the children to work in the fields, but attendance is better in the urban areas.

In addition to restraints that were evident in the behavior of students, I observed a certain amount of rigidity in the school curriculum. The young students are not trained to inquire but are rather indoctrinated with the philosophy of the People's Republic of China. The welfare of the state reigns supreme. With 70 million photos of Chairman Mao on walls in China, there is no doubt who is god in China and who reigns supreme even in the classroom. Teachers, some just 17 years of age, are allowed to teach upon completion of junior high school with little or no formal training.

After students complete the 5th grade, they study English until they complete their formal education. Being able to communicate in English is perceived to be essential to success in the business world in China. However, because the language is

Chinese children in public classroom.

taught by poorly qualified Chinese teachers, students and most of the teachers are unable to communicate fluently in English

Education for deaf students in China was an area where I had particular interest. As we drove our van onto the playground of a middle school for deaf children, the children crowded around the van to such an extent that their teachers had to push them away in order for us to get out. The students were fascinated by my brown round eyes, brown hair, and white skin and reached out to touch my clothes and my skin. Some of the students were playing ping-pong, and I asked if I could play. One cannot imagine the reaction of the students as I played ping-pong with the deaf children. They laughed with glee and clapped their hands when I would make a point. Since they have great respect for older people anyway, I seemed to make a positive impression on the students because I could play ping-pong, which is a much-loved sport in China.

Though there is little formal training for teachers of the handi-capped and few materials available for classroom instruction, I

was impressed with most teacher's efforts and the warmth they showed their deaf students in this urban school. Children in urban areas have more opportunity for educational services than those in the rural areas. For example, the children in the deaf school I visited were taught sign language but those in the country, so I was told, do not have the opportunity of specialized training and educational services.

While visiting another school designed for mentally handicapped children, I learned that it was the only school in this city of a million people. In this school only children between the ages of seven and thirteen were permitted to attend school. There were no schools for children younger or older, nor was there a school for the non-ambulatory or profoundly handicapped individuals. There is much to be desired in school programs for handicapped children, as well as for those in the regular classrooms.

Home Life in China

Family housing is congested in China. During my travels I did not see a single dwelling that was designed for only one family. People live in dormitory-like compounds, and in the cities many people live in just one continuous building. With masses of people to shelter, minimum space is available for families. Each person has on the average of 65 square feet of living space. Houses are primarily constructed of masonry, two or three stories high and in rural areas these buildings formed a compound. A family will usually occupy one room with a bath down the hall, and if heating is available for the living quarters, it is provided by a stove, possibly using corn stalks for fuel. However, most families are not fortunate enough to have heat. Though electricity is available in many homes, it is much too expensive to use for heating; usually it is utilized only for a single light and possibly a television set.

According to governmental statistics, of the 1.2 billion people in China, there are 70 million who are poor with an average income of less than $7,000 in American dollars. Many of these very poor people live deep in the mountains in desolate cold areas, or on plateau regions in central and western China. Others who are

members of the 55 minority tribes are scattered in the rural areas of China. Though poverty is prevalent, it is estimated that seventy-five percent of the homes have television sets. Only 15 percent have washing machines; thus, the task for women of providing the family with clean clothes is laborious. Providing the family with food is laborious, though this task often becomes a family effort, with cooking continuing throughout the day in some compounds. Even though most rural Chinese have sufficient food for survival, their diet consists primarily of rice and white tea (hot water). The diet is supplemented with some fish, chicken, green vegetables and other items that may be available. I only saw two dogs and no cats in my travels because not only are the animals expensive to maintain, but may be used to supplement the diet.

When I went for tea at the home of a faculty couple, I discovered that they lived in one room in a boy's dorm and shared a bathroom with male students. The room was neat and clean in spite of the lack of a closet or storage area. For afternoon tea, I was served candy, millet chips, dried white fruit that was spicy hot, and something similar to prunes. It was a real sacrifice for this family to provide such elaborate refreshments for my visit. The couple had only one child, a four-month-old baby, who was wrapped in so many layers of clothes that I could hardly see its face. Chinese babies wear "split" clothes so when the child has to urinate the mother opens the hole in the back of its clothes for the baby to urinate in a pan. I was astounded that a four-month-old baby had been taught this body function and learned

This photo taken from my apartment window is typical of faculty housing on a university campus.

that diapers do not seem to be in vogue in China. A toddler or older child squats wherever he/ she is and opens this split in the pants or clothes to eliminate. Children could be seen squatting inside stores and on the streets eliminating, so I learned to step cautiously.

My first experience of spending the night in a home was in Shanghai, though it was with a couple from Canada who was living in a typical Chinese apartment. The small bedroom was sparsely furnished with only a bed and nightstand and no heat. There was no kitchen, but a wok and a hot plate were set up in a closet where breakfast was prepared. There was a small table in a hallway but no chairs, so I stood to eat oatmeal with apples, a wiener, bread and tea. It was my only American-style meal in my month-long stay in China.

In another home I shared a meal with a Communist Chinese family. The sparsely furnished home, which was above the quality of the average apartment, was owned by a couple with political ties to the government. This meal consisted of at least 15 dishes which included sweet orange soup with tofu, dried peanuts, rice,

Winnie visits in the home of a couple and their parents who are communist.

green vegetables, fish soup (with the fish eyes still in), thin fried pork strips, and a wonderful dish of beef on brown rice with husk. Since the mother was away on business, her two grown daughters prepared the meal, which must have taken an entire day. I found most Chinese to be gracious hosts, who make every effort to honor their guest with the best they have, even going beyond their means to provide a sumptuous meal and gifts.

The father of this home talked of his early days in China, of his political connections, of the economy, of his family, and of his desire to see one of his daughters come to the United States to study. (A common desire of most young Chinese that I met was to come to America). The father of the house presented me with numerous gifts, as did his daughter when we departed.

Later I was treated to an elaborate Chinese meal provided by the managers of a factory. The meal included various dishes with tofu, pig intestines, frogs, chitterlings, and marinated chicken feet. Since the skin of the chicken feet was tough, I just chewed on the chicken toes although I kept dropping them since I had little proficiency with chopsticks. The frogs were cut in quarters and I was only able to eat a small amount before my stomach went on strike. Later we were served tea in a pagoda. The managers of the factory were so gracious that they even peeled my banana and a mandarin orange for me to eat. I had not enjoyed so much attention since I had been in China.

While I was at the Jiangxi University in NanChang, I visited the open market, where most of the merchandise was placed on the ground. It was here that women came daily with their baskets to purchase food for their family. Without refrigeration, which most homes did not have, shopping was usually done daily. Everything from live animals, bird eggs, and fruit, to rough toilet paper could be bought at the market from peddlers, many of whom were women. People would gather around me to see what I was going to buy as I squatted over the merchandise. Sometimes the owner of the produce would provide me a stool so I did not have to squat. Chinese squat often and easily, and they recognized that I was not accustomed to squatting for very long. I bought mostly fruit, toiletry items and postcards and would

I often shopped at a market on the campus.

respond feebly with my "thank you" in Chinese. They laughed out loud at my attempt to speak Chinese and didn't seem to notice that I was embarrassed!

With homes unheated and temperatures ranging from 40 degrees at night to 70 degrees F during the day, people appeared to adapt to the cold and no one seemed to complain about the temperature. My little apartment was so cold that I slept with my socks on, long underwear, pajamas, and even a cap, plus snuggling under a heavy Chinese comforter. There were times during the day that I would go to bed with my clothes on to get warm. It was just too cold to even take a bath. My greatest luxury was a pair of battery-powered socks that kept my feet warm. One day I discovered that one of the interpreters who assisted me experienced great discomfort with the cold in his right foot. As a child he had experienced polio which resulted in his having to use a crutch and experiencing poor circulation of his foot. I gave him my battery-powered socks even though I was not sure that he would be able to afford additional batteries later.

During my teaching tenure at Jiangxi University most of my meals were brought to my apartment door in a thermos container. The bottom of the thermos container was filled with rice, while in the top tray there was usually a chopped up fish (bones and all)

sometimes bird eggs, green vegetable, noodles and sometimes a big round cookie. Each morning I, along with other faculty guests in the dormitory, received our allocations of two thermoses of hot water delivered to our door. As I walked on the campus, I met people with containers going to a central distribution place for their allocations of hot water. Water for drinking, which is scarce in many areas of China, has to be purified before use.

Women in the home have few opportunities of traveling outside of their cities or rural areas. When I flew to Beijing, I invited a female faculty member from Jiangxi University where I was teaching to accompany me as an interpreter. She had never traveled out of the city where she lived due to the cost of travel as well as the fact that few families have automobiles. This woman relished spending a few days in a hotel with a bath connected to the room. Visiting Beijing, the political center of China, eating at nice restaurants, seeing the China Wall, and visiting the Imperial Palace was a new and exciting adventure for her. She was so elated that she wanted to treat me royally. She wanted to carry my luggage, even my purse, would stand beside me as I sat on a bus, and sometimes would walk ahead of me to clear a passage for me in a busy crowd. It was difficult trying to express to her that, even though I was paying for her expenses, we were equal. Most women of China lack the privilege of traveling freely in their country and enjoying the good things their country has to offer.

Marriage for women in China is now based more on mutual love than the ancestral tradition of arranged marriages by a couple's family. In 1949 the feudal marital and family system was all but dissolved, and it is now estimated that 80% of marriages of women under 40 years of age are made by the choice of the couple. Today women can maintain their own formal maiden name and sometimes the children take their mother's name as well. Previously in old China men held surnames only, and most women who had no surname adopted their husband's name after marriage. Though divorce is an option for a couple, less than one percent of Chinese marriages ends in divorce.

There is also evidence of change in the rights of possession and the inheritance of family property. A male child is still favored due to the male's prominent role in society, and Chinese culture

has previously dictated that any inheritance from the family estate be given to a son. In spite of new legislation to provide for inheritance by females, culture often takes precedence. According to laws, however, men and women can now jointly own family property and in most cases, sons and daughters have equal rights to an inheritance.

Violations of Women's Human Rights

Violations of women's human rights are more visible in China than perhaps any other country in the world. With the government's restricting such areas as freedom of assembly and speech, there is retaliation against those who oppose governmental policies, especially for the women of China. For example, not only were the students in the Tienamon Square incident punished, but retaliation was shown to their families as well. Mothers and wives of the demonstrators for freedom tell of incidents of being harassed by the government for years because their relatives participated in the Tienamon Square demonstration.

When a mother of a 17-year-old son, who was killed at Tienamon Square, spoke out concerning the massacre, she and her husband lost their university positions, were subjected to house searches and interrogations, and were virtually placed under house arrest. One does not speak out against the communist government without consequences. Stories also circulate about women activists who have been beaten and harassed by Chinese authorities, and there are also reports about serious abuses such as female infanticide and the trafficking and sale of women.

Women who are imprisoned for political and/or religious dissent often experience torture and sexual assault. They live with harassment, periodic searches, surveillance, and detention. There appears to be little research to document these abusive conditions that women encounter, but reports indicate that the state-sponsored violence against women is common. Many such abuses go unreported due to the lack of networking for women in China and the tight control of information by the government. It is

reported that women's rights have been violated in the name of doing what is best for the Party.

These violations are not due solely to the harsh dealings of the communist government; the long traditions of a male-dominated society continue to play a major role in the subservient role of women. The Chinese communist culture, which has little respect for individual rights, has even less respect for the rights of women and children. It appears that, for the most part, Chinese women continue to be silent and thus accept what comes to them without voicing complaint. Some women are ashamed of the abuse they receive from their husbands and accept this disrespect as a way of life.

As was stated previously, although only 10 percent of the people of China are communist, the other 90 percent are tightly controlled by the communists. Citizens are unable to openly oppose the government without reprimand and would not even hint of dissatisfaction with the government. The fear of being accused of counter-revolutionary activity is prevalent and real. The government closely controls information released to newspapers and other public media; thus citizens are limited in receiving actual accounts of happenings in their country.

Before arriving at the Jiangxi University, I was told that the room of my apartment probably was wired for eavesdropping purposes, that my mail could be opened, that I was not to talk of politics or religion, that I must receive permission to travel, and that I should be careful about any comments regarding the government. It was necessary to obtain permission from the Foreign Affairs office even to fly to Beijing. I was even careful of what I wrote in my journal. I felt it necessary to take my journal with me most of the time, rather than risking someone reading my comments. These limitations on my activities gave me a new appreciation of the meaning of "freedom."

Many Chinese people do not have the freedom to choose their profession or job but are assigned to fulfill a specific need. While visiting a factory that employed more than half of its workforce with handicapped people, I had an occasion to talk with a Communist Party Secretary at the factory. I learned that if people are

Much of China vegetation is watered by hand.

hesitant about coming to work or are not working up to standards, he "persuades" them to do so. Chinese work with a big brother looking over their shoulder. When I asked teachers of the handi-capped if they experienced burnout in teaching the handicapped and often changed jobs, the response was "No, our teachers do not experience burnout." I later learned that even if they wanted to change jobs, it was not possible. People were assigned to teaching and factory and business jobs and that was final.

Since the People's Republic of China was established in 1949, some changes regarding women have been positive. For instance, in 1992 the government passed the "Protection of Women's Rights and Interests." A committee has been established to implement this law and to oversee the protection of the legal rights of women. Also, a law was passed in 1991 entitled the "Regulations on the Severe Punishment of Criminals Who Kidnap and Sell Women." Since then there has been a decline in the trafficking of women and children. The All-China Women's Federation is the largest non-governmental organization to safeguard the rights of

women. Though the government has passed regulations, lip-service seems to have taken the place of true implementation of some of the goals. With over 5,000 women's organizations existing in China, including female lawyers, judges, journalists and engineers, the prospect of parity for women is improving.

There is an obvious disparity between what the government says about women's rights and what actually happens. According to governmental documents, women have the same right of property ownership and inheritance as men; they have equal family rights (including the right of family planning); they have a right to an education, and they have a right of equal pay to men. However, this is not the story one gets when talking with the people. This is not the story told by women who leave China. It is not the story that comes from advocates of women's rights in China. Progress is being made but not as quickly as the government would have people believe. Human rights for women are advocated but in reality implementation is lacking. The government does admit there is much to be done in regards to the rights for the equalization of women, but improving the role of women must in no way create entities that might threaten party rule.

However, there have been some positive aspects regarding the status of Chinese women. Because women have made significant advances in their economic independence, there is a greater independence in other areas of their lives as well. With the earnings of women being about 40 percent of the total family income, they have gained more decision-making power in their families. In rural areas the income of women makes up an even larger percentage of the family income. A modern family is gradually replacing the patriarchal system with more equality; however, old traditions such as the role of women in Chinese society are difficult to erase.

Family Planning and Health Issues

China, with the largest population of any country in the world, faces the need to control its population, or starvation for many of its people may be eminent. Thus, the implementation of

its drastic family-planning program seemed necessary to curb some of the 20 million babies born each year. With China having only seven percent of the world's farmland and having to feed 22 percent of the world's population, control of reproduction seems to be critical to the survival of China's people. The average amount of farmland is less than 1/5 of an acre per capita thus creating a shortage of land for growing food. There is also a strain on housing, transportation, medical care and education causing the government to implement the most drastic family-planning program known today.

In order to curb population growth the government strongly recommends later marriages, later childbearing, and only one child per family. However, if a rural couple has good reason to have two children for farming purposes, there must be four years between two births. The government imposes heavy penalties on a couple if they have a second child, unless the first one is handicapped: for example, limited education for the second child, parents prohibited from working for the government, certain funds for the family may be eliminated, and other stiff penalties. Families will experience substantial difficulties surviving the heavy punishment imposed by the government and thus they do not have a second child.

Contraception is considered the primary means of birth control and the contraceptive drugs and devices are free, but so are abortions. Family-planning service stations have been set up to provide family planning sessions as well as health care for pregnant women, mothers, and children. Medical workers make home visits to provide childcare, to help in the prevention of diseases related to mother and child, and to keep meticulous records on the family. Since the implementation of the birth control measures in 1979, births have dropped from 5.9 children per woman to about two in 1995. Eighty-three percent of the women use some form of contraception, according to figures released by the government.

Along with such a massive birth control program come international concerns regarding abortions and infanticide of female babies. Male babies are still the preferred choice; thus, it is esti-

Because of the extreme cold, babies are wrapped warmly.

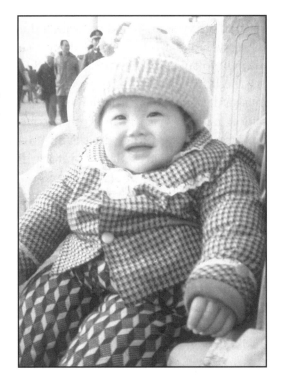

mated that five percent (1/2 million annually) of female babies die due to infanticide, sex-selection abortion, abandonment, drownings, or strangulations. With the early detection of the sex of a child, abortion is common. In fact, abortion is encouraged by the government, which advocates that it is one's patriotic duty to have an abortion if the person is already a parent.

Infanticide is also encouraged. A young woman tells that during the starvation years parents, particularly in the rural areas, had to "get rid" of girls to save the boys. Some threw them into the toilet, and others were simply abandoned. She tells the story that as a child she saw a decomposed baby's body swarming with worms by the roadside. One woman tells of her father's comment concerning her reading and mathematical ability while she was in elementary school: "Too bad," he said, "that you are not a boy." This phrase was repeated continually to the female child.

It seems that the government in their effort to control the population has failed to prevent the abuse of the female child.

With so many abandoned baby girls the female population is less than one half of China's population. The death of female infants is difficult to substantiate, but the belief is that it happens often.

Medical care in China is moving slowly forward, but with such masses of people it is difficult to minister to the health needs of 1.2 billion people. With little ground cover and throngs of people moving on the ground, dust is an environmental problem that causes a high degree of respiratory diseases and other health problems, and many people in the cities wear white masks to filter out the dust. Polio is another disease that has plagued many people of China. Recently, China has made great attempts with aid from world health organizations to inoculate its people from several major diseases, including polio. Health concerns and population control are not the only problems of the present, but without addressing them now the future of China is bleak. However, in implementing the imposed family planning program, a woman's freedom is limited in choosing the number of children desired.

Vocational Aspects of the Women's Lives

Most women between 15 and 54 are in the workforce. Women have come from the tradition of docile homemakers to employment in every conceivable occupation, such as factory work, education, medicine, agriculture, law, the military and a few in the political arena. Many women are overworked in factories as they sit long hours in tedious and tiresome work, producing such items as delicate embroidery. Most people work at tasks assigned by the Communist Party officials and do not, for the most part, have choices regarding their vocation. It is estimated that 45 percent of the total work force in China is made up of women, and women outnumber men in vocations like education, tailoring, sewing, handicrafts, work with leather products, and in printing.

In spite of the harshness of communistic rulers, the government has encouraged employment of women in China, even attempting to elevate the status of women. Whether their employment is due to the need for a greater work force or other reasons,

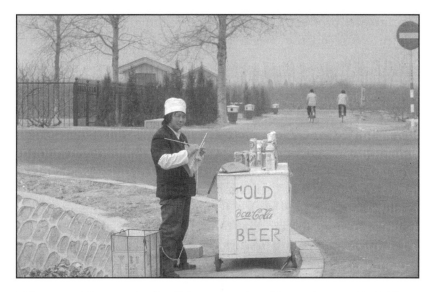

Woman, with a sign in English, entices tourists on the road to Beijing.

women are employed in most vocations in China. Because the country is obsessed with materialism, working women are viewed as a means to raise the family's standard of living. Although abuses continue to exist in China, the employment of women has risen faster in China than employment of women in most other developing countries.

Clothing is scare for the majority of China's people. Although many women living in cities dress much like Westerners with their short skirts, tight pants, high heels and stylish hair arrangements, the majority of women, most of whom are peasants, dress in plain, loose-fitting clothing, suitable for field work. For the most part, women wear their black, straight hair pulled behind their ears or cut slightly above the shoulders. Most women, I observed, seem to wear the same clothes every day to work.

Prior to 1949 women were not allowed in politics. Along with the elevation of the educational level of women came their emerging involvement in the political realm. The government made efforts to train women and promotes them in the political area since their skills would be beneficial to the development of China. With the involvement of women came a greater workforce and

thus greater productivity. As women began to demonstrate their ability to succeed, they began finding greater status in all areas of Chinese life.

While women work, their children are placed in governmental childcare facilities. As a result, social reorganization for the family has emerged because traditionally the child has been nurtured in the home. Now there are 450,000 kindergarten schools and nurseries where children are taught patriotism and group ethics by trained workers.

A vocation that has emerged during recent years for Chinese women has been in athletics. The women of China have come a long way—from the binding of their feet in the first half of the century to participating in world sports competitions at the end of the century. Since 1949 women from China have won more than half of the world's sports championships.

In 1957 Chinese high jumper, Zheng Fengrong, jumped a height of 1.77 meters to break the world record. Huang Xhihong, shot-putter, became the first Chinese woman to win a championship in track and field competition. Chinese women have won 44 world championships since 1961, when Qui Zhonghui won a world championship in table tennis. China's women diving teams have won 34 world championships with Gao Min, a Chinese woman diver, winning more than 70 gold medals and 11 world championships. In 1950, Yang Wenyi matched the world record for 50-meter free style in swimming and in 1992 six women won four gold medals and five silver medals at the Barcelona Olympics.

Chinese women have also performed well in volleyball, winning championships in world competition, and have also excelled in gymnastics, badminton, weight lifting, and speed skating. The government has sought to bring into focus its fine women athletes as a measure of public relations, especially since there has been worldwide focus on the issue of abuses of human rights within China. The strength of women athletes has brought national focus on China's women as role models, not only in China but in other nations as well.

Christianity vs. Atheism

Historically, religion was a strong influence in the lives of the Chinese, but with the arrival of Communism came the declaration of atheism. Religion was abated; its influence, however, especially as regards women, continues to influence the Chinese culture today. Even Confucius, who produced the major system of thought for China and provided the official ideology of China for many years, does not speak kindly of women. In his writing he says, "Only women and 'XiaoRen' are difficult to deal with." After Confucianism came Taoism and Buddhism, with Christianity and Islam coming at a considerable later time. It was these last four religions, however, that organized and built temples, churches, and mosques. Though most people seem to have related to Confucianism, Taoism, and Buddhism in some way, they were not necessarily devout adherents to any one school of religion. Thus, when Communism arrived in 1949, no one specific religion seemed to offer strong resistance to the Communist Party's move to disavow God.

Following the arrival of Communism in 1949 came Maoism (the chairman of the Communist Party, Mao Zedong). Mao explained that everything was to be "worshipped," but there was no god. In essence he was their god. He placed seventy million photos of himself over China and began the destruction of formal religion. Churches were wrecked or converted to secular buildings, slogans were painted on churches, and parking lots of religious building were used for storage. Christian leaders were persecuted and killed, but some of the immovable, oppressed Christians went underground.

In 1978 the constitution of China gave official support for formal religion in China but it also provided the right to propagate atheism. In 1982 the constitution allowed freedom of religious beliefs and protection of religious activity. Some churches have become active since then. When I was in China in 1990, the knowledge of these freedoms provided by the government had not filtered down to the local government or to most people, for I

was told numerous times that it was illegal for me to discuss Christianity. For example, on my first Sunday in China, I went to a Christian Fellowship in Shanghai, which the government sanctioned. However, those in charge of this "fellowship" or church, which met in a hotel, had been informed that Chinese people could not come to the meetings. Christians were informed that they must not even talk to a Chinese person about the fellowship or of Christianity, yet a government announcement that I read in a local newspaper stated there was freedom of worship in China. In another city, as I conversed with local people, I was told that I could not talk with them about my religion, nor could they own a Bible; however, if I were asked a question about Christianity, I could respond.

Though I was told that many Chinese hold underground Christian services, I did not witness these meetings. I did talk with several Chinese people about God because of inquiries about the sacrament of the Lord's Supper, the Trinity, and other aspects of Christianity. One woman learned of Christianity through other Christians in her city and wanted me to discuss various aspects of Christianity with her. Though this person told me that she prays regularly, she could not discuss her adherence to Christianity, even with her family, for fear of retaliation.

Ancestor worship plays a major role in some of the many minority tribes. For example, the Tujia people, living in the remote area of Human and Hubei provinces of China, live in two-story houses built of wood or brick and stone with a Chinese-style tiled roof. The main living area is a room for daily activities where their ancestors are enshrined and where the family gathers to worship these ancestors. Strongly revered in their ceremonies are the herbalist shaman, who performs chants and rituals to placate the dead and to protect the living from demons and ghosts. The Tujia worship many gods and believe that through works there is redemptive power. They also believe in the cultivation of human virtue and that people should return to agricultural communities to follow nature. Along with ancestor worship, there are various rites including healing and exorcism.

The Communist government says that there are approximately eight million Christians in China, but others establish the number at a much higher level. Regardless of statements released by the government on religious freedom, my experience tells me that freedom of worship, as I understand it, does not exist in China.

Searching for Parity

Though there have been immense advances in the last fifty years in the lives of the women of China, from the binding of women's feet to national political involvement, from 10% literacy to 70% literacy, from traditional homemaker to professional jobs and factory worker, there are still many injustices confronting the women of China. Women have advanced from being concubines and victims of polygamy and the sale of their children, to owners of land, proprietors of businesses, superior women athletes, women with educational opportunities, and upward movement toward equal employment. Perhaps these advancements have not come for the right reasons, but nevertheless progress has been made. The Communist government saw the opportunity to activate a new "work force" through women, and in order to fully utilize their potential it was necessary to educate and train women, as well as to raise their status in the nation.

Though the government has included many "equality" laws in their constitution, that does not preclude prejudices still existing toward women. Women and men both suffer in China due to the harshness of Communistic rule, which controls the freedom of individuals. All groups must be submissive to the ruling power and nothing shall preempt the authority of the People's Republic of China.

I have viewed China from an outsider's perspective even though there were many interviews with a variety of people living in China, reviewing articles in Chinese newspapers, and comments from those who have previously lived in China. Most statistics that I have used are those published by the Communist

government and are subject to scrutiny. Though it is difficult to document the extent of abuses and discrimination against women and children, especially female children, there is strong evidence that violations of women rights continue in China today. Even though advances have been made in many areas affecting the lives of Chinese women, there is still much that must be accomplished for women to receive equality.

5

Haiti and Its Struggling Women

It was in Petit Guave that a young Haitian woman robbed us. Joanna, my companion, had been reluctant to stroll in this unfamiliar village, even on a Sunday afternoon. I certainly knew that two American women in their 50s could be victimized, but the enchantment of a new adventure caused me to insist on the walk.

Our journey took us through the narrow bending streets where small lean-to huts and open-air selling-stalls were filled with Haitians seeking relief from the sweltering heat. There was no traffic so the streets became a gathering place for the community. Families and friends chatted with neighbors. As we approached, however, they stopped their conversation and became motionless. Children pointed and laughed at our paleness, while adults gaped as we walked down the middle of the street.

As we finished our walk and began to make our way back to our temporary residence, we realized that we were lost. Without knowledge of the Creole language, it was impossible to ask for directions, so I uttered a nervous half-laugh. Joanna suggested that I control my laugh as the people might assume that I was directing ridicule at them. I summoned my courage as we moved forward, longing for a sign that would direct us to our residence.

Already struggling with anxiety due to being lost, a young native woman approached us aggressively. Even without understanding her Creole words, I readily became aware that we were being robbed. Eager to be cooperative, I placed my hands over my head. Haitian people, not more than thirty feet away, quietly observed the vulnerability of these American women but offered no assistance.

The woman did not appear to have a weapon, but I was frightened. The young robber groped at Joanna's clothes, rummaging through her pockets but found nothing of value as we had left our possessions at our residence. As she looked at me, I turned my hands outward, trying to indicate that I had nothing of value with me. Appearing disgusted, she immediately turned and disappeared into the crowd.

Quickly scanning the crowd of Haitians who were silently observing the event, we cautiously continued our journey. Within a short time an American missionary driving a truck along the crowded streets saw our dilemma and escorted us to our residence.

Haiti, a Destitute Country

As I arrived in Port-au-Prince, Haiti, I observed masses of people in poverty and chaos in this most deprived country in the Western Hemisphere. I discovered a harsh, uncompromising, and frightening society which had been governed largely by dictators who showed little interest in the welfare of the people.

Joanna and I were arriving in Haiti to spend several weeks observing and assisting missionaries who worked there. As we departed our plane and hurried through customs, I experienced a run of anxiety. An official grabbed a box which I carried and sliced it open with a sharp knife. When we could not readily produce keys to our suitcases, we were sure he would cut open the suitcases as he had the box. With loud shouts and apparent disgust with our inability to produce keys, he simply waved his arms and threw our luggage aside. A young boy grabbed our luggage and moved it some thirty feet closer to the exit. I at-

tempted to give him a dollar tip, but he shook his head. I thought, "How nice that he is doing this for free." I realized my naiveté when he held up five fingers and I realized he wanted a $5 tip. I could only come up with $4, so he grudgingly settled for that amount.

As quickly as the luggage was placed on the floor, four or five other young boys rushed up to us, pleading with us to let them help with our luggage. They were boisterous, loud and demanding, acting as if their very lives depended on our tip (and perhaps it did). Fortunately, some missionaries arrived just in time to assist us with our luggage and we quickly departed the airport.

I learned that Haiti, which is a country about the size of Maryland, abuts the Dominican Republic, and together they form the island of Hispaniola which is positioned between Cuba and Puerto Rico. Haiti is only 700 miles south of Miami; and its name means hilly or higher ground, which is descriptive of the topography rising above the Caribbean Sea.

Port-au-Prince, the capital, has over 1.5 million people. The presidential palace, a symbol of the best of Haiti, is surrounded by shanties, children with bellies bulging, and a mixture of unfamiliar odors and noises. Streams of people flow endlessly through the streets to provide the highest population density of any city in the Western Hemisphere. The image that comes to mind is bees in a hive.

As we traveled through the city, I found traffic was congested due to the streets jagged with potholes and the bumper-to-bumper traffic. Small, dilapidated buses, covered with designs of bright, showy flowers and boldly written scripture verses, were overloaded with passengers dangling precariously from the sides and on top. Horns blew incessantly at every turn, especially at intersections where traffic lights were nonexistent. I observed only a few traffic lights in all of Haiti. With all these impediments, traveling ten to fifteen miles would usually require at least an hour.

Walking in the city was an adventure. The treacherous, dusty streets were paved just in the center of the roadway with dirt areas on the side. Sidewalks were primarily a dirt pathway. Open

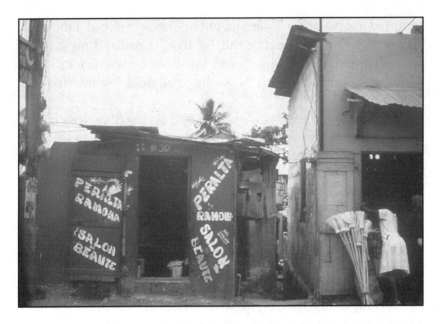

Beauty shop in Port-au-Prince, Haiti.

sewers, strewn garbage, throngs of people loitering, and shabby open air businesses were abundant. Crossing streets without a traffic light was a challenge.

Some people, especially the women and children, stared at us while others continued with their tasks at hand. Viewing the city and all its poverty gave us a better perspective of its effect upon women.

We observed the lush, green, fertile meadows filled with coffee bean plants and sugar cane, and we saw how the fruit trees and sisal (a source of twine) inched up the steep slopes. With the slopes so steep, we learned that farm workers anchored ropes around their waists and lowered themselves from the top of a mountain to till the soil on the mountainsides. Doctors that we visited with told us that some of the most serious accident victims they treated were those individuals who had fallen from the hillsides while tilling the soil.

The home of missionaries James and Tilla Peak was to be our headquarters while we were in Haiti. The house was located on a peak high above the city of Port-au-Prince. A snake-like road of

rocks and almost continuous potholes led us to the residence, which housed two families. It was a large, sparsely furnished house, with a captivating view of the Caribbean Sea, mountains, and a rambling coastline where ships sluggishly floated to port.

The Haitian Woman's Living Conditions

Life has perpetually been difficult for the Haitian woman due partially to the apparent lack of initiative or concern of Haitian men. Life for most Haitian men is characterized by drinking, trekking over the countryside, or loitering in the streets. The average man, as I observed, lacks motivation and ambition for providing necessities for his family. He does break the soil for planting, but thereafter most of the growing and harvesting of crops is left to the women.

Until the reign of the Duvaliers (1971-1996), women were protected from political violence, but during that reign of terror women were no longer protected from political horror. They experienced rape and torture and were killed for just being a member of a family that in any manner had views in conflict with the policies of the Duvaliers. It was a disadvantage to be a woman during their reign. Neither were old people and children excluded from the atrocities of this regime.

I came to realize that the Haitian woman's life is one of illiteracy (more than half cannot read or write), deplorable housing, few opportunities for jobs, poverty, low status, and physical and sexual abuse. In no country in the Western Hemisphere do women fare worse than do the women in Haiti.

Housing for the Haitian families usually consists of one or two rooms, sparsely furnished, with as many as ten people residing in one house. I was appalled to see houses that consisted of four poles and a tarp or those of straw-stick-mud construction with thatched roofs. Some of the shacks, which were spaced about one foot apart, consisted of tin roofs, stone and mortar sides with doorways but no doors. Many homes were simply cardboard lean-tos.

In sharp contrast to this poverty, though, I found a relatively small area of Port-au-Prince with attractive and substantially built

Typical housing for most Haitians.

houses surrounded by lush gardens of bougainvillea and hibiscus. These were residences of the elite of Haiti, perhaps four percent of the population.

As we drove through the streets, we observed women, some with their breasts exposed, taking baths by showering with a water hose in their yards or on the street. Also, it was ordinary to see women squat in the street to urinate. We saw women washing their clothes while bathing in the river, others washing clothes in pots near their houses or on the streets and stretching them on stones or bushes to dry.

Adding to the work of the women is the fact that water is in limited supply. Wells have been dug throughout Haiti in strategically located places where women and children come to secure water for the home. It is not unusual to see many women and children gathered around the pump waiting their turn to fill their containers; in fact the well serves as a gathering place.

The first time I took a shower at the Peak's house I soon discovered that hot water was available only in the afternoons. The water pipes on top of the house were heated by solar energy, and once that water was used, there was no more hot water until the next day, so I learned to shower with cold water. However, after I saw that the majority of the Haitian women did not even have a shower, I never complained about cold showers again.

These cold showers were welcome, though, after we suffered through the suffocating heat that greeted us most days. It was May and I had not anticipated the intensity of the heat. Electric fans were available, but because we spent some of our time in places where there was electricity for only a few hours a day, fans were often useless. Again I realized the contrast in that many Haitian women do not even have electricity, much less fans or air-conditioning.

On a visit to the small town of Petit Guave, not only did we have to withstand the extreme heat but the tarantulas as well, tarantulas that grow as large as one's hand. I observed them crawling on the windows and walls and creeping along the ground. I was cautioned to be alert for them, especially in the bathrooms, since they seek water. I did not forget. At night when there was no electricity I scrambled in the dark for matches and lit a lamp. Tarantulas are just one of many hardships that a Haitian woman has to deal with in the home.

One of the reasons Haitian woman struggle with financial insecurity is due to lack of opportunity for work. Unemployment in Haiti is about 75 percent, and most of those who are employed are men. A woman from the elite class might secure a position as a schoolteacher or a position in a government office, but most of the elite women are unemployed and remain in the home. The peasant woman is delighted if she can find a job as a maid or cook in a residence which could pay as much as $60 a month. Women, particularly in the urban areas, become prostitutes. Most are paid about $1.75 for sex; however, a virgin receives as much as $5.00. The average salary for a Haitian is about $375 a year.

Women also receive a small income from selling their products. Country women come to the city to sell small quantities of vegetables and other farm produce alongside the urban women. Selling stalls consist of tables similar to what we would find at a flea market, or the produce is placed directly on the ground. Unwrapped fresh meat and fish, with no refrigeration, is a feasting place for flies and other insects. Piles of rice, fresh vegetables, native fruits, sugar cane, and live chickens are available. Household items for sale included soap, bolts of cloth, hand-crafted items and woodcarvings. Vegetables and meats bought each day

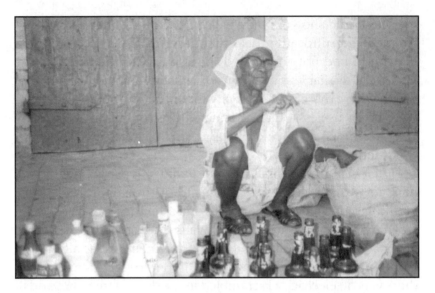

Women sell anything, even old bottles, to earn a little money.

by the non-Haitians must be soaked in a solution of water and bleach to remove contamination.

Our most exasperating shopping trip in Haiti was to downtown Port-au-Prince to shop for the mahogany vases we especially wanted to buy. We parked our vehicle near venders who were hawking their vases on the street, and by the time I had walked thirty feet I was surrounded by four men trying to sell me mahogany carved wares. For more than thirty minutes Haitian men shrieked loudly begging me to buy their products, pulling my arms and directing me toward their little piles of merchandise. On one occasion there were at least ten men clamoring at me simultaneously. I became so infuriated at the invasion of my space that I screamed and hastily made my way to our jeep. The sellers followed me, sticking their items in the window. Frightened at their intrusion, I rolled up the jeep windows and looked away. Women of Haiti were never so aggressive in selling their products.

Because I wanted desperately to walk freely among the people, one morning at dawn, I persuaded the gatekeeper of our compound to unlock the gate. The man was hesitant about my walking alone but finally pushed opened the gate and I was on

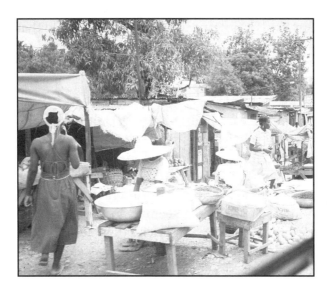

Women sell merchandise from small handmade stands or off the ground.

my way. I was apprehensive about being on the streets alone and not speaking Creole, but I wanted to observe the Haitians' way of life at the beginning of their day.

People were just beginning to stir. Most women in their soft, loose, faded clothing just stared at me, which made me a little uncomfortable, but I was getting used to being a curiosity. I assumed that some women were preparing for an early meal while others were setting up their market paraphernalia for the day. Some women spoke or nodded a greeting, but a few disregarded me, as did the woman who stopped to urinate on the street just in front of me.

I observed an old man either meditating in his front yard, reading or praying aloud. I saw children at play on the streets, as there were almost no yards. As I watched the children, especially the girls, I knew their future was as bleak as their mothers' had been. Little hope exists for these girls unless drastic changes are made in their country.

Most of the Haitian people were friendly and gracious to us, curious about our American clothes, light hair, and white skin. The Haitians' color ranged from a rich, dark black to very light skin—generally, the lighter the skin color, the higher one is in the

class system, although this is not true in every case. I was told that some of the prominent officials of Haiti are very black.

Education of Women and Children

Education does not receive a high priority in Haiti, especially for women. Only 47% of the women are literate as compared to 59% of the men. The peasant women, even from childhood, labor in the fields, perform domestic functions, and transport food to market. This leaves little time for children to attend school.

As I visited numerous schools it seemed to me that most teachers are dedicated to teaching, but lack adequate training, have few supplies or equipment, and in most instances teach in less than adequate buildings. Most everything in Haiti is substandard, and schools are no exception. I did not observe discrimination between boys and girls, but the literacy discrepancy between men and women clearly indicates that discrimination does exist.

One of the schools we visited was a remote mountain school located in the vicinity of Petit Guave at Verger. Before our journey began, our guide, Rev. Roux of the Wesleyan church-school, gave us a tour of his coffee crop and provided us with a pungent bag of unrefined chocolate-brown coffee beans. Because there was no road to Verger, which was miles into the mountains, we drove about a mile to the base of a range of mountains and parked the vehicle. We then climbed a rugged trail the rest of the way.

Scaling the mountains to arrive at the school was a long, hot journey. It was a rugged hike with cascading vegetation fanning us as we climbed the winding trail. When we paused under the shade of trees, we could see the Caribbean Sea dotted with vessels and small islands roofed by foliage. Wild blossoms filled the air with their sweet aroma.

An elderly, barefooted Haitian woman caught up with us on the trail, carrying a full carton of twenty-four soft drinks in a wooden case balanced precisely on top of her head. This is a customary method of transporting heavy loads. We were apparently moving too slowly up the trail for her, so Joanna and I exchanged sheepish glances as we stepped aside so she could continue with her journey.

We met a schoolgirl coming down the hill, and Pastor Roux asked why was she walking away from the school. Her answer was that she had not been in church the previous Sunday so she could not attend school on Monday. This was an inflexible rule by the church which had authority over the school . . . no church on Sunday, no school on Monday.

As we continued upward on the trail, we approached several huts that were residences for some women parishioners of Rev. Roux's. These women, wrinkled beyond their years, wore dingy, shabby dresses, which hung almost to their bare feet, and pieces of white cloth bound around their hair. One lady wore the cloth in the fashion of a turban and had placed a man's hat on top of it. The pastor translated our greeting to the women, and we were invited to sit on the porch of one of their one-room straw roof-huts. The unpainted chairs, which were crudely hand-carved, offered an invitation to rest, which we could not refuse. Our faces were blazing red from the heat, our legs wobbly, and our bodies exhausted from the climb. We relaxed with their bony, yellow dog lying nearby on the gray, stone porch floor and mostly sat and smiled at each other. They offered Pastor Roux a drink of water but did not offer one to us. We could not have accepted anyway because of the risk of contamination.

After a brief rest we continued the journey. We soon came upon a small clearing where the ensnaring tropical forest had been cleared. We found three women standing near a huge, black pot that reminded me of my mother's wash pot when I was a little girl. They were the "lunch room women" who provided a noon meal for the children at the school just a short distance away. This pot, ordinarily with a fire built around it, was the "kitchen" for the meal: however, the previous night's rain had left the ground boggy so the women were unable to get a fire started. There would be no noon meal today for the children, but school would continue anyway.

Only a few hundred feet up the trail we finally came to the Christian church-school, a building which was used for church on Sundays, and a school on weekdays. This building of concrete block, approximately 30 feet wide and 50 feet long, was the schoolhouse for 240 students and 9 teachers. The children had

*While climbing up to a mountain school, we rested on the porch
with Haitian women.*

*Some children attend classes outside due to the lack
of a school building.*

hiked for miles through the mountainous areas to attend this school.

The children, some gaunt, others apparently healthy, sat on dirty-gray wooden boards with no backs, jammed as close together as books on a bookshelf. All the children were taught in this one building, except the kindergartners and first graders, who sat outside under a tin roof covering. Three school sessions were offered per year with a cost of $3 per session for each student. Electricity was unavailable, as were school supplies or furniture. I saw only one broken chalkboard propped against a wall for the teachers' use.

After we observed the classes and met with the teachers, we began our relatively effortless return journey down the mountain. The descent was twice as fast as the ascent.

Lack of quality education is one of the keys to Haiti's dilemma. Education would give women a greater chance of overcoming extreme poverty and degradation that daily confronts them. It would enable them to comprehend the necessity of good nutrition, of health care for the young, and of caring for their bodies; in short they could learn to better maximize their potential.

Voodoo—The Real Religion in Haiti

Roman Catholicism is the official religion of Haiti and is practiced by the elite, but the peasants practice a combination of Catholicism and vodum (voodoo). Voodoo has no formal theology or town church, no regular habit for priests, but it appeals to the uneducated and has been practiced since most Haitians were imported to Haiti as slaves from Africa. Voodoo teaches that sickness or disease is the result of evil or mystical magic placed on the individual. The evil spirits must be appeased by magic or removed by exorcism or other means. Voodoo adherents trust in many gods, make animal sacrifices, relate to the supernatural, and participate in self-induced mythical seizures. Vodoo is based on the belief that the dead may return to control the living.

When Haitians accept Catholicism or Christianity, the tenants of voodoo are not easily cast aside. The result is a strange fusion of

dogma that permeates the religion of the Haitians. The 500 plus Christian missionaries, who through the years have introduced Christianity to the Haitians, offer not only the gospel to these people but introduce a new, and hopefully, better way of life.

Listening to missionaries tell of leaving the U.S. to work among the Haitians makes one aware of their sacrifices. One missionary said that before she came to Haiti her mother charged her with loving the heathen better than she did her own mother. Another missionary said her father told her if she went to Haiti as a missionary that she was never to come home again. Many years later when her father was near death, he repented of his comments and offered financial support for the cause.

Another missionary left the mission field in Haiti to return to the States for retirement, but the urgency for presenting salvation to the Haitians caused her to reconsider retirement. She returned to Haiti, to the people who needed her. She said she could not forget Isaiah 57:10, which says, "Feed the hungry! Help those in trouble! Then your light will shine out from the darkness and the darkness around you shall be as bright as day" (The Living Bible).

These missionaries offer hope to the Haitian women who have known only desolation. Christianity elevates the status of women not only through the presentation of salvation but also through social, educational and medical services provided by the missionaries. Women are given a new respect for life and for themselves as they learn of God's love for them.

Reality in Haiti's Health Issues

One of the major aspects of missionary work in Haiti is the training of women in health and home care. Most women never see a doctor, even during pregnancy or delivery of their babies. The birth rate in 1995 was 4.8 children per woman with a death rate of 13% for children under five. Sexually transmitted diseases are rampant with only 10% of women using contraceptives. We were able to visit two clinics, one in Petit Guave and the other on the island of La Gonave.

Visiting the medical clinic at Petit Guave that served some of the families of the school children at Verger was an enlightening

experience. One missionary nurse trained ten Haitian people to assist her in a medical clinic. With limited facilities, these individuals were performing a mammoth task. They were administering physical examinations, taking x-rays, performing lab work, and filling prescriptions. What this one nurse and her assistants were doing would require many physicians, nurses and lab assistants in the U.S.

The Haitians who required treatment in the clinic would arrive at dawn to receive a membership card, which cost one dollar. To receive a membership card, the patient had to attend a six A.M. chapel service to hear the story of Jesus. Those receiving a card would stand in line six or eight hours, waiting their turn to be examined. I observed on one occasion approximately seventy-five people patiently waiting outside the building to receive treatment. There were crippled children, sick babies, old people with gaunt eyes and feeble motions, and many adults who sat with their heads in their hands.

The clinic was a small building, about 40 by 60 feet, which included an examining room, a pharmacy, a recovery room, an x-ray room and a windowless, dark room which contained ten boards positioned on the floor where seriously ill patients could lay. Within this room was an area with a fireplace where a member of the patient's family was allowed to cook for the patient. Patients not so ill normally waited outside for their turn to see the nurse. There was no other medical service available.

My second contact with a clinic/hospital was at La Gonave, an island about twenty miles out in the Caribbean Sea. Joanna and I were to observe and assist with routine tasks in the hospital. We had been forewarned of the 20-mile ride through the sometimes-treacherous Caribbean Sea in a small boat. However, when I saw the 25-foot, crudely designed wooden boat with a 30-horsepower motor and a sail, I momentarily balked. Because of the warning about the possibility of encountering a rough sea, we had taken motion sickness pills for the journey. The pills, plus the heat, made us so relaxed that we reclined on the seats of the boat and used umbrellas to reflect the sun. Other than being splashed by the waves and enduring the heat, the journey to La Gonave was uneventful.

Upon approaching the island we observed mountains of succulent greenery, rocky cliffs, and white beaches. Haitians were wandering along the shores, which were dotted with small fishing boats and straw-mud shanties. It felt good to step on solid ground and walk under the palm trees that were bending with the wind.

La Gonave, an island of 70,000 people, had few roads for the eight or ten cars on the island but numerous trails for donkeys. The parking lot near the hospital was filled with donkeys that had transported seriously ill patients to the hospital. Some patients had ridden donkeys or walked up to twelve hours to arrive at the hospital. I did not see an automobile on the island but observed one motorcycle.

The hospital at La Gonave consisted of one large ward, some examining rooms and a staff of two doctors and five nurses. Supplies were limited. The pediatrics examining area consisted of a dirt floor with a lean-to shed and a table for the nurse. The babies or children, who came with their mothers, wore no diapers, so you could readily see the preference for the dirt floor. At the end of the day the workers used a shovel to clean the area just as we would use a broom. We noticed that mothers would place their children under a nearby water faucet to keep them cool while they were waiting to be examined by the nurse.

While at the hospital I met a medical missionary couple, Dr. Ben and Helen Sampson. He, a physician, and she, a nurse, had been missionaries to Haiti for 36 years. Dr. Sampson, whose skin was yellow from bouts with hepatitis, said he usually sees 600 patients a week at the clinic and that he normally treats about 500 patients a year in the 36-bed hospital. Illness unique to women included uterus, breast and stomach cancer. Common illnesses for both men and women were tuberculosis, typhoid and different types of cancer. Seldom did Dr. Sampson observe cardiac problems, ulcers, colitis or diverticulitis. He attributed the lack of these diseases to the diet and relative calm life-style of the Haitian people.

Mrs. Sampson, a pediatric nurse, also taught health classes for mothers on nutrition, prenatal care and child care. These classes presented a new concept of motherhood for the Haitian woman.

Mrs. Sampson also trained young Haitian women to be leaders in health care. After 36 years in the mission field in Haiti, Mrs. Sampson knew that she would soon be required to retire, and she hoped that the local women would continue teaching health care.

There was an epidemic of malaria while we were there, and a missionary's daughter who was experiencing a severe case of malaria came from the mountains to live in the building with us. We had been inoculated for malaria and I prayed the shots would be effective. We also observed several typhoid patients (some with very high fever), a child with severe boils, a diabetic whose foot had been amputated, a pneumonia patient, and a person paralyzed by unknown causes.

After arriving at the hospital the patients were required to attend a chapel service, as were those at the clinic at Petit Guave. On the first day there we observed over 200 patients who, after receiving their medical card at the chapel, stood (or sat) in line for up to 12 hours to see the medical staff. On our second day there the medical staff examined 265 patients, a record number for one day. Patient loads of this magnitude required the staff to work 14-hour days, which is remarkable since three of the five nurses and one doctor were over 70 years of age.

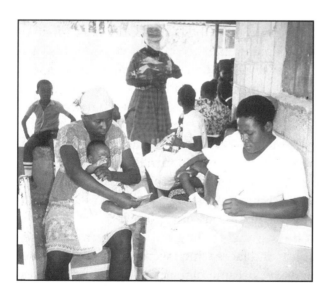

A nurse attends to medical needs of children at clinic.

One afternoon while I was on the hospital grounds, a young woman approached me. She held a bloody towel over her face and was obviously in intense pain. I was unable to communicate with her or her companion, but I knew it was an emergency. I directed her to the physician's office where he performed surgery on her face. I learned that another woman with whom she was fighting had bitten the woman's nose almost completely off. Apparently it is not unusual for a woman to disfigure another woman when the two women are fighting for the affection of a man.

Dental health care in Haiti was in as much chaos as other medical services. In conversation with a Haitian dentist I discovered that he had developed his skill through reading books and had no formal training at a university nor any supervision in his training.

Before leaving the island we walked the beach, inhaled the refreshing sea air and made photos of children. One child in particular caught our attention. As we approached, she ran into her hut to hide from us—or so we thought—but she reappeared with a clean dress, smiling to pose for a photo. Another small, gaunt child sang to us as she minded a pig that was tethered to a tree.

When the time came to leave La Gonave, we boarded the same open boat that had brought us to the island. Only the captain of the boat and another Haitian man accompanied us on this two-hour sea voyage and, since neither of the men could speak English, there was no conversation on the voyage. With our luggage secured in the boat, we settled in for what we hoped would be a restful sea voyage. The sea mist on our faces was refreshing. However, ominous clouds in the distance would soon produce disturbing winds and rain and turn the sea into a rolling, bellowing monster. When the storm hit, the whitecaps grew and the boat began to roll. At first the tossing was not too severe, but I quickly realized this was not just a spring shower.

The mist from the sea was cooling but the salt from the sea began burning our lips and faces which were swollen and tender from the heat. The waves became higher and we found it neces-

sary to hold onto the narrow seats to keep from being tossed out. I knew we were in trouble. Wearing a life jacket did not provide the security I wanted, so I found another life jacket to sit on. I could not hold onto it though, for by then I was being tossed from one seat to another. The Haitian captain motioned for us to change our seating. He placed us strategically in spots on the boat to give balance. It was impossible, however, to remain in just one spot. The second Haitian man was tossed almost in my lap and in an attempt to right himself, he grabbed my leg. At other times I would have been outraged by such a move, but at a time like this we were simply trying to survive.

If only the captain of the boat could have told us whether he had experienced this kind of storm before. He took the sail down and tried to maneuver the boat directly into the waves, cutting the motor off and on as each wave struck the bow of the boat. I knew that if one of the gigantic waves came inside the boat, we would sink.

In the midst of the storm I observed Joanna crouched in the bottom of the boat and shouted, "Joanna what are you looking for?"

"My purse," she said, "so I can get my lipstick."

"Joanna," I said with a nervous chuckle, "where we are going God will not care if you have lipstick on or not!"

"My lips are burning," she shouted back, "and the lipstick will help."

Actually, I thought, I could use a little lipstick myself.

I was acutely aware that any moment a big wave could fill our little boat with water and sink us, so I promised God if He would just get me through this one I would not be so adventuresome again. The storm lasted for what seemed like hours but I am sure it was probably only 20 or 30 minutes. I waited for the "calm after the storm," but it never came. After the peak of the storm, the waves were still boisterous. Even when we tried to dock at the usual place, the waves were too rough, so we had to travel north to find a docking area that had better protection from the rough seas. It was rather difficult just getting out of the boat but land never looked so great. We had scraped knees, churning stomachs, and wobbly legs as the result of our experience. That was the most

excitement I'd ever had for a $25 ride, and we knew it would be a long time before we took another trip at sea in a small boat.

Women Predestined to Hardships

Haiti, with beautiful sea shores and mountains, lush green fields and swaying palms, is exhilarating, yet it is difficult to get beyond the poverty, devastation and drabness at every turn. The lack of a workable infrastructure, deficiencies in the political system, substandard housing, and inadequate education and health care systems places the country in a frightful situation that is difficult to overcome. Missionaries and other humanitarian workers strive to provide a better way of life but progress is slow.

Life is indeed hard for the Haitian, especially for the women. But one will find kind, generous women who bear their hardships with great spirit. Hope for a better life is dim, yet they are proud of their meager possessions and livelihood. Living in shacks and toiling rocky and sometimes infertile soil does not deter their spirits. There is warmth and love in their care for each other, and they mostly accept their fate in life with whatever dignity they can muster.

Haitian woman prepares food for her family.

6

Albania:
Women Digging Out
of Tradition

Soon after I arrived in Tirana, Albania, to serve as educational consultant, I observed a little girl sitting in a brown cardboard box on a street corner. This little girl, who looked to be less than 2 years of age, was there on cold, rainy and windy days as well as on hot sunny days. At other times I saw her crying loudly, and I saw her sleeping with her head dangling to one side of the box. Sometimes I observed her eating an apple that shoppers had tossed into her box along with coins. By the close of a day many coins had accumulated in the box. Either her legs were bound or she was paralyzed because I never saw her trying to crawl out of the box.

Once I observed a young woman seated on the pavement near the child. I was told she was the mother and that she was usually drunk or drugged. I was also told that children are sometimes deliberately crippled so they can be placed on the streets to beg. How could such abuse happen, day after day in Tirana, the capital of Albania? It happened because there is no childcare agency or law to prevent the exploitation of children—part of the aftermath of fifty years of Communism.

Albania, the Poorest Country in Europe

Albania, one of the European Balkan countries, is the poorest country in Europe, about the size of Maryland and located across the Aegean Sea from Italy and bordered by Greece, Macedonia and Yugoslavia. Approximately nine million people call themselves Albanians, even though only about one-half of them actually live in Albania. Following World War II, the borders around Albania were drawn in such a manner that half of its citizens found themselves living in Yugoslavia. Even after fifty years of isolation from their mother country, these Albanians would like to be reunited with their country, and it remains a critical issue with the Albanian people.

Even though Albania is the poorest country in Europe, it is a beautiful and fascinating country. There are rolling farmlands with fields of yellow mustard huddled at the foot of rocky mountains; there are sprawling green valleys with flocks of grazing sheep tended by shepherds; there are numerous goats with their jangling bells; there are rushing streams that flow into the Adriatic Sea; and there are the silver-leaf olive trees clinging to the hillsides. One of the hopes for economic development in Albania is to entice tourists to enjoy the splendor and tranquillity of this virgin country.

Distracting from the splendor of the landscape, however, are thousands of inoperable automobiles cluttering the roadsides, silent factories, abandoned greenhouses, loitering men, scattered debris, substandard housing, continual blowing of automobile horns, and the congestion of automobiles, trucks, wagons, motorcycles and bicycles. Because of leaking water lines, there seems always to be puddles of mud and water in the streets. If one can get beyond these unpleasant features, Albania is a land of enchantment.

The Impact of Communism on Women

Many changes came to women under the rule of Enver Hoxa beginning in 1949; a harsh and dominating Communist leader

who was appointed dictator shortly after World War II. Some of the changes were positive, but others were devastating. During his 50-year regime, he drastically altered the lives of the Albanian people, banning religion, forbidding travel, outlawing private property, banning imports and exports, and isolating Albania from the rest of the world. He even severed relations with his Communist comrades in Yugoslavia, Russia and China. Hoxa developed a homegrown style of Communism that brought terror and agony into the hearts of the people. Albania, in essence, was in captivity.

On weekends Hoxa transported urban people to the countryside to build railroads, cultivate land and construct bunkers—a total of 700,000 bunkers, most of which remain scattered throughout the country. These bunkers—small, round, two-foot thick concrete structures—served as defense shelters for two people. They were built to protect citizens from an anticipated invasion by the Western world. Hoxa told citizens that Albania was the most successful and prosperous nation in the world and that the potential of invasion was imminent. After Hoxa's death, however, the people discovered they were not the most affluent nation in the world, but were indeed the poorest country in Europe. Today these useless bunkers are visible in cities, on the seashore, in people's yards, in fields and pastures, and all along the roads. No place in Albania was immune from the construction of these bunkers.

Prior to the communist reign, eighty percent of Albania's population consisted of poor peasants and field workers, while the remainder of the people were professionals—educators, merchants, and bankers. With the event of Communism, women who had previously been confined to farm labor were now viewed as a vital source to fill professional jobs. This change in philosophy created a new, completely untapped work force.

With the implementation of democracy in 1991 Albania is making substantial progress toward civil and political rights. There has not been sufficient time to erase the serious human rights violations, such as police brutality, lack of freedom of speech, discrimination against women, corruption of the legal

system, and high unemployment. Today it appears that most of the people of Albania are struggling with disorganization, corruption, and poverty. Freedom arrived in 1991 but not without a price.

With the rise of Communism, revolutionary changes occurred in the life of Albanian women. Women who were illiterate and regarded as chattel under tribal law were now being ordered out of the home to be educated. Even the old women in the rural areas were taught to read, thus raising the level of literacy from 10 to 90 percent over a period of 50 years. Hoxa encouraged women to overcome their conservative attitudes and develop new interests in life. He said, "Anyone who tramples on women's rights should be trampled into fire." The law stated that not only were women to have parity in the labor force, but they should also have equality in education and in family matters as well. There was, however, considerable resistance by men to these drastic changes, especially when women were assigned positions that had previously been occupied only by men. During Hoxa's reign, he saw that a third of the Communist Party members were women.

Two widowed Muslim women.

Even though Communism attempted to bring parity to women, the long tradition of the subjection of women could not be erased in fifty years. A few of the changes that occurred under Communism remain, while other changes are obsolete. For example, under Communism, women were encouraged to have many children, but presently women are limiting the size of their families and lobbying for reproductive rights. Also, abortion was illegal under Communist laws, but now women abort babies on the average of one every two years with more babies being aborted than surviving. Finally, under Communism, couples seldom divorced, but now divorce is on the rise. Women, many who view divorce as an escape from abusive relationships, initiate about 70% of divorces.

With the collapse of Communism came the closing of state enterprises, resulting in unemployment for masses of people, but it created the beginning of a free market system. For the first time this gave women an opportunity to open small business such as snack bars and various retail stores. The fact that they knew little about the free market system did not prevent them from delving into the business world. In fact men have been less aggressive about opening new businesses than women, but it seems men expect jobs to be given to them. They usually inherit their fathers' professions and possessions, while the women have to work harder and become more aggressive to survive in the job market. Women often suffer from discrimination both in employment and in career advancement.

Unemployment for everyone, however, is very high—up to 80%. Thus both men and women cross borders to work illegally in Greece, Italy, Germany and other countries in order to secure a livelihood. Within Albania, people are usually poorly paid for their labor. In Kruja I visited shops to purchase hand-woven wool rugs and paid $45 for a rug that took a woman twelve days to weave. That was wages of about $4 dollars a day which was typical of wages paid for manual labor in Albania.

Much of the work women do is menial. As we drove over the countryside, this was evidenced by women working in the fields and tending their sheep. As they watched their flocks, they also

stood in the fields spinning wool by hand for clothes and rugs. Before 1980 it was estimated that half of the agricultural work force in the mountains was women, and in some very remote areas that estimate was seventy percent. Whatever jobs women do, men tend to supervise their work.

In 1990 there was only one woman in Parliament. Though a few women have been appointed to high level positions, women have not been accepted into the political arena. Tradition hinders them as they try to advance to be members of the legislative body of their country. However, because women work harder than men and sixty percent of the students at universities are females, some predict that women will eventually be leaders in Albania.

Living Conditions of Albanian Women

As I approached the British missionary's residence that was to be the home for my colleague and travel companion, Nancy, and me for the next several weeks, we discovered that the house was located behind a six-foot wall as were most of the other residences. We entered though a metal gate, which was locked at all times, to find a small, white two-story old house with a small dainty front yard. I had to duck under the wet clothes fluttering in the wind to climb the outside stairs to the small apartment. The quaint apartment consisted of a sparsely furnished bedroom and bath plus a kitchenette. The electric stove was cantankerous and a wooden board was used to brace the door closed. A small butane heater in the bath helped to lessen the damp coldness of the Albanian spring air. However, layers of clothes were still necessary, not only outside of the house but on the inside as well. I borrowed wool stockings from a missionary to warm my constantly cold feet.

A daily challenge for Albanian women is the scarcity of water in the homes. The deterioration of the city water system in Tirana results in leaking water mains, which causes an almost constant scarcity of water and low water pressure. Water is unavailable except for short periods of time, usually at meal times or late at night. We learned to save water in buckets for household use, but drinking water had to undergo a purification process. The water pressure was so low in the day that we were told to wash our

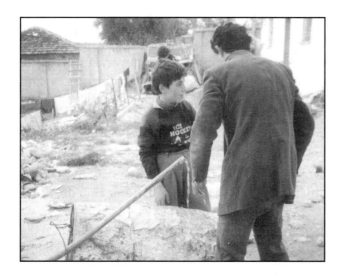

Children drink water from a pipe at school. Water, a scarce commodity, is wasted due to the lack of a spigot.

clothes in the washing machine at our landlord's apartment early in the morning—at about 4:00 A.M. I decided that I could wash by hand at a more convenient time. In the school for handicapped children the source of water for the children to drink was a pipe that extended out of the ground and flowed continuously when water was available. A spigot would have saved thousands of gallons of water plus eliminating the puddles of water that accumulated at the base of the pipe. In some of the rural areas women walked miles to secure water for their homes.

In addition to the scarcity of water, housing is a major concern for the Albanian women and their families. In the urban areas a family of four may live in one unheated room and share a bath and kitchen with three or four other families. If a family owns more than one bedroom, they may choose to rent the second bedroom to another family for income. Because of low income, scarcity of existing housing, and the excessive cost related to construction of houses, the Albanian women and their families face a dilemma in securing adequate housing. A newlywed couple may wait as many as ten years before they can purchase their own home. In rural Albania, women find themselves living in houses made mostly of stone and cooking over a fireplace. Certainly these inadequate living conditions make life more laborious for Albanian women.

Even though Albania's economy was based on agriculture in the past, there had been a limited variety of food available. With the onset of free enterprise and importation, however, the larger towns and cities now have a better selection of fruits, spices, and vegetables, meats such as goat, lamb and chicken. At the street market one can purchase live animals for food, or may choose to purchase dressed, but unrefrigerated meat. This variety of food is not available in the rural areas or small towns, though in a swampy area of a small village I saw little boys rat-catching. They placed the jumping rats in a mesh bag to take home for consumption.

Though women shop daily for vegetables, it is bread that is the mainstay of the Albanian's diet. To them bread is the food of life. When bread becomes scarce, people become frightened and will stand in long lines to purchase a loaf of bread. A small bakery was located a block from our apartment where we daily bought bread for twenty cents a loaf. The bakery had a front window for walk-up purchases, just like a drive-in. We would stick the unwrapped bread under our arms and hurry to our apartment to eat the bread

In recent years a variety of fresh food is available at the open market.

while it was still warm. The bread had a hard crust but was wonderfully smooth and chewy on the inside. This bread, along with goat cheese, fruit, milk and banana, peach or pear juice was our main diet.

The mile walk to the Stephens House Restaurant, an American-style restaurant, and one that was frequented by missionaries of many denominations, was a difficult walk in cold, rainy weather. The walk was worth it, though, as we always fellowshipped with missionaries and discussed their work. One day when we were having lunch with a missionary at the Stephens House, a missionary received a rather disturbing letter from her family back in the states. To cope with her stress and give solace to herself, she ordered four scoops of ice cream for her lunch—and I thought to myself, "I will probably be upset tomorrow about lunchtime myself."

Indestructible Women in the Education System

I, along with Nancy, a speech consultant, was in Tirana as volunteer educational consultants under the auspices of the Cooperative Baptist Fellowship. We were there at the request of a school administrator and Devita, an Albanian teacher. Devita had been instrumental in making contacts through missionaries to secure our services. We were to assist teachers in the development of curriculum materials for mentally handicapped students in a public school. I discovered that the severely mentally retarded students, in most cases, were isolated at home, often under deplorable conditions. One individual told me of visiting an Albanian home and of being taken to a barn where two naked mentally retarded children were lying on hay. Such is the plight of many severely handicapped individuals. However, some mildly handicapped students were taught in schools, though the teachers had not received special education training. In rural areas, where even the normal children had difficulty getting to school, there were no special education programs.

As we began our work, Nancy and I walked a mile to catch a mini bus, which was to take us to the school for the handicapped students. We considered this early morning walk a little inconvenient until we learned that some children in rural areas walk miles to school in the winter with their feet wrapped in rags because they have no shoes. When the little bus arrived, we squeezed in with the thirty-five children and their teachers on a vehicle that would normally seat twelve people. In spite of being over-crowded, it was a happy experience for the retarded children as they sang, laughed and talked for the hour journey to school.

After an extremely bumpy ride we arrived at an attractive three-story school building on the outskirts of Tirana. The building was extremely clean and pleasant to be in, even though there was no electricity. I was anxious to learn how this building happened to be more accommodating than the buildings at other schools. I was told that one of the teachers of the handicapped students, the wife of a Communist leader, prevailed upon her husband years ago to have the government build a school for mentally retarded students. Over a ten-year period the classroom building was constructed, although adjacent buildings for the handicapped are still under construction.

Our task was to observe teachers and demonstrate materials and methods for enhancing the instruction of handicapped students. We quickly discovered that the Albanian teachers, all of whom were women except for one man, were strong, assertive women who let us know that they were competent in their teaching. Some teachers gave clear indication of their unhappiness with these two American women invading their territory and presenting new approaches. The classroom teachers were less interested in change than were the administrators of the school.

Being aware of the unavailability of supplies such as staplers, hole punchers, construction paper, pictures, clear tape and other materials, Nancy and I took a large suitcase filled with supplies to demonstrate and present to the teachers for their classroom use. One teacher's response, "Is that all you brought?" Another teacher commented, "Did you bring only two staplers—only two?"

Few if any of the teachers expressed appreciation for our having traveled 8,000 miles to spend several weeks in their school to help them improve the curriculum for their students. I painfully came to the realization that we were in another world, another culture, and that Albanians were fifty years behind American programs in special education. We would have to adapt both to their environment and their abruptness, as well as to their direct approaches to us. Could it be that their curriculum was more appropriate for their students in their unique society? Perhaps the American curriculum was not the most effective solution to their educational problems. Actually, I came to appreciate the strength of the Albanian women and their direct confrontation with us. We were aware of where we stood with these women even though it was not always positive.

While Nancy primarily assisted teachers in the methods of speech development, she became interested in the woodworking project of the high school handicapped students. The only male teacher in the school taught these students. Due to inadequate supplies the students made only dominoes or small wooden boxes. Nancy thought she could assist with developing additional motor skills for the handicapped students through the teaching of gardening skills. There was ample space on the school ground for a vegetable garden and the woodworking teacher was amenable to the suggestion of training students in gardening skills. Nancy spent hours securing hoes, shovels, rakes and seed for the garden project. As she gathered the supplies from missionaries and other individuals for the class, she learned that a few years ago someone else had also proposed this idea of gardening. Tools and seeds had been donated, but the teachers of the school took them home with them. Thus, none were left for the student's use. However, this did not deter Nancy from securing tools and garden supplies, which she donated to the school.

Devita, the Teacher

Soon after arriving in Tirana, Devita, an Albanian schoolteacher of special education, invited Nancy, a missionary and

myself to her home for lunch. She, her husband, son and her husband's parents, lived in a simple four-room house at the end of an alley in Tirana. Upon arrival at her home we were offered wine or Pepsi to drink (Pepsi is considered a sophisticated drink in many foreign countries). As we sat on a couch, they opened a folding table and placed it in front of us to serve a Greek-like meal. To begin with, each person was served a large platter of tomatoes, cucumbers, red peppers, and black olives followed by a large green Greek salad with orange slices. The third course was a platter of roast beef with boiled eggs in the center of the meat, surrounded with about two cups of fried potatoes for each person. In addition there was a platter of meat wrapped in a thin dough. For dessert we had caramel flan with bananas. Though Albanians are poor, they provide an abundance of food for their guests. Trying to be polite we ate a little of everything, which was far more food than we needed or wanted.

At the end of the meal Devita requested that her husband remove the dishes from the table. We later learned that this was the first time her husband had ever removed the dishes or helped in any way with a meal. Customarily, men do not assist with household chores, but Devita had previously informed her husband that we American women expected men to assist with meals and that he should do this to please us. Her strategy worked.

Devita and her husband had been saving for years to purchase their own home. Shortly after we left, they unwisely invested their savings in a pyramid, get-rich-quick scheme. The pyramid scheme collapsed and they, along with thousands of other Albanians, lost their life's savings. This corrupt pyramid scheme was a major factor in creating civil unrest, which eventually necessitated foreigners leaving Albania.

Women Locked by Tradition

Prior to World War II women were subservient to men and had been for hundreds of years. One of the early clans of Albania was the Gegs, who placed great emphasis on the family structure. The social structure of the family even supplanted the laws of the

state. The father's word was law, with women occupying an inferior status; in fact, women were considered beasts of burden. Women were treated as servants, confined to the home and not allowed to eat with men. At a museum in Kruja, I observed the dining room of a historical house. Adjacent to the dining room were peephole windows where women were to view the men and determine if the men had need of their services. Females had no rights, such as owning property, nor the right to seek divorce. A husband was allowed to beat his wife and even put her in chains, if she dared disobey his orders.

Even though life is still difficult for women today, many areas of everyday life have improved compared to early history. One of the most difficult areas in the Albanian's life, especially for women, is coping with substandard medical service. Although medical services are free, a simple fever can lead to death due to the scarcity of medicine and lack of competent medical staff. An American told me that in a conversation he had with a medical student, the student indicated that he had never used a textbook in studying for his medical training. Medical care and research related to women's concerns are virtually unknown.

Because wholesome, nutritious food is unavailable for many Albanian people, diseases and illnesses, especially among the children, are evident. A pediatric urologist said that he examines 300 to 400 children a year with kidney stones, due to poor nutrition, impure water, and lack of water.

It was fascinating to observe some of the unique customs and coping mechanisms of the Albanians, especially the customs and traditions of women. One fascinating custom was that of kissing each other on the side of the face; women kissing women and men kissing men. It was not acceptable for the men or women to kiss each other.

Women do not like having their photos taken, but children adored the attention they received in posing for a photo. I collect photos of old women, so I tried to snap, unobtrusively, a few photos of them. One day in Tirana, I discreetly (I thought) snapped a photo of an old woman dressed in the black and white garb of a widow. When I took the photo, she was crossing a street

in front of an elegant house, which was almost hidden behind a high fence. Immediately, an impeccably dressed man sprinted from a gate in front of this house and in Albanian shouted his intense displeasure with my taking a photo. I'm glad that I did not understand the Albanian language because I would probably have been even more frightened if I had understood what he said. I knew by his body language and tone of voice that he was very angry. He thought I was photographing the house and reached out to take my camera. I thought he was angry that I was taking a photo of the old woman. I held on to my camera and made a quick departure.

Later in discussing the event with others, I discovered that the owner of this house had recently built a modern grocery store in Tirana, which had been bombed, killing five people and injuring others. The owner of the bombed store lived in this elegant house surrounded by guards and was cautious about strangers, especially those with cameras that appeared to be photographing his house. I was cautioned to avoid taking a camera near this house again. With or without a camera, I avoided the street where the house was located.

Humanitarian services are slowly making inroads to this developing country. For example, medical missionaries are aiding in relieving suffering and preventing diseases

A woman's attire indicates she is a Muslim widow.

and malnutrition. Through International Aid, a service organization, some medical services are provided, but their efforts are not always consistent. Delays in medical service have resulted in death when, for example, insulin for a diabetic is delayed for months.

We saw the result of inadequate medical care as we were driven to a gypsy village to observe Alvin, a ten-year-old gypsy boy afflicted with stuttering. After traveling ten miles on less than adequate roads, we parked our vehicle and walked about one-half mile to the boy's home, a small dilapidated shack whose front door was secured by a large chain that came through a hole in the door and was then nailed to the wall. No one was at home, but

An Albanian child, loved but lacking in adequate health care and sanitation.

while we waited for the boy and his family to arrive, more than twenty curious women and children gathered around us. These people seemed enchanted by these two American women, especially by my friend and colleague Nancy, who is a beautiful blond lady with a personable smile. We felt an unbelievable warmth and rapport with the gypsies as we touched and held the children and as Bill, a missionary, interpreted our conversations with the women and children. We saw children with crippled bodies, children with hearing losses and those with scars evidencing previous medical problems. There was little we could do but feel a sadness for these deprived chil-

dren and the gypsy women who had little to offer the children
other than their love.

After about twenty minutes of conversation with these
women, we were invited to the home of one of the women for
coffee. I did not want to eat or drink anything prepared in these
homes, but I realized it would be impolite to refuse their hospital-
ity. We entered the small, meagerly furnished home, followed by
several of the people with whom we had talked. We were served
Turkish coffee and an orange soda as we chatted with the family.
My first sip of coffee was so strong and thick that I became choked,
and was embarrassed as they all laughed at the wimpy American.
Because Turkish coffee is the preferred drink of Albanians, I was
determined to drink this coffee, so I would take a sip of coffee and
follow it with a gulp of orange soda to wash the coffee down. Later
I learned that if I waited for the grounds of the coffee to settle to
the bottom of the cup, I would have saved myself great embarrass-
ment.

Alvin, the young boy with the slight stuttering problem,
arrived just as we were preparing to leave. Nancy talked with him
and made several suggestions, such as needing a male adult to
bond with Alvin for emotional support since there was no father
in his home. In that he had been deprived of school due to his
stuttering, she recommended that he be placed in school, even
though speech therapy was unavailable.

A new and popular custom developing in Albania is that of
buying lottery tickets. It is especially popular when the ultimate
prize is to immigrate permanently to the United States. Albanians,
like people in other developing countries, have the misguided
idea that living in the United States is utopia. Two Cooperative
Baptist Fellowship missionaries in Albania from Georgia were
acquainted with an Albania man who won the Albanian lottery to
immigrate to the United States. They taught him English and
assisted his family in acclimating to living in Georgia because of
the missionary's connections there.

The streets in Albania are filled with potholes, mud, debris
and uncovered manholes that are six feet deep. A person told me
that one evening he and his wife were walking on the street

Streets are narrow, covered with debris, and usually muddy from leaking water mains.

holding hands. She suddenly disappeared. She had stepped into a manhole and he could only see a little of her brown hair protruding out of the manhole. Fortunately she was not hurt, just embarrassed.

A custom observed was that of men urinating in public. The Baptist Center, where we often visited, is located in downtown Tirana, adjacent to a parking lot. The wall of the Center is a convenient place for men to urinate. When the Center was first purchased in the 90s, a guard was hired to discourage men from using the wall as a toilet. It was common to see men urinating in public but not women.

It is the women of Albania who make a semi-normal life possible for Albanians. They work as much as 14 hours a day. In addition to holding outside jobs, they are responsible for housework, childcare, and meeting the whims of their husbands. Women, especially in the northern rural areas, are still considered servants. While some of their husbands work, most husbands spend a large portion of their time loitering, playing dominoes and chess, and drinking *raki*, a locally produced liquor. I observed

women carrying heavy loads of grains or large jugs of water while walking behind their husbands, who leisurely rode donkeys.

In the male-dominated society of Albania, wife abuse is still treated as a family matter. Wife beating or marital rape is common, and such crimes are not reported for there are no government-sponsored programs that protect the rights of women, nor are there shelters for abused women, although a "hot line" for reporting domestic violence is available. Many women have come to expect cruelty from their husbands as a part of their role—it is what you get if you are a woman—and beating a wife to keep her in line seems to be the mind-set of the Albanian man.

Another aspect of the neglect of women is that they are not included in sports, as they neither participate actively nor passively in sports events. An American told me that at a soccer game where 52,000 people were spectators, only one or two of the spectators was a woman. Women do not appear to be interested in sports entertainment nor are they welcomed. It was noted that no extracurricular activities, such as music, art, or sports, are offered in the schools. Thus, women have few opportunities for developing skills in sports or other outside interests.

Albanian women do not drive automobiles. Thus when an American woman drives an automobile, it creates quite a commotion. An American woman tells of driving one night and being stopped by a policeman, who asked, "How long have you been driving?"

"How old are you?" she asked.

"Twenty-two," he remarked.

"Well," she replied, "I was driving before you were born." With that she drove away.

On another occasion an American child commented, "When Mom drives, the Albanian people move way back from the street."

Another way Albanian men have subjugated women is in the area of forced prostitution. These women, mostly young and innocent, are kidnapped or lured to cities, even cities outside Albania, with promises of a better way of life. Once a young woman loses her virginity, she is considered an outcast and cannot return to her family, especially in the rural areas where family tradition prevails.

No statistics are kept on volunteer or forced prostitution in Albania, but it is said that many women are involved. Thousands of women are sold as mistresses or brides to older men and some of these are taken to countries such as Macedonia or Greece. When they become illegal residents of another country, these women have no legal protection. I am told that many 14- and 15-year-old girls long to return to their families but cannot do so. Macedonian police say that some 600 women are sold in a year to Macedonian men, who may pay as little as $400 or as much as $7,000 for a woman.

I was told by a man that his next door neighbor's daughter was kidnapped and sold into prostitution. Another resident told me of threats to his teenage daughter. Yet another related the story of men attempting to kidnap a gypsy girl for slavery. The girl's brother stopped the kidnappers when he stabbed one of the kidnappers with a knife. (The kidnappers were frightened and fled.) Later the gypsy brother was placed in jail for using a knife to protect his sister.

While visiting in the home of an agriculture missionary couple on the west coast of Albania, I observed a beautiful 12-inch wood carving of a girl portraying an angelic glow of purity and beauty. When I inquired about this unique carving, I was told that an Albanian wood carver, whom the couple knew, began carving an image of his daughter. During the process of carving the statue, the daughter left home to go to the city to become a prostitute. Heartbroken over his daughter's departure from the morals that he had taught her, he changed the face of the carving to resemble the missionary's daughter.

Albania, the First Atheistic Country

During his Communist reign, Hoxa declared Albania to be the first truly atheistic country in the world. He destroyed not only churches, mosques, synagogues and all symbols of God and worship, but he also tried to destroy the human soul. He declared that Albania's religion was Albania. Though the nation lived under a regime of atheism, it is said that many people kept God in their hearts. Many stories are told of the atrocities against thou-

A handicapped woman on the street asking for alms.
Very few services are provided for handcapped people.

sands of Christians who refused to deny God and thus were imprisoned, tortured and killed.

When Albania voted in 1992 to install a democratic system of government, the borders of this small country were opened to the world. As a result, more than 600 missionaries entered Albania within a five year-period. The minister of culture, who oversees religious affairs, says there are presently 80 Christian societies and sects active in Albania. These missionaries are attempting to minister to the Albanian people, who are primarily adherents to a moderate form of the Islamic faith founded by Mohammed. Other than the Islamic faith, there are adherents to the Greek Eastern Orthodox Church, and the Roman Catholic Church.

The thrust of missions with these hundreds of missionaries has taken many directions with each denomination eager to share its story. Among the ministries the missionaries promote are planting new churches, teaching new agriculture methods, providing medical services, ministering to students and teaching English as a second language. Albanians assume that knowledge of the English language will open doors of opportunity. Most of the humanitarian services were halted in 1997 due to civil conflict.

Christian missionaries use the Bible, along with other materials, to teach English. The Muslims, adherents to the Islamic faith,

do not express objections to the use of the Bible as a text for learning English. Using the Bible is one means whereby missionaries can present the gospel of Jesus Christ to Albanians. On one occasion, as Paul used the Bible to teach his students, a missionary read the story of the prodigal son. An Albanian man said, "I am that son. I took my father's money and went away; I spent the money and then I returned home. My father forgave me."

Another incident related was that of an Albanian farmer who was given a Gideon Bible many years ago. As he read the Bible, he became a follower of the Christian faith and became convinced that he owed a tenth of his possessions to God. Thus, the profit he made from a tenth of his land he used to build a small church on his farm. When the missionaries arrived he said, "I already know your God and have built a house of worship for Him."

Women Experiencing Change

There appears to be some relief on the horizon for Albanian women. A task force has been set in place by the Albanian government and independent business foundations to try to seek some means of assisting women. The Women's Legal Group was established by twelve women's organizations to consider legislation that would address the rights and protection of women and girls in Albania. In 1995 this group gained recognition by Parliament for its work in monitoring women's legal protection. This group is hopeful that they will bring the Albanian legal system in line with international standards on women's rights.

Other organized efforts of women include research and lobbying for laws dealing with domestic violence and the rights of women to own land, as well as lobbying for laws related to land inheritance. Women also have been successful in getting the legislature to pass a law insuring women's reproductive rights.

Though the plight of the Albanian woman is one that is harsh and demeaning—which consists of caring for the home and the children, working in fields, and doing whatever it takes to earn a living, having no recreation, poor nutrition and health care, and being abused by her husband—there does appears to be some hope in the future.

There is an Albanian proverb which says, "Where there is nothing, even the king cannot give." Though Albanians are poor, international aid and mission efforts are helping to alleviate some of Albania's stressful conditions. Countries throughout the world are assisting in developing business expertise, giving technical advice, and rendering financial aid. Christian organizations offer humanitarian services and present a message that will elevate and enhance the status of women. Hopefully, not only will Christianity benefit women, but it will also help the Albanian men understand that women are people of merit.

In spite of the plight of the Albanian woman, I am encouraged that women's organizations and advocates for human rights will empower the Albanian women to move into the 21st century seeking parity and recognition. Momentum, coupled with an unwavering hope, will lift these strong women to their rightful place of dignity and worth.

The future of this little Albanian girl will depend on the efforts of the world's people who care about her plight.

7

Thailand's Women in Crisis

IT WAS HOT, well over a hundred degrees, as several other Americans and I stood on a busy street outside a mosque in Thailand. We were waiting to hear the resounding midday calls from the minarets luring Muslims to prayer time. The green multi-tiered roof of the mosque glistened in the sun, and I could see the shrubs dripping with pink and white blossoms as I peeped through the fence surrounding the courtyard of the mosque. When the gates finally opened and people from the streets began entering the courtyard, I walked briskly toward the mosque entrance following two men of our group. As we approached the entrance to the courtyard, one of them caught me by the arm and said, "Winnie, you cannot go in."

"Why not?" I asked.

"Because you are a woman and no women are allowed to walk in the courtyard or enter the mosque."

I was already hot, having stood for at least half an hour in the blistering sun. Now I was angry that I was prohibited from entering even the grounds of this mosque because of my gender. It was not right. But then I was in Thailand, where I knew that women are held in low regard. I cringed at the discrimination and

felt there was nothing I could do, so looking through the openings in the iron fence, I made photos of the mosque and moved on.

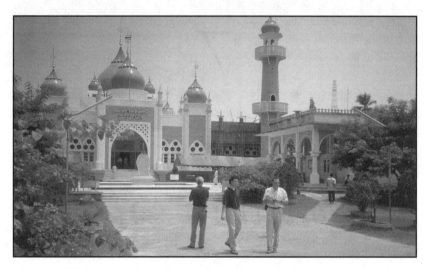

*Women are not permitted to enter even the courtyard
of the Muslim mosque.*

Thailand—A Land of Smiles

I was being introduced to Thailand, a country in southeastern Asia about the size of France. Many of the ancient ways of Thai life are still preserved, such as the famous Thai smiles, the graceful Thai manner, the classical music, dance and art, the serenity of Buddhist monks walking early each morning to receive their alms, and the respect and honor shown for the elderly. There is also the irresistible natural beauty of sandy seashores surrounding coral reefs and fields of crops, including jasmine rice in the river basin rainforest. There are the awe-inspiring temples, the colorful and graceful "long neck" boats, and great restaurants with delightful cuisine peppered with spices, and the invariably hospitable host at every turn. I was also fascinated with the herds of elephants that are primarily utilized for work in the forest. It is a tantalizing country but one faced with numerous problems. The Thai culture is swinging toward Westernization, which significantly impacts the serenity of their culture.

Thailand has long been entrenched in a predominantly rural and agricultural way of life. Eighty percent of the 61 million people in Thailand continue to live in the rural areas with their lives evolving primarily around the family, farm, community, and temple. However, there is a constant migration to the city where traditional culture is being altered almost beyond recognition. Even though the government promotes the restoration of ancient temples and attempts to maintain traditional customs, it is difficult to do so amidst the dazzling array of prosperity that offers a new approach to life. When tradition collides with change and when the East meets the West, materialism often supersedes deep-rooted values.

Thai people have traditionally referred to themselves as the Land of Smiles, and many people see this as a natural and appealing disposition of their lives. A smile may serve to welcome people, to calm a person in distress or to diffuse an explosive situation. A smile often indicates that people are happy and contented, but this is not always true. In Thailand, the majority of the people are in the lower echelon of society and are very poor with little chance of bettering themselves. It is difficult for them to be happy when they are deprived of life's essentials. One man who expressed concern regarding the poor economy of Thailand said, "We are not a land of smiles; we have much too many problems to smile."

In spite of it having one of the highest crime rates in the world, Thailand is the most frequently visited country in Southeast Asia. Tourists flood the country to enjoy the good buys at the markets, to visit the elaborate mosques and temples, and to visit the sidewalk cafes with delicious spicy food and luscious fruits like watermelon, mangoes, and pineapple. Another element in Thailand is the brothel houses with their prostitutes, especially in Bangkok, which lure men from all over the world.

There is a social hierarchy system in Thailand that demands that the inferior person show respect to a superior. This is a very meaningful part of the Thai's life. One may show respect through the traditional greeting called the *wai*. This gesture requires a bow with the hands clasped together with the fingertips reaching to about the neck level. The lower the head is bowed, the greater the

respect to a superior. If a man is making a *wai* to Buddha, he will drop to his knees, bowing his head to the floor, while women sit with their legs to one side and bend their head and body down with the head near the floor. The inferior always initiates the *wai*. When I visited schools, the children always performed the *wai* and I responded. I was informed that students should initiate the *wai* because I was a teacher. Though this strict social hierarchy has been an innate part of the Thai culture, it is becoming less frequently used, especially in the cities. The trend is more toward equality rather than the superior-inferior system.

Another aspect of the superiority status is reflected in a physical high-low continuum regarding the top of the head. The head is the most important part of the body and the feet are the least and dirtiest part. It is an insult to touch the head or even point to the head with the lowly foot. The foot is not to point in the direction of an individual at any time. This hierarchical philosophy is a significant part of how a Thai perceives his body.

All of this became evident to me as I traveled in Thailand to serve as an educational consultant. My responsibilities included leading seminars with Cooperative Baptist Fellowship employees who homeschooled their children and to teach English as a second language in village schools. I also served with an American medical team of three physicians and with several other individuals who taught English as a second language.

Women As Caregivers in the Home

It is the family that makes a Thai what he or she is, and it is the family that provides a haven for the children from the distractions of the world. It is the family that teaches a child to respect his or her elders and superiors, and it is the mother that binds the family together as she nurtures and adores her children. Seldom are children abused in Thai society.

The middle-income family, which usually lives in the city, will most likely dwell in a two-storied structure with wooden walls and a tile roof. Usually the largest room is a sitting room that provides a raised platform with mat and pillows for lounging and sleeping. The kitchen will be connected to the main part of the

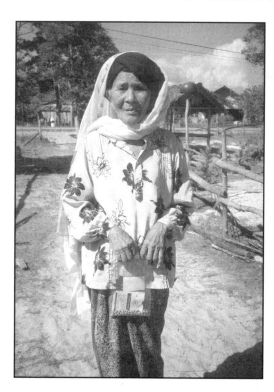

A Thai homemaker.

house but set apart somewhat. The upstairs will be the sleeping room for guests.

The poor city dweller may live on a houseboat or in a rented structure built from bamboo, lumber, boxes, or perhaps tin salvaged from oil cans. Many of these homes may be swept away by floods during the monsoon season or may be periodically destroyed by fire. As we rode up the Chao Phraya River in Bangkok on a dilapidated riverboat, I discovered that the river and canals serve a number of purposes—as the home for houseboats, as a sewage disposal system, and as a transportation system, especially for those delivering their vegetables or goods to the market. The river also entices tourists because it provides a panoramic view of city dwellings and of the many gold encrusted temples.

Since most of the people derive their livelihood from agriculture, the Thai woman works in the fields during planting and harvesting of the rice crops, then after harvesting again becomes involved in her domestic chores. One essential chore is to secure water for her family which usually involves walking to a central

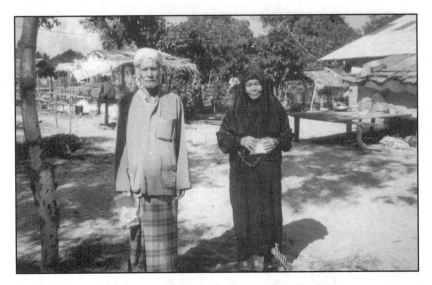

A farmer and his wife in a rural village.

well, sometimes a long distance from her home. Often there is no plumbing for the home and the family lives on a dirt floor, but most likely there is a television aerial protruding from an unstable roof.

Outside the home, the woman and her family center their activities around a common building, which is a community center, built by the government. It is here they come for medical or social services and community activities. These buildings are usually nice, white masonry buildings located in the center of the squalor of a rural village.

As we walked along the shores of the fishing villages, I observed the abject living conditions of the fishermen's families. Women stood outside their dirt-floor huts, chatting with neighbors, some holding small naked babies. The fishermen had returned from their early morning fishing and were gathered in small groups throughout the village, while the children played and some paused momentarily to observe the strangers who invaded their village. Sprawled around their huts were fishing gear, freshly washed clothes, usually a bird cage with a bird, small pens for their cock-fighting roosters, and piles of rubbish. The

Woman seeking medical assistance at a free clinic in the village.

heat, during this midday stroll, was intense, and by noon most of the people had left their huts and moved under the shade of trees in the village.

Often in the villages I saw an elevated flat stand, similar to a table, usually about three feet high, constructed mostly out of sticks. These stands were located under a tree where people sat to cool. Several times in villages I observed children or babies lying on these little tables as they played and chatted. Here they were exposed to the breeze that offered some relief from the heat.

Even though rice, fruit, and fish are the staple food in most rural villages, there is more variety in progressive communities with tapioca, coconuts, soybeans, and sugar cane for sugar. In the towns and cities there are wonderful spicy foods that consist of shrimp, hot curry, a spicy soup with the flavor of lemon grass, coconut meat and milk to flavor dishes, white and yellow noodle dishes, scrumptious omelets stuffed with pork, and a variety of sweet and sour dishes. My favorite Thai food is a watermelon drink consisting of pureed watermelon, syrup, and crushed ice. This cool refreshing drink revived me more than once, and I found eating Thai food a delightful experience.

A place setting at a Thai table consists of a spoon and fork, but the fork is used only to rake food on to the spoon. Not only does one use the spoon to eat with, but the side of the spoon is also used to cut food when necessary, although most food is cut into bite-sized pieces prior to cooking.

I gradually learned some of the customs of the Thai people, but not before I had caused myself some embarrassment. For example, soon after arriving I was eating in a restaurant and was

served a large whole fish. After eating from one side we flipped the fish over to eat the other side. We were later informed that the proper way to eat a whole fish is to lift the fish slightly, scrape the meat from the bone, and then replace the fish in its original position. Since we flipped the fish over, we learned it meant that the fisherman who caught the fish would have bad luck. Thereafter, I never flipped a fish. I did, however, eat some whole small fish that were about the size of one of my fingers. With reservations I ate head, tail, and viscera, all in two or three bites, as I was instructed to do. In that I was with Thai friends, I felt compelled to follow the custom, even though it was not a comfortable experience.

For women who have moved to the town and cities, there seems to be a change in the cuisine from fewer ornate dishes that take an inordinate amount of time to prepare to the more Western influences of noodles and fast food such as hamburgers. I was surprised to see a McDonalds in Bangkok, but I welcomed the hamburgers and fries since I had eaten rice three times a day for the two previous weeks.

Women in the cities are a new breed. They portray new freedom and can be observed in cities such as Bangkok with their miniskirts, cosmetics, and frilly tennis shorts. They drive cars and work in offices. Some venture into higher profile jobs like being members of parliament, but only a few have the opportunity of having high paying or more influential positions. Some of the women are leaving the rural life of their country cousins and the influence of their mothers to seek new vistas with more conveniences, increased education, and better jobs. Many of these women become fluent in several languages and have personal incomes that provides them some degree of independence.

Though some women have moved to the city for a new adventure, they still follow many customs as a result of tradition. For example, a display of public affection between the sexes is unacceptable, and a woman will not walk down the street holding hands with her husband for fear of losing face. However, the private life of a woman seems to be of no concern; perhaps that is why prostitution is not only tolerated but appears to be an accept-

able way of life for young women. The taboo against touching across sex lines can be seen even in the laundering of clothes. A man may refuse to touch a woman's undergarments because his self-esteem might be damaged.

Some of the women of Thailand are choosing to remain single because of the demanding role of being a homemaker, working outside the home, and meeting the demands of a husband. Many women are choosing to break with the traditional cultural role of being a mother and caregiver and adopt the role of a professional woman.

Women As "The Elephant's Hind Leg"

There is a saying in Thailand that women are "an elephant's hind leg"—i.e., forever destined to follow the lead of men. Though this has been implicitly true for centuries, it is changing slightly, especially for women in urban areas who are demanding job parity and seeking self-sufficiency. Nevertheless, it is advantageous for men to maintain the traditional submissiveness of women, thus women have an uphill struggle as they seek respect in Thai society.

Thailand, formerly known as Siam, was popularized by the movie *The King and I*. In this movie the King proclaimed, "Women are made for men." This concept continues for most of the men on Thailand, who advocate the belief that women should devote their efforts to pleasing men. Even though the Thailand Constitution provides equal protection and rights for men and women, the laws on divorce, prostitution, marriage, rape, abortions, and social security are poorly enforced. The government, which consists primarily of males, withholds the enforcement of equal human rights in most cases.

Women often experience obstacles with a husband's infidelity, abuse, and rape. I was told that 70% of the men have mistresses, second wives, or a sexual relationship outside of their marriages. It seems to be a socially acceptable tradition, even though the Civil and Commercial Code of Thailand states that a marriage cannot take place if the man or woman is the spouse of

another person. Before the passing of this law, a man could have as many wives as he could afford. As is true in many countries, Thailand's laws and its social practice are often far apart.

One study of a slum area of Bangkok indicated that 50 percent of married women in the slum area are beaten regularly. This physical abuse of women probably exists through much of the country. Women have little legal recourse. Rape is another culprit that women encounter. A woman has to prove that she has been raped and, even if she can do so, there is virtually no action against the rapist. If the rapist, however, is from a country other than Thailand, he is dealt with in a more severe manner.

Abortion is illegal according to the law, but it is estimated that some 300,000 women have abortions each year. With 31 million women in Thailand, this abortion rate is low compared to other developing countries. Most of these abortions, up to 80%, are for women living in the rural areas who for economic or family reasons desire the elimination of the pregnancy. Contrary to the situation in some other developing countries, girl babies are not aborted because of their sex. Parents view the female child as the person who will probably support them in their old age.

In more than 90% of divorce cases, it is the woman who keeps the children. Though more than half of the fathers indicated they are willing to pay child support, only about one in five do so; thus, a financial burden is placed upon a mother as she seeks to support her child or children.

Another form of discrimination against the women of Thailand relates to their marriage to a foreigner. If a Thai woman marries a foreigner, she loses her rights to own land, though this is not the case for men, who can retain their rights to land if they marry a foreigner. It is this type of discrimination that women feel is unjust and are seeking to rectify.

Mia, a Typical Peasant Woman

I will never forget Mia, one of the peasant women I met in a village soon after arriving in Thailand. She was a woman, perhaps forty years of age, who came to a medical clinic located in her

village staffed by three American doctors. Her village, located on a dirt road near a canal, consists of about 125 families. She had much in common with her neighbors, for they were all poor, lived in similar huts, ate about the same food and received about the same low yearly income. Her face was radiant and I observed a real Thai smile as I handed her vitamins, pain relievers, and several other medications prescribed by the American physicians for her ailments. Though her lips murmured strange and wondrous sounds that I could not understand, I knew she spoke words of appreciation for the medication as her demeanor and gestures indicated her pleasure.

Her village has its own government, consisting of an elected headman and a council of elders and priests, highly respected individuals. These leaders are honored for their wisdom and virtue, especially as they grow older. The typical headman must be a leader, a peacemaker, and one who uses persuasion rather than aggression. Thai's are masters at avoiding conflict and will go to great lengths to make peace, even to the point of lying. They do not criticize their leaders and especially not their king.

Mia's family probably consisted of a mother, father, siblings and perhaps one or more grandparents, but there were probably not more than six members in her family. She may have had a married sibling living in the home temporarily, but since children are taught independence, married children usually live under a separate roof, perhaps in the family compound. Respectful relationships are taught in the home and traditionally form the basis of the organization of Thai society. With minimum influence on the family by the Thai government, the family is left to function much as they choose.

As a child Mia was probably punished mildly for her unacceptable behavior, but it is a rare occasion for a family to use severe corporal punishment. She was taught to respect her elders and accepted her place in the family hierarchy plus learning the basic respect-prestige pattern of Thai culture, which is based on age differentiation and other factors such as wealth and the priesthood. This hierarchical approach, instilled at an early age, continues to dominate Mia's thinking.

As a child, Mia probably played nude in the family compound until she was three years of age, though her brothers remained nude until they were five or six. She probably played with her wooden dolls, made mud pies to sell in a make-believe market, and cooked meals of weeds in toy clay pots. Probably at about eight years of age she was assigned to care for her baby brother and began assisting more with household chores. In general, her childhood was carefree and happy.

She probably began school when she was eight, entering a primary school within the wat compound and attended classes until she was 14 or 15. On the other hand, she may have had to help at home and attended school for only a four-year primary course. At school Mia had very meager supplies, limited facilities, and insufficiently trained teachers, but school made an impact on her life. In addition to reading, writing, and math, she also studied Thai history and Buddhist ethics. She eagerly participated in various ceremonies and holidays and made contact with children from nearby villages.

By the time Mia reached 16, she was given some freedom. After working full time on the farm, her parents allowed her go to the town market, make purchases for herself, and occasionally have her hair cut or get a permanent. Until Mia married, her parents carefully supervised her relationship with the opposite sex to assure that she maintained her chastity. When she became interested in a young man, she could court him only in the presence of other teenagers or her parents. She probably met her husband-to-be at the rice mill when she was pounding rice for the family meal or in a work group on the farm. Knowing that parents closely chaperon their daughters, a young man usually seeks sexual liaisons with older women in other villages or prostitutes, not his girlfriend or fiancee.

When Mia married, she probably chose her own mate but sought her parents' approval. Mia, as well as many of her friends, probably eloped to get married. Though her parents would frown upon elopement to save face, they most likely were happy to avoid the expense of a wedding. Mia's family probably knew her fiancee's family, for it is common for couples to marry into families with whom they are acquainted.

Many of Mia's friends live as man and wife without a marriage ceremony, but Mia chose marriage because she knew that her husband would be legally responsible for their children. Most marriages are monogamous in name only. When Mia's husband makes a good crop, she might even suggest that he take another wife to help her with the chores. Most likely, however, if her husband takes a mistress, he must maintain two establishments. The fact that the government is refusing to recognize a second wife and requiring the husband to make the children of a mistress his legal heirs has discouraged men from seeking second wives.

Mia probably delivered her first child during the first year of her marriage. Thais love children and typically most children are wanted. Though Thai women are knowledgeable of birth control, most do not avoid pregnancies nor do they terminate their pregnancies. A midwife or relative probably delivered Mia's children in her home. After delivery, she went through a period of "roasting," which means she lay by an open fire for an uneven number of days to promote the restoration of her health and strength. She nursed her child until a second child was born.

Mia did not push her children to sit, stand, walk, or even to become toilet trained. She probably scolded her children for disobeying but treated the child as an individual person with some rights and responsibilities. The older siblings are taught that they have a major responsibility in raising the younger siblings, and there is seldom jealousy or rivalry among the siblings. Perhaps this is due to the hierarchial pattern that the younger children must defer to the older children who are expected to treat the younger child with tolerance and affection. This social pattern will form the basis of the child's behavior throughout his life.

Mia assists her husband with most tasks on their six-acre farm located two miles from the village. They choose to live in the village rather than to be isolated on their farm. In doing so, they must walk or sometimes ride in a cart each day to reach their farm. Mia plows, plants, and helps her husband with the harvest, and her husband in turn helps with some of the household chores, such as cooking, helping with the children and doing some cleaning. Mia's husband is the head of the household, but if he dies, she will assume the role of leadership in the family, espe-

cially since she brought property into the family when she married. Her husband is spokesperson for the family, but he often consults with Mia before making major decisions.

Mia will probably never join an organization, club, political party, or school association because this is not part of the Thai's social structure. They are not a nation of joiners. Her community is organized more laterally than vertically. Each person will make his/her own way in life, often leaving family loyalties behind in search of personal success. The Buddhist religion states that each individual should seek one's own salvation, unaided and unhindered by others. However, the family, the village, and one's religion make a significant imprint on an individual and together provide the foundation for the social world of a Thai.

As Mia and her husband grow older, their social standing in the village is elevated. Mia may speak in village affairs and represent her household at village meetings, if her husband cannot attend. She has the primary responsibility for the buying and selling of goods in the local market. In addition, she handles the family money and now has more input into how it is used. Old age is considered to be about sixty years of age, and about that time people begin their preparation for death. Usually the family affairs are turned over to one of the children and the old couple will spend time accumulating merit (seeking greater reward for their afterlife). The old women will take care of the grandchildren, help with household tasks and do good deeds for others.

Mia knows that, when she dies, she will be bathed by a member of her family, dressed in white clothes, and then wrapped in white cloth with one hand extending outside the wrappings so that relatives and friends can give her the final anointing with cold water. She knows that the monks will come to her house and chant the service for the dead and that her friends will take up a collection for the expenses of her funeral. The village men will make a beri (place of cremation). The ceremonies will be elaborate with several services, including one seven days after her death, and a morning service will be held at her house to ensure happiness for those still living there. Food, tobacco, candles, and incenses will be presented to the monks who will then take the

gifts to the temple, and a special breakfast will be prepared for friends to share with the family. Through these rituals comes an affirmation of the social and religious bond that reaffirms the social unity of the village. To Mia, it is comforting to know that she will be honored with an elaborate funeral ceremony as she comes to the close of this life.

I will never forget Mia—the leathery tan face that already evidenced wrinkles well beyond her years, and I will remember her struggles as well as her smiles and pleasant demeanor. Some of the details I learned about her, while others I surmised, depicting the life of a rural Thai woman.

Vocational Choices of Thai Women

In the rural areas women assist with the family farming and work in the fields, especially during the busy months of planting and harvesting. After harvesting the rice, opium (the main cash crop in the north), and other crops, women are involved in home activities such as weaving, and making mattresses or pillows for

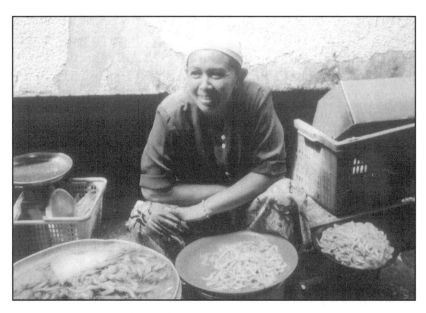

A Thai woman sells her fish and other produce at an open market.

the household or for selling at the market along with fish or vegetables that they have grown on the farm. Women are expected to contribute to the family income; however, when women work in agriculture outside the family farm, they receive on the average only 81% of the wages received by male agricultural workers.

As I visited the market places, I observed hundreds of selling stalls, most of them operated by women. The aisles of the market with their dirt floors were usually narrow and created congestion as early morning shoppers came to purchase food for the day. The odor resulting from the seafood, freshly slaughtered animals, and live chickens was a memorable experience. I limited my shopping to the areas of the appetizing fruits and vegetables and other items for sale, such as bolts of cloth, plastic containers and toys, and household cleaning supplies. In order to get the best buy, I learned that one needed to bargain with the seller. However, I found the items so economically priced that I chose not to bargain on the few pieces of fruit and vegetables that I purchased. Though the life style of people in most rural communities is quiet and easygoing, one of their major sources of income is the growing of grasses to sell as addictive substances. Women work as laborers in these fields and many laborers use drugs so they can work longer hours and harder at their job. The *Bangkok Post* reported that in three Thai communities that consisted of 750 families, 80% of the people were addicted to or were involved in illicit drug trade.

Traditionally jobs have been more available to men than women causing families to place more importance on education for boys than for girls. Ironically, though, it is the young woman who goes to the city to work and sends money home to educate a brother so he may secure a better job. It appears that a daughter feels more responsibility to repay her parents for their contributions to her life than does a son. Thus, more women are now receiving an education and are going outside of the village to work in order to help support the family.

Since there has been a migration of women from the rural to urban areas for employment, there has also been an increase in young mothers leaving their children in the care of their families in the villages. Several factors which affect a mother's decision to

leave her children with her parents include whether she is separated from her husband and the number of children she has. Thus, employment of young mothers in the city places new responsibility on the traditional family.

The earning power of women is not as strong as that of the men. Twice as many women as men earn less that $80 per month in manufacturing jobs, with women receiving about 70 percent of what a male earns. Open discrimination is common since Thailand has no laws that restrict gender-based discrimination. Both international firms and domestic employers often restrict specific jobs either to male or to female applicants. Many companies will hire females because they can pay them lower wages. The lower paid occupations tend to be more sex specific, as men become bus drivers and mechanics and women become seamstresses, hairdressers, nurses, and teachers. The Thai people seem to be aware of the need for parity in the work force, but the civil codes do not indicate parity happening any time soon. Countries which aspire to economic progress need women to work, not just at the menial, low paying jobs available to them presently, but in positions where their abilities can be maximized.

Redefining Thai Health Care and Education

My second day in Thailand was spent with a medical team of three American physicians and several others assisting at a health clinic. The physicians drove directly from the airport to minister to more than 200 village people, some of whom had been waiting for six hours to be examined by the doctors. The clinic was held in an open-air village community center. The doctors had brought six trunks filled with medications, such as vitamins, pain relievers, creams and antibiotics to distribute to the village people. Several of us "filled" prescriptions following the doctor's examination of a villager. The old, the young, the poor, the sick and some not so sick came to see the American doctors and left with a bottle or plastic bag of medicine.

Some of the villagers had walked miles on the extremely hot day to receive medical services. At the clinic a single bed was placed in the middle of the crowd for an examination table and

two long tables were set up for medicines. In addition, there were three small tables, one for each doctor and his or her interpreters, and villagers formed long lines to visit with a doctor. The patients did not undress, but the doctors could listen to their hearts, examine their arthritis or sores of the extremities and other visible ailments. There were women with their heads covered in Muslim attire; there were women who appeared malnourished; there were women who were crippled by their arthritis, and mothers with small babies. These people, I was told, never see a physician, although a large medical hospital is not more than forty miles from them.

During a four-hour period the doctors used their skills to relieve suffering and bring words of kindness to these poor village people, but these physicians could only touch the surface of a people who needed more extensive medical care. Among the type of illnesses they treated were respiratory problems, rashes, malnutrition, and worms. Later a Thai doctor told us that the most common illnesses at the hospitals are cancer, hepatitis, and liver problems.

The day of the clinic was without a doubt the hottest day I had ever experienced. Dehydration for "aliens" is common, so we drank bottles of water whether we wanted to or not. Sometimes I just splashed the water on my red, burning face. To add to my

The author assists with the distribution of medicine at a medical clinic.

discomfort, I went around to the back of the building where the clinic was held to use the toilet. When I started out, I found the door stuck. I almost panicked because the heat inside was intense and there was no ventilation. I yelled for help and kicked at the door and became frightened and more overheated, but none of the Thai patients who were at the clinic could understand English. I imagined that I would die right there of a heat stroke. Finally someone understood that I was in distress and secured an American who kicked the door in. That was the last time I used public facilities in Thailand.

Although discrimination exists for women in most professions, I found that women employees of a large teaching hospital in Hat Yai were employed on an equal basis with men. The dean of the hospital and several doctors and teachers with whom I had contact were female and highly respected in their professions.

Education for women is increasing. Fifty years ago only 40% of the women were literate as compared to 65% for the men. Twenty-five years later 61% of the women were literate as compared to 80% of the men. In the rural villages, however, the literacy rate is as low as 20%. The rural schools are often located in the local wat (temple) with little equipment other than a chalkboard, almost no supplies, and large classes. Often the teacher is

Children leaving their village elementary school.

the only one in the classroom with a book. Thus, her method of teaching is rote memorization. Urban children have better trained teachers, smaller classes, and better equipment. Inadequately prepared teachers is thought to be the single greatest factor in the lack of quality education. When prospective teachers enroll in teacher colleges in the urban areas, most do not desire to go to village schools where there are very low salaries and inadequate resources.

Serving as a teacher of English as a Second Language to teachers and students in the villages gave me an opportunity to visit the public schools. The children attend school in facilities that are unattractive and crowded, with 40 to 50 youngsters in a relatively small room. They sit on long benches with little tables in front of them but no desks. The heat in all the classrooms where I taught was unbearable; perspiration dripped off the end of my nose as I taught, but the teachers and children appeared to take it in their stride. The children always gave the *wai* (bow), were courteous, well-disciplined, and had a warm Thai smile. As several of us taught ESL classes, we observed that the learning of English is a panacea to the Thai. The teachers, most anxious to learn English, would remain for hours after a long day in the classroom to gain just a little additional knowledge of English.

I co-taught some classes in one village school with an American college student who was the son of one of the American physicians. Since he was a handsome young man, the second graders were absolutely enthralled with his presence in the classroom. We tried to teach the children the alphabet and a few words of English by holding up pictures and pronouncing words for them, but with more than forty second-graders in a room, it was a difficult task. There was only a chalkboard in the room for teaching, but fortunately for our classes, we had brought materials to assist us in teaching.

At another village where we taught, the headman had announced that Americans would come to teach English classes. It was the first time Americans had been invited into the community, and it presented a tremendous opportunity not only to teach English but also to prepare the way for additional services for the

people. That evening more than sixty village people came to see and learn from the Americans. Children, teenagers, mothers with their babies, fathers, and even grandparents came to hear what we had to say. Not all the people could get into our meeting place, so some just hung their heads through the windows, stood in the doorway or even stood outside to listen. The women brought a cool beverage for us, which was most welcome. It was a tremendous opportunity to touch people who had so little.

The Americans working for the Cooperative Baptist Fellowship in Thailand find it necessary to homeschool their children during their tenure in Thailand, and the major reason for my going to Thailand was to conduct seminars for these parents regarding homeschooling for their children. I presented teaching methods and strategies for use in their classes as well as introducing new materials and ideas to supplement their curriculum. When children from other countries are located in the urban areas, they can usually attend private schools which have higher standards and are deemed more appropriate for student learning.

The Women of Patpong and AIDS

Bangkok is the prostitution capital of the world. Patpong Road, in the heart of the city of Bangkok, is a maze of bars flowing with go-go girls, streetwalkers, discos, call houses, massage parlors, and brothels. With prostitution licensed, the streets are alive every night with men, notably male tourists, seeking entertainment. As I walked down Patpong Road, I observed the raunchy establishments with red flashing neon signs and became aware of the enormous size of some of these nightclubs that accommodate up to 2,000 people at one time.

Bangkok is a congested city, especially Patpong Road, which is awash with selling stalls in the open air that provide merchants a haven for dispensing their wares, from earrings to carved elephants, from vases to stuffed animals. The myriad of people created an impassable situation that required us to wait our turn to walk past the merchants. As I wandered down the street toward the brothels, I saw faces that I cannot forget. Beautiful young

women who were scantily clad and faces tinged with heavy make-up were luring men off the streets into their brothel. Some seemed so very young, in their early teens, willing to give whatever services a man was willing to pay for.

According to the Thailand Prostitution Act, prostitution is licensed and legal, but it is unlawful to be involved "in public acts of soliciting, congregating and operation of places of prostitution." I was told, however, that the degree of police surveillance of prostitution establishments depends upon who finances the houses of prostitution. In reality, the laws are not enforced, and the prostitution industry, which appears to be vital to Thailand's economy, thrives as a lucrative investment for businessmen and some government officials.

Some of the estimated 200,00 to 800,000 prostitutes in Bangkok are young women from Thailand's rural areas who come willingly to the city to provide income for their families, despite the fear and humiliation of being a prostitute. Families will say their daughter has gone to the city "to work." Most neighbors will be aware of the daughter's occupation, but it is not discussed. Eventually, she may return to the village and farm life, or she may remain in the city. There are, however, young women of the rural areas unwilling to go to the city who are sold into bondage to provide food and housing for their families. In recent years, though, with the improvement in the economy, fewer of Thailand's young women are sold into prostitution, although there are reports that more girls are being transported from neighboring countries into Thailand's sex slavery.

A news report stated that after a brothel fire in Phuket, a popular Thailand resort, the skeletons of six girls, ages 12 to 16, were discovered. Some were chained to beds and others were chained naked on catwalks, probably for sale to European, Asian, and Thai businessmen. Only a number identified these girls and women. It is rare for such reports to make the newspapers, for there are two things that are not discussed openly in the media of Thailand—the sex industry or public criticism of the monarchy. Either is met with outright denial.

As one might expect due to the flourishing sex industry in Thailand, AIDS is ravaging the country. It is believed by many that

one out of every thirty people is infected with AIDS or is HIV-positive. Estimates are that 50 to 70 percent of the commercial sex workers are infected, with as many as 70% of the men of Thailand frequenting brothels or having mistresses. AIDS has also been transmitted from the husband to the housewife. I learned that 10% of pregnant women have AIDS or are HIV-positive. Thus a new generation of AIDS babies is being born.

Some have suggested that husbands usually take care of a wife with AIDS, as long as there are available financial resources, but when funds are exhausted, the wife is abandoned. On the other hand, women seem to take care of their husbands until the husbands die. "That's just the way it is," so I was told.

When I visited a hospital, I learned that hospitals do not treat AIDS patients. The medication that is available in hospitals is used for those who are curable. With the average life expectancy for the HIV patient being only six to seven years, medication is not administered to AIDS or HIV-positive patients.

I learned of a village for AIDs patients from the three American doctors with whom I was associated. A Thailand man who wanted to provide a haven for the outcast AIDS patients, many of whom had been abandoned by their families, founded the village in 1994. This man borrowed money to buy 26 acres of land where 150 AIDS and HIV-positive men, women, children and even babies now reside. Only three workers are available to assist the patients—a Buddhist monk, a mother who came to care for her son, and a 24-year-old man who traveled 2000 kilometers on his bicycle for two years in order to work in this village. Nurses from a hospital, some 30 miles away, come

A mother and her baby are among the 2 million Thai with AIDS.

occasionally to the village to advise in the care of the patients, such as how to dress a wound and meet some of the personal needs of the dying patients.

Because there is no funding for this village, these AIDS victims live in huts, sleep on one-half inch mats, and suffer from a deficiency in nutrition. They survive through donations plus the crops they are able to grow in their village area. Without medication or medical personnel, the patients endure intense suffering. Those in early stages of AIDS care for those in critical stages, even spoon-feeding them when they are unable to feed themselves. They are aware that their turn will come when someone will need to care for them. The patients seem to accept their lot and willingly minister to those who are critical until they become too weak themselves to care for their own needs.

Buddhism's Influence on Women

Buddhism, the official religion of Thailand, began during the 5th and 6th century with the basic premise that life does not begin with birth nor does life end with death, but life is a part of a cycle influenced by previous existence. They believe that an individual works out his own path to Nirvana through good works, meditation, and the study of Buddhist philosophy. Buddhists adhere to five basic precepts—do not take life, do not steal, do not commit adultery, do not tell untruths, and refrain from intoxicants. Though 90% of the Thai are Buddhist, and Thailand is considered one of the prominent Buddhist countries in the world, it is said that Thais break most of these commandants every day.

Women play a minor role in the Buddhist religion. She cannot become a monk but she may become a nun. She must shave her head, wear a white robe, and live in nun's quarters on the grounds within the temple. The fully ordained monk takes a 227-vow ordination, whereas the nun takes a simpler, 10-vow ordination. Although monks walk the streets each morning at 5:00 A.M. with their lacquered bowls for their almsround (to receive their daily food), nuns are not allowed to do so. Local women greet the monks as they walk each morning, hoping that a gift of food to the

A nun, with a shaven head and dressed in white, collects alms at the market place.

monks will help them in accumulation of merit. At the temple a nun is relegated to perform only menial services. They do, however, spend much of their time, as do the monks, in meditation and counseling of people.

A visit to Emerald Buddha, located at the Grand Palace in Bangkok, is a highlight for most Thai tourists. The elaborate religious temple, PhraKeo, contains the Emerald Buddha. This elaborate temple is highly ornate, laden with gold, and topped with a multi-tiered roof. On our visit to the temple, we viewed with appreciation the massive and detailed carvings and decorative arts. We were instructed to remove our shoes as we entered the temple and sat on the floor with hundreds of worshipers as they bowed to the floor to worship the Emerald Buddha. These temples are a showplace of royal treasures and glorious architecture and are reminiscent of Thailand's place in history. The

temples are centers of worship and are significant in the religious life of the people who come to meditate, to learn the tenets of Buddhism, and to receive guidance. In rural areas the temple or wat serves not only as a place of worship but also as a grammar school, health center, and community gathering place as well. There are 30,000 Buddhist temples in Thailand, most of them located in the rural areas.

Spirit worship is an important part of the Thai religion. As I looked out of my second-story hotel window, I could see a spirit house in the yard of a nearby home. At first I thought it was an elaborate birdhouse, shaped like a miniature temple adorned with tiny white lights similar to those used at Christmastime. I learned that almost every house and public building has a spirit house for placating evil spirits, a custom that is very much a part of a Thai's life. Spirit worship dates back to animist customs that include the belief that spirits are all around and one must refrain from stepping on them. The belief is that a harmonious household can be achieved by placating the spirits with rice, fruit, water and offerings. Sometimes small figures are placed in the house to represent the property's guardian spirit post. The Buddhist religion is tolerant of many superstitions and philosophies and a variety of beliefs such as those of the Muslims, Hindus, Sikhs, and a few of the Christian philosophies. Though religious freedom is said to exist, there are some Buddhist groups that are intolerant of Christians, even to the point of physical violence toward them.

The Thai Muslims, numbering near one million people, reside largely in the southern area of Thailand. These Muslims center their activities around a mosque and differ not only in religion from the Buddhist but also in dress, behavior, language, and patterns of living. They are very poor and considered to be at the bottom of the rung in society. They are a dark-complexioned people and are despised by most other Thais. The Muslims usually conflict with the Buddhists and are antagonistic to each other in spite of Thailand's Constitution which advocates punishment for those who insult another's religion, stating that people who do so "shall be punished with imprisonment from one to seven years." This is another example of the Thailand's gap between the law and the custom.

Thai Women—Bent but Not Broken

Although the women of Thailand may smile, many of them have sad smiles because they are relegated to positions of inferiority and are designated as the "elephant's hind leg." However, there is a drift, especially in Bangkok and other Thailand cities, away from some of the traditional Thai culture toward implementation of Western trends. Women are securing better employment positions, a greater share of wealth, and recognition of their accomplishments. They are moving from the status quo to seeking additional educational and health services, more physical comforts, and a voice in governmental affairs. Even in the villages women are seeking more leadership roles.

Women are also seeking new approaches as improved communication modes become available and as modern transportation allows for movement. New vistas are opening daily for women. People from separate villages are coming closer together and sharing new ideas. In addition, an increase in commercial farming allows more income to the family, which in turn provides heretofore unknown amenities such as television, additional clothing, and new items for the home.

Another change that is affecting women is the initiation of criticism by the news media of the government and its policies regarding prostitution and other policies and reforms. Though women and some concerned men try to initiate social change, the cultural tradition weighs heavily and meaningful changes will be made slowly.

There is encouragement for women through the legal advice and assistance given by such organizations as the Friends of Women Foundation, the Foundation for Women, and The Women Lawyers Association of Thailand, who are seeking legal reform for women. The women of Thailand struggle, not only with traditional values but also with the pervasiveness of AIDS. A government whose economy is dependent on resources from prostitution is snatching lives away from women, but the "hind leg" grows stronger each year. The women of Thailand dare to dream and do not relax from the struggle. They will continue to take risks and battle for equality.

Women Must Persevere
As If Their Lives Depended on Their Efforts and They Do

As I LOOK BACK on the countries I have visited, a number of vivid scenes come to mind. I remember seeing an Albanian woman walking along a road with a load of hay on her back, following closely behind her husband who rode unencumbered on a little donkey. I remember watching another Albanian woman weaving wool thread as she stood in the fields tending her sheep. I remember a Thailand woman tending the crops in the fields with a hoe, working long hours, then returning home to handle family chores and care for the children. I remember an Indian women laboriously digging in the hard clay with a pick to help in the construction of a road in India; and a humped over Peruvian woman struggling with a bag of sticks and branches on her back twice her size as she walked down a dirt road; and in South Africa I

191

remember the women who walked more than ten miles a day to work as domestic servants. I see the women working, but what do the men in the lives of these women do while the women toil? Some work, but many congregate in villages, drinking alcohol and playing dominoes, and many loiter on the streets, in hotels, or at bus stations, squatting or sitting on boxes wherever men gather.

Perspectives of Women in Developing Countries

Even more devastating than the long laborious hours of work these women must do is the domestic violence that they must endure with little recourse. Husbands consider wives as their property to be utilized for work or pleasure. When women do not meet their men's expectations, they often encounter violent reactions from angry and sometimes drunken men. Even though law enforcement officers may voice opposition to violence toward women, they usually refuse to intervene, even in cases of severe abuse, treating incidents lightly as a "family affair." This attitude among law enforcement officers prevails partially because leaders do not consider abuse of women an issue of human rights. Women may experience unjust imprisonment, beatings, rape, incest, torture, mutilation, and even murder. Although most countries do not have adequate statistics regarding violence, reports indicate that violence toward women is rampant. One note of optimism is that there appears to be a slight upward trend in the enforcement of laws regarding human rights, including those regarding women.

A part of the violence directed toward women in undeveloped countries is the flourishing business of prostitution. In countries such as Thailand, young females, some still just children, are sold into bondage by parents for prostitution. Even though laws exist in most countries that prohibit the selling of girls into slavery, they are ignored by those who enforce the law. When countries benefit from sex-tourism and parents benefit from selling their daughters into bondage, it becomes a mammoth task to alter this long-standing tradition.

Men in developing countries succeed in their quest for women to produce children but may fail to assume responsibility for the physical and emotional needs of the children, thus relegating women with the primary responsibility of supporting and maintaining the family. However, a man's lack of support for his family does not diminish his desire for the children to bear his name, for his virility is a great source of pride. A woman bearing many children is then caught in the web of her struggle to maintain her family. Her tears flow silently while her arms embrace her children, her greatest love and reward for being.

Even though it is estimated that women produce some 45 percent of the world's food, they are granted only 10 percent of the world's income and one percent of the world's properties. (The United Nations Conference of Women in Copenhagen, 1980). In Africa, for example, 75 percent of the agricultural work is performed by women in addition to their fetching water and firewood for the home. Their work schedule is such that most of their waking hours are spent in physical labor either in the fields or other occupations and performing home responsibilities at night. Women barely earn enough to keep their bodies and soul intact.

Women in most developing countries are prohibited from participating in social events with men. For example, in India, women are usually prohibited from sitting at a table during a meal when males are present. They, along with the children, eat leftover food after the male has finished. Since women spend most of their waking hours working or caring for the family, they find little time for social events if they were available. In several developing countries I observed few, if any, women eating the evening meal with husbands at restaurants. Men, usually four to six at a table, reveled in gaiety as they ate and drank, leaving the women at home to care for the family.

Women in developing countries that I have visited live under the heavy cargo of prejudice, abuse, inadequate health care, and insufficient protection. They are often treated as minors, requiring permission to effect meaningful changes in their lives. They have fallen into this predicament due to misinformation, false teach-

ings, superstition, ignorance, apathy, and the male's desire for power. A country's culture is a major factor in influencing the male's behavior, which has provided the male with the impetuses for mistreatment of women.

One of the causes for the servitude of women is that all of the world's major religions, including the Christian religion, sanctions the subjugation of women. Religions are patriarchal in nature and through the centuries have promoted male supremacy, even having male gods to worship. The fundamentalist or zealous right wings of religious groups are even more adamant regarding the subordination of women and have made even greater efforts in recent years to maintain a patriarchal philosophy since women have begun to seek respect, dignity, and a place of recognition in society. There are, however, a few religions that are attempting to elevate the status of women within their domain.

It is paradoxical that women, who put their faith and trust into a religion, discover that their own religion is the major institution that advocates the subordination of women. As I visited churches in several countries, in most I observed that females outnumbered the males in church attendance, especially in many of the Protestant and Catholic churches, and I learned that more women maintain ties to the church than do men. Yet it is the religious institutions that vigorously fight to maintain male supremacy. In Peru, where Catholicism is the state religion, perhaps 80 percent of those in church services that I attended were women, but of course, it was the male priest who directed the service.

Some religions treat women as if their bodies represent the morality of all mankind. The responsibility for morality is placed on the woman without any responsibility assumed by the man. For example, in some countries the woman covers her entire body when she is in public. Some African countries practice genital mutilation (possibly as many as 20 million women) to remove chances of a woman's engaging in sexual relations before she is married. Millions of men see it as their duty to restrain women from sexual promiscuity and maintain control over them.

A justification tactic for the subjugation of women by fundamentalist religions is that the moral foundation of the home will remain intact only with women under masculine control. Women

have been instructed, and many agree, that they must "sacrifice themselves" for the good of the family. In the Christian religion the fundamentalist advocates "getting back to the Bible," which means for the women "getting back to the home." Thus women are kept subdued by the church, preventing them from preaching and speaking and taking leadership positions within churches. In Muslim areas, such as Thailand, women cannot enter the mosque because of their gender.

Fundamentalists in the Protestant religions use the Bible to justify their subjugating treatment of women through their interpretation of the scriptures, which was written in a period of male dominance. Part of the mistreatment of women is the male's desire to maintain power within the church, convinced that males are superior to females in intellect, logic, and leadership, and that men are favored by God.

I recently received via the Internet the little story that said, "When God made man, he looked at him and said, 'I can do better than that,' and then he made woman." Perhaps this is a little farfetched, but many portions of the Bible give parity to women. Galatians 3:28 states the Biblical position that God's love is for all people. Paul writes, "There is neither Jew nor Greek, slave nor free, male nor female, for you are all one in Christ Jesus" (New International Version).

Too often mothers have heard, "It's a pity it's a girl." In most developing countries a female child learns that she wasn't wanted, nor is she considered to be of value. In India a female baby may be aborted, or if a girl baby is born, she may be abandoned and left to starve. Girls recognize early what a heavy burden they become to the family—another person to feed, a husband to find, and an extra expense to her family for a dowry for her marriage. They are aware that theirs is a life encumbered with rejection, humiliation, violence, subjugation, and toil, and their self-esteem is almost nil and understandably so.

It was the patrimonial principle that initiated the bondage of woman. Could there be a revolution in the masculine conscience to initiate positive attitudes toward women? If men offered empathy, recognized that women are deserving of parity, exhibited respect and commitment to their women, and developed skills in

relating to women, most of the violent acts that degrade women would diminish or disappear.

Some women in these developing countries, however, will not progress beyond their present situation because they are their own worst enemy due to religious indoctrination regarding the submissive role of women and the teachings by their mothers to acquiesce to husbands. They have accepted their impasse and do not seek a more acceptable way of life. For these women, it is difficult to change when change is not desired.

Seeking Solutions

The value system women develop will determine to a large extent their advancement toward a more appropriate life. Since there is a positive correlation between one's self-concept and one's success, a woman needs to perceive herself in a positive light in order to succeed. She needs to build strong self-confidence regarding her abilities and potential which will likely thrust her forward into making significant changes in her life.

In order to enhance their self-esteem women will need to ascertain appropriate means of releasing their anxiety, anger, shame and humiliation. Women need to recognize, but not accept with fatalism, the conditions under which they live. For example, a statement often heard, "beating is what women expect," should be replaced with a more positive approach of what can be done to alleviate the existing dilemma. Women must seek alternatives to their lifestyles through problem solving, support groups, political interaction groups, international organizations, and encouraging local and national awareness of the circumstances that exist.

In most unindustrialized countries that I have visited, women are becoming involved in small grass roots organizations and political action groups to demand that the matter of human rights for women be addressed. They want to own property, to be given police protection, to have control of their bodies, to seek a divorce when abused, and to be included in the legislative process, especially when laws regarding women are being made. They want laws granting women rights to health care, education, social services, and a voice in local affairs. However, without deliberate

efforts by many people and perhaps outside support from concerned agencies, these events will not likely occur or will occur slowly.

The media must denounce the travesties regarding women. In some countries, such as China and Thailand, the news media are less than candid regarding the atrocities heaped upon women and quietly sanctions the abuse of women. In Thailand the media has refused to condemn prostitution, partly due to the economic benefits of sex-trade. Sex-selection and abortions of female fetuses in India appears to be an acceptable procedure, and little is noted in the media regarding this matter. Little attention is given to other travesties, such as kitchen fires in which a husband kills his wife in order to secure a new wife and a larger dowry. Hideous events such as these must be published through the media so that people with a humanitarian bent can address the dilemma.

Women need mentors, business advice, support groups, loans, and leadership training in order to develop their own enterprises. Groups from many countries are attempting to provide such services on a small basis to women in a few countries, but additional help is needed. Owning a small business will strengthen the economy and provide income to women and enhance their self-image. A business will also relieve many of them from the laborious tasks of trying to eke out a living.

Education is one of the most significant avenues in elevating the status of women. Education at the elementary level for females in undeveloped countries seems to be on par with male education. As children progress to higher levels of education though, and choices must be made as to who attends the university, a family usually determines that the male student is in greater need of higher education and training than the female. However, many women continue to make advancement in university education and other areas such as vocational training. In Albania, half of the students at one university are female. I heard it said, "Men are fearful that if women become educated they will take over the country." Worse things could happen.

The issue of adequate salaries and professional advancement for women needs addressing since such recognition is substantially lower than for males. Sixty percent of the world's illiterates

are women, but gains are slowly being made in the area of literacy and job training which will provide women with more opportunities for meaningful employment. Vocational training and parity in the job market for women is vital if women are to obtain an acceptable role in society. A few women, however, have broken the barrier and achieved significant employment, even a few in the political arena.

One of the most significant humanitarian endeavors on behalf of women has been financial contributions from individuals such as Ted Turner, who made a million-dollar grant to aid women in Africa, grants from philanthropic foundations, and aid through international organizations. These gifts have made a significant impact on raising the awareness of prejudice toward women and have provided funds for organizing groups for fighting injustices. Philanthropies will make gifts available only when they are aware of the circumstances that exist toward women. These funds will make it possible to alert the world to focus on the real issues that have been obscured due to ignorance and apathy.

Another humanitarian effort for alerting the world to atrocities and injustices that exist toward women are national and international meetings. Examples of such meetings are the World Congress Meeting on Women and the 2000 African Conference which addressed the inhumane struggles in Africa, especially as they relate to women and children. It is this type of awareness that will make a difference in the lives of women and children. Our challenge is to address the rights of all humans, not just those of women.

One of the benefits to a country from the liberation of women is that, when women become educated and are given opportunities to maximize their potential in the work force, the economy of a country will be enhanced. China is an example of a country in which women have been utilized vocationally to promote the economy of their country. Though women are said to have equal opportunity in China, that goal has not truly materialized, but at least women do (not necessarily by choice) work in significant employment arenas. Ignoring the potential of women in the work force results in significant loss in the country's job market.

When each person is treated with respect and equality, the world will be a better place in which to live, not just because the law has coerced man to conform, but because man recognizes within himself that it is the right thing to do. Loving each other makes us better people, for with love comes respect, trust, and caring for the needs of others. Though men and women differ in many aspects of their lives, this difference does not justify one sex's dominance over the other. When the world has a healthy discontent regarding the indentured status of women, it will create the impetus to thrust women into new roles of acceptability.

When women's status is improved, children also become the beneficiaries. Children suffer, as do women, when essential environmental and emotional needs of the mother are not met. Thus, children will benefit when adequate health care, nutrition, clean water, and a safe home environment are provided. Helping women with education, health care, and jobs provides a more stable home environment for the children.

Women will become better wives when they receive humane treatment. They need a safe atmosphere which will enhance their role as a significant member of their family. They need love, understanding, and an opportunity to live with dignity. Women have walked too long with "stones in their shoes." Caring about and loving them can alleviate some of the stones and aches, and provide a smoother walk for their hurting feet.

Index

About the Author

WINNIE WILLIAMS is a retired associate professor of special education from Southern Wesleyan University, Central SC. She received her undergraduate degree from Mississippi College, Master's degrees from New Orleans Theological Seminary and Clemson University. Additional studies were at University of South Carolina and University of Southern Mississippi. Prior to teaching at the University level she was a counselor and psychologist.

She is active in the Cooperative Baptist Fellowship, the First Baptist Church of Clemson, SC, service organizations including Rotary and is a frequent writer on missions and women's issues. She speaks throughout the South to churches, women's groups, and civic clubs.

Her travels have taken her to South Africa, Swaziland, Puerto Rico, Haiti, Peru, China, India, Albania, Thailand, Macedonia and Kosovo where she worked as an educational consultant, university teacher, missionary, and Rotary Good Will Ambassador.

Winnie and her husband Woodie, emeritus professor at Clemson University, live in Clemson, South Carolina. They are the parents of three adult children and six grandchildren.